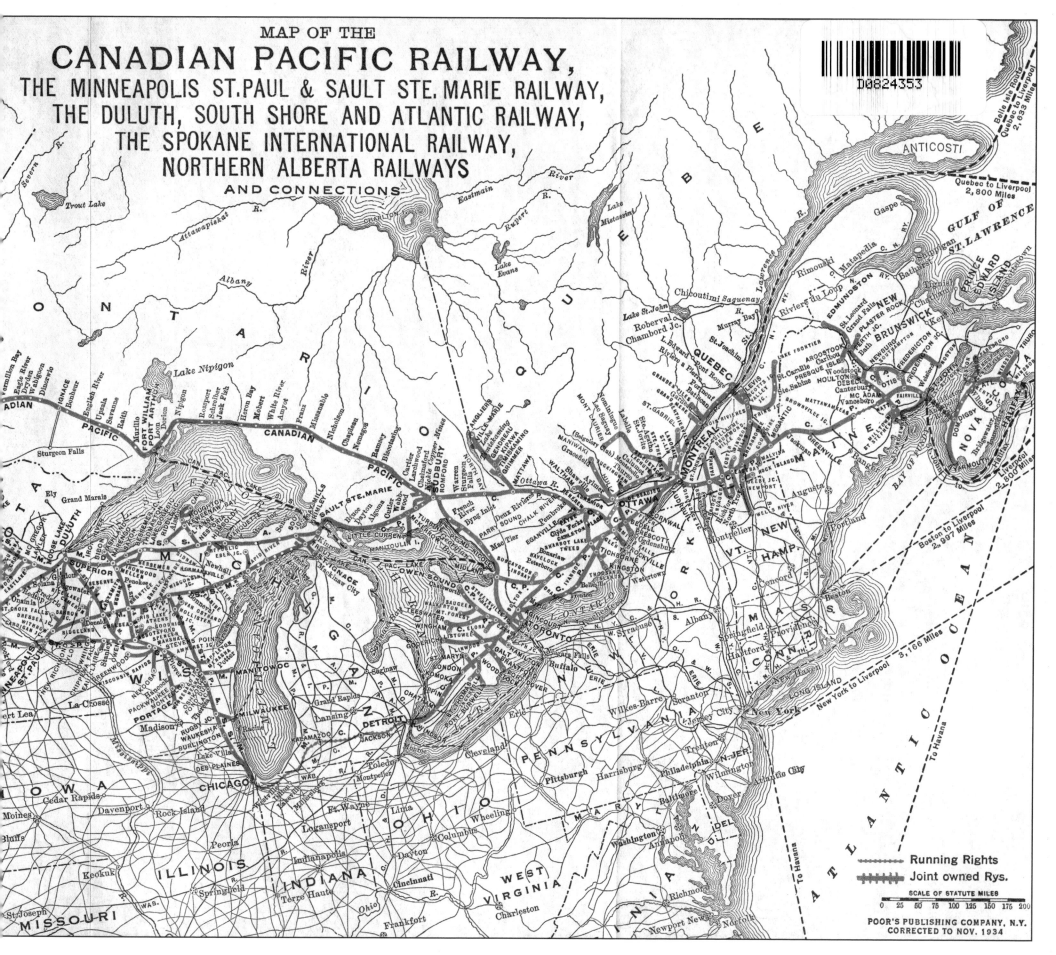

MAP OF THE
CANADIAN PACIFIC RAILWAY,
THE MINNEAPOLIS ST. PAUL & SAULT STE. MARIE RAILWAY,
THE DULUTH, SOUTH SHORE AND ATLANTIC RAILWAY,
THE SPOKANE INTERNATIONAL RAILWAY,
NORTHERN ALBERTA RAILWAYS
AND CONNECTIONS

Running Rights
Joint owned Rys.

SCALE OF STATUTE MILES

0 25 50 75 100 125 150 175 200

POOR'S PUBLISHING COMPANY, N.Y.
CORRECTED TO NOV. 1934

Nothing is too small to know, and nothing too big to attempt.

William Cornelius Van Horne

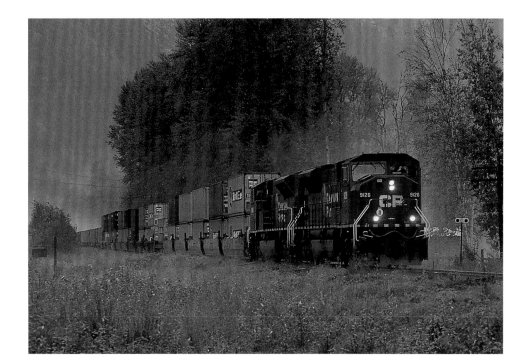

Canadian Pacific

STAND FAST, CRAIGELLACHIE!

GREG McDONNELL

The BOSTON
MILLS PRESS

A BOSTON MILLS PRESS BOOK

National Library of Canada Cataloguing in Publication

McDonnell, Greg, 1954-
Canadian Pacific : stand fast, Craigellachie! / Greg McDonnell.

ISBN 1-55046-402-7

1. Canadian Pacific Railway Company—History.
2. Canadian Pacific Railway Company—History—Pictorial works.
3. Railroads—Canada—History—Pictorial works. I. Title.
HE2810.C2M195 2003 385'.0971 C2003-901184-4

Publisher Cataloging-in-Publication Data (U.S.)

McDonnell, Greg, 1954-
Canadian Pacific : stand fast, Craigellachie! / Greg McDonnell. -1st ed.
[240] p. : col. photos. ; cm.

Summary: A tribute to the Canadian Pacific Railway.

ISBN 1-55046-402-7

1. Canadian Pacific Railway Company—History.
2. Canadian Pacific Railway Company—History—Pictorial works.
3. Railroads—Canada—History—Pictorial works. I. Title.
385.0971 21 HE2810.C2.M43 2003

Published by BOSTON MILLS PRESS
132 Main Street, Erin, Ontario, Canada N0B 1T0
Tel 519-833-2407 Fax 519-833-2195
e-mail: books@bostonmillspress.com www.bostonmillspress.com

In Canada: Distributed by Firefly Books Ltd.
3680 Victoria Park Avenue, Toronto, Ontario, Canada M2H 3K1

In the United States: Distributed by Firefly Books (U.S.) Inc.
P.O. Box 1338, Ellicott Station, Buffalo, New York, USA 14205

Design: McCorkindale Advertising & Design
Chris McCorkindale & Sue Breen

Printed in Canada

The publisher acknowledges the financial support of the Government of
Canada through the Book Publishing Industry Development Program
(BPIDP) for its publishing efforts.

Jacket
Restored to her original splendour, FP7 1400 leads the *Royal Canadian Pacific* at
Field, British Columbia, October 5, 2001. Greg McDonnell

Rear Jacket
Generations pass. Microprocessors make way for reciprocating steam as Hudson
2816 tears past AC4400CW 9646 and SD90MAC 9126, idling in the siding with
a westbound intermodal train at Eldon, Alberta, on September 23, 2001.
Greg McDonnell

Page 1
Truck frame, business car *Assiniboine*, December 8, 2000. Greg McDonnell

Page 2
Grain and 80-pound rail, P&H elevator track, Mossleigh, Alberta, October 8, 1998.
Greg McDonnell

Page 3
Stand fast, Craigellachie! Weathering a severe thunderstorm, SD90MAC's 9126
and 9149 work west of Craigellachie, British Columbia, with Toronto—Vancouver
train 493-26 on August 29, 1999. Greg McDonnell

Page 5
Elements and essence. CP 201001, scale track, Galt, Ontario, June 1, 1982.
Greg McDonnell

Page 240
Reporting marks on 40-foot boxcar CP 221411. Greg McDonnell

Field, British Columbia, October 5, 2001.
Greg McDonnell

Foreword

This book covers a subject near and dear to my heart—Canadian Pacific Railway.

And the book highlights my favourite topics.

It begins with a most appropriate lead-in—a dedication to CPR's most precious asset: its employees. Yesterday's and today's employees have been and continue to be engaged in making CPR a safe and significant enterprise on the road ahead to continuous improvement. This company is more than tracks, cars and locomotives. It's people. And it is these people who make it work so well.

The book celebrates the Scottish heritage of the company —a heritage I proudly share with CPR's founding fathers.

The charity and outreach initiatives of CPR *Empress*— steam locomotive No. 2816—and the Holiday Train underscore the company's concern and care for humanity and the communities in which CPR operates.

And stopping every single train on the system, on the 11th hour of the 11th day of the 11th month, is a fitting way to pay tribute, not only to CPR veterans who lost their lives in world conflicts, but to all who made the ultimate sacrifice. As I write this on the 59th anniversary of Canadian troops landing at Juno Beach on D-Day, I feel the same strength of conviction as I did the first Remembrance Day, in 1999, CPR stopped every single wheel on the system from turning. This

was something that had not been done on the CPR for 84 years, when, in September 1915, CPR marked the passing of its railway building general—William Cornelius Van Horne.

Sweating the assets in innovative ways gave birth to the *Royal Canadian Pacific*. What better way to preserve, enhance and optimize the use of an elite fleet of 1920s business cars, that saw only episodic use, than to make them available for special charters and upscale excursions.

This winter was particularly rough. Harsh weather—snow and extreme cold—stressed our track and caused a few derailments. Ed Dodge and I were struggling with these problems the first weekend in February, and how to get our railway back to optimum service. We took a break from the stress and set our minds on naming the two newly refurbished *Royal Canadian Pacific* (*RCP*) cars about to enter service. We thought of Canadian Pacific, its history and its heritage. And what better way to evoke all that than to recall the clan Grant's rallying point in the old Scottish county of Banffshire. Or to recall that day, November 7, 1885, when Donald Smith drove the last spike in the Monashee Mountains of British Columbia, at a place also named after that "rock of alarm" Craigellachie!

So the newly refurbished *RCP* 1926 sleeping car became the *Banffshire*, and the 1931 dining car was called the *Craigellachie*.

Canadian Pacific—stand fast, Craigellachie!

Robert J. Ritchie
President and CEO
Canadian Pacific Railway
June 6, 2003

Stand Fast!

Stand Fast, Craigellachie,
Where they drove the last spike in;
To bind a vast Dominion,
To let a brand new day begin.
A whistle screams out of history,
As red diesels roll their loads,
Westbound to the Pacific,
*On the rails of Van Horne's Road.**

Stand fast, indeed! I am truly honoured.
When Greg McDonnell asked me to contribute both words and photography to his latest book project, *Canadian Pacific: Stand Fast Craigellachie!*, it seems that I heard a clock ticking.

What I heard was likely one of those classic Seth Thomas No. 15 "World" clocks that once were part of the CPR furniture in stations and offices all across the "World's Greatest Travel System." The ticking of that old Seth Thomas timepiece was the counting of my time, indeed my life and times, in over 35 years (and *still* counting!) with the CPR and its subsidiaries.

TIME. I've got time now for reflection. Time to reflect on a railroad career that includes engineering, mechanical and transportation departments in over ten different positions.

Time served almost everywhere the CPR's big steel rails go, and a lot of places they no longer go.

West from old New England and Quebec, across the Prairie Region to the mountain districts of Revelstoke and the Kootenay, even to the insular rails of the storied Esquimalt & Nanaimo.

GEOGRAPHY. The CPR has left its mark on the incredible landscape it penetrated and changed. Thanks to CPR engineering genius, the late John Fox, my time with the CP began in Kicking Horse Pass, at Yoho, British Columbia, as a water boy. The steel gang wasn't a job, it was a paid adventure! Sights like CP's flagship silver-dome streamliner *The Canadian* climbing eastward through Cathedral and coiling through the Lower Spiral Tunnel were perks thrown in for free!

HISTORY. The CPR and Canada's social history are synonymous with each other. The late David P. Morgan, editor of *Trains* magazine, and author Greg McDonnell have argued that the proper date for Canadian confederation should actually be November 7, 1885, when the CPR was officially completed at lonely Craigellachie, British Columbia.

A plain iron spike,
In an oak cross tie,
Driven home by a ringing maul.
Then fifteen words from old Van Horne;
He said, "Good work boys,"
*And that's all.**

PSYCHE. Does CP stand for "Canadian Psyche?" Is there actually a "CPR" way of thinking? I think there is. Any entrepreneur worth his or her salt knows that time is money. The CPR knows that, and the CPR experience has taught generations of Canadians that.

The CPR constantly reminds all of us, rank and filers and managers alike, shippers and suppliers, grievors and railfans, that time and money matter to the CPR.

Want a real challenge? Represent any of CPR's unionized employees as a "grievor." The stimulating exchange as

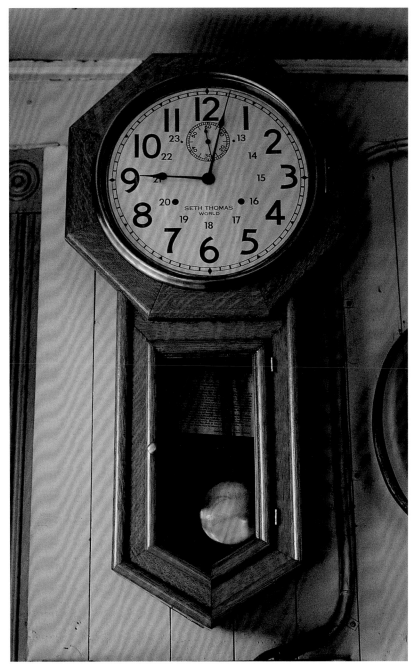

What I heard was likely one of those classic Seth Thomas No. 15 "World" clocks that once were part of the CPR furniture in stations and offices all across the "World's Greatest Travel System." Time, in the station at Zorra, Ontario, is marked by the beat of a Seth Thomas World clock on September 19, 1973. **Greg McDonnell**

collective agreements are tried and tested builds character like little else.

Even today, I invite you to stroll beneath the remnants of the Bush train sheds leading to the concourse of Montreal's Windsor Station. A special thought may cross your mind: If CP stands for "Corporate Profit," then surely one must marvel at the lucrative, worldly business decision made through the ages within the modest but classic confines of Windsor Station. I know I do.

Perhaps what CP really stands for is "Company Pride." Scheduled employees and company officers alike still demonstrate dedication to the company cause—something unusual in big business today. Answering big challenges has been part of the CPR ethic since 1881. Yet today's CP railroaders still answer challenges with ingenuity and, best of all, a healthy respect for the art of railroading.

For me, the CPR has been many things. A first love, a mistress, my employer, an educator and at times a magnificent obsession. The CPR has always been one of the best pikes to railroad on. Only "rails" with class need apply.

This book celebrates the CPR way. So do recent CPR efforts to remember the past through the *Royal Canadian Pacific* and the operating restoration of H1b 4-6-4 2816. You can thank Rob Ritchie for all of the above. A modern-day railroad president with a sense of both business *and* history, Mr. Ritchie leads by example in the CPR's second century. Van Horne and Crump would approve, I'm sure!

Stand Fast!

> ...*Big red diesels hauling Kootenay coal,*
> *And time freight to the sea;*
> *Over John Fox Bridge,*
> *Through a nine mile bore,*
> *In the second century.**

Stan J. Smaill
Montreal, May 22, 2003

* From the song *Craigellachie* by Stan J. Smaill, copyright 1985, Smaillways Music. Used with permission.

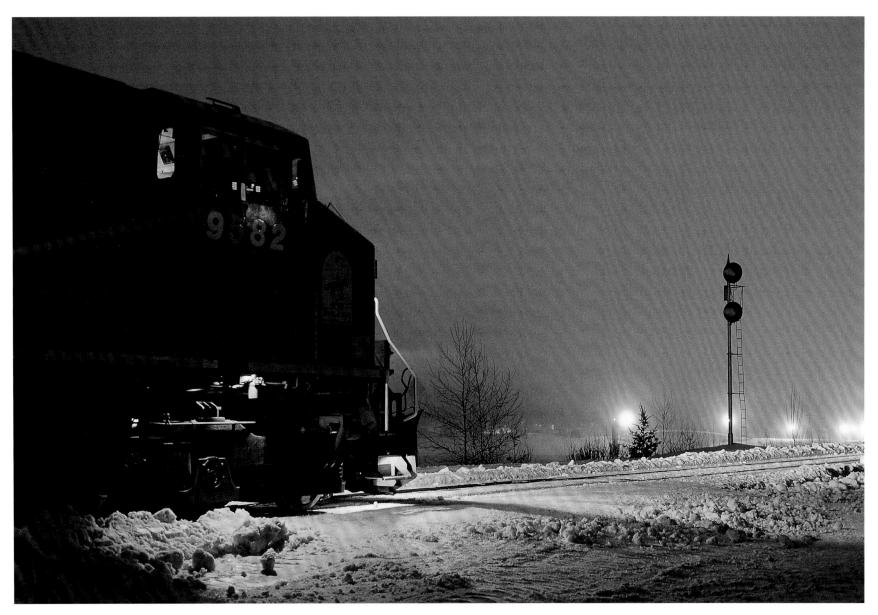

A bad day for trains. Tracer-like beams from the signals at Sicamous stab the icy night air as AC4400CW 9582 holds the siding with train 832-10 stuck on the wrong side of an avalanche at Three Valley, British Columbia, at 0145, February 1, 1997. **Greg McDonnell**

No One Said
It Would Be Easy

All red at Sicamous.

Stabbing the night with tracer-like beams, the signals guarding the Shuswap Subdivision at Sicamous, British Columbia, glare red as GE's 9582 and 9541 ease up the siding with train 832-10. The frigid air is heavy with ice crystals and filled with the guttural chug of FDL engines, the whine of A.C. traction motors and the squeal of steel on steel as the train creeps up to the red signals. Brake shoes tighten their grip on 422 steel wheels as engineer Phil Mason sets the brake.

At a minute to midnight, 101 Crowsnest coal empties shudder to a stop and a good trip goes to hell.

It is, as Patricia Conroy would say, a bad day for trains. Just 45 miles from Revelstoke—home for Mason and conductor Garry Channell—the 9582 East is stuck on the wrong side of an avalanche at Three Valley. To make matters worse, the plow helping crews clear the line has derailed. Toronto–Vancouver hotshot 401 leads the pack of westbounds cooling their wheels on the far side of the slide, and a parade of eastbounds is stacking up behind 832-10. In the midst of an already difficult winter, nature has again flexed her muscles; Mason, Channell and the 832-10 are going nowhere in a hurry.

Time and Mother Nature have taken the round. At 0400, February 1, 1997, engineer Phil Mason writes out instructions and a note for the relief crew as conductor Gary Channell ties down train 832-10 at Sicamous, British Columbia.
Greg McDonnell

From the Navvies and Chinese labourers who signed on to build this railway through the uncharted wilderness, across muskeg and mountain ranges, to the section men toiling to

re-rail the plow at Three Valley, the Calgary RTC struggling to keep his piece of the railroad fluid, and the men in the cab of the 9582 on a miserable winter night, CPR people are a special breed. Since the days of Van Horne and Stephen, they've taken adversity and hardship in stride. For better or worse, they wear their company service as a badge of honour, and go the extra mile—if not for the company, then for personal pride in a job well done.

Nearly 120 years after the fact, the spirit and tradition of Craigellachie lives on. This work is dedicated to that spirit, to the generations of CPR workers who have upheld it, and to the people who continue to do so today.

No one said it would be easy. Nothing truly worthwhile ever is.

A bad day for trains... Robert (Bob) Hambleton, GRR, Kitchener, Ontario, June 13, 1983.
Greg McDonnell

Paul Wood, Dumfries, Ontario, June 13, 1983.
Greg McDonnell

Ian Libbey, Lytton, British Columbia, September 20, 2001.
Greg McDonnell

Rhonda Millar, Swift Current, Saskatchewan, October 16, 1995. **Greg McDonnell**

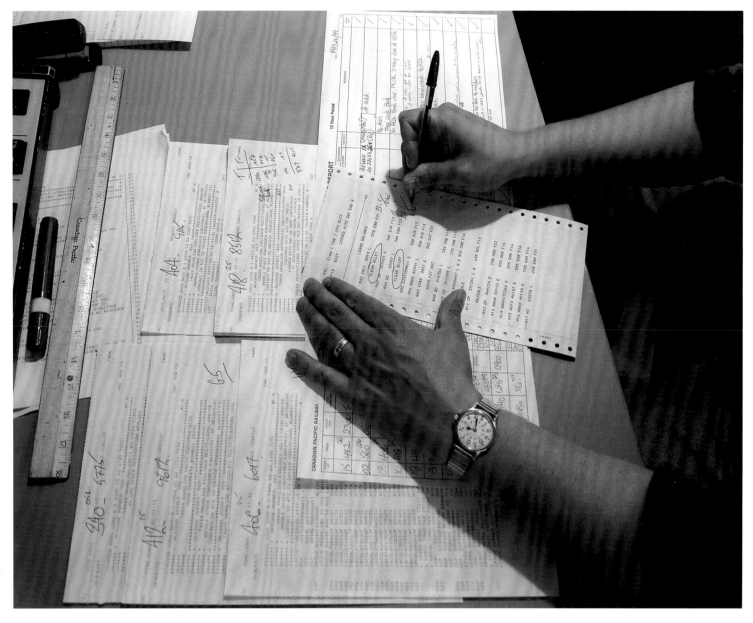

Marking switch lists in the time-honoured manner, the hands of the South Hump Coordinator line up work for the yard crews at Winnipeg, Manitoba, at 0226, May 29, 1999. "A lot of tonnage gets moved with a 59-cent Bic," notes the photographer. **A. Ross Harrison**

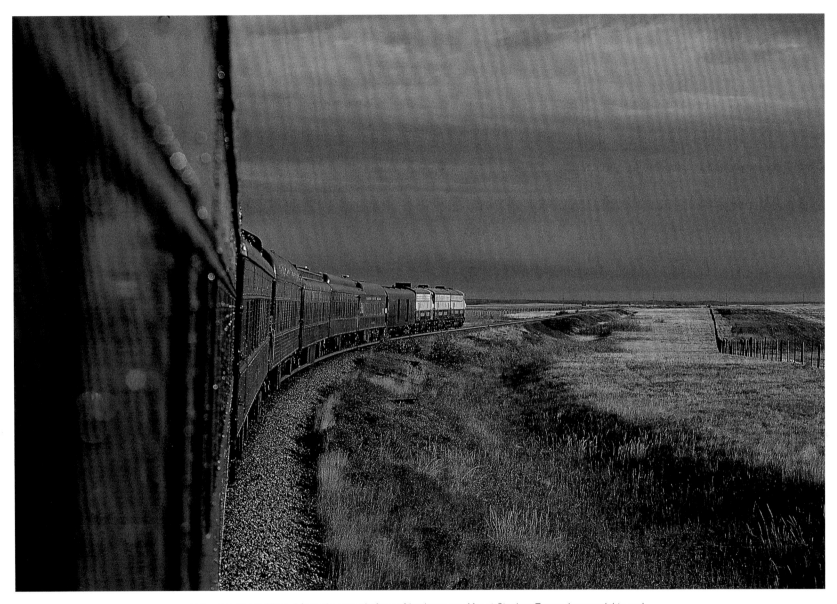

Living the dream. Viewed from the rear platform of business car *Mount Stephen*, Tuscan heavyweights and maroon-and-grey F's 1400, 1900 and 1401 glisten in the early morning light as the *Royal Canadian Pacific* races into a prairie sunrise east of Peigan, Alberta, on October 7, 2001. **Greg McDonnell**

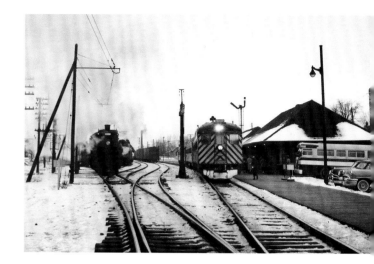

The World's Greatest Travel System

Only Canadian Pacific would dare proclaim itself the "World's Greatest Travel System." Only Canadian Pacific could live up to the claim.

I embraced CP's audacious proclamation as a small boy, taking the company at its word with the innocence and enthusiasm of youth. My acceptance was based, not on knowledge or experience, but on faith. Faith, and the fact that I knew when I was in the presence of greatness. And I *was,* on that summer evening in the late 1950s when I first set foot in the Canadian Pacific Railway station in Galt, Ontario.

There was something about Canadian Pacific. Something about waiting room walls hung with paintings of the north shore of Lake Superior, the Canadian Shield and the Rocky Mountains, and with posters that beckoned one to "Travel *The Canadian*…the scenic dome route across Canada," and "Sail the *Empress of Britain* to Europe,"

I knew when I was in the presence of greatness...and I was, at Galt.
Coal smoke dusts the Grand River Railway catenary wires at Galt, Ontario, on March 10, 1956, as G1 Pacific 2209, Mike 5171 and a pair of Pacifics wait in the wings while RDC's 9050, 9051 and 9052 stop with Windsor-bound train 629. Parked in the "Bus Only" spot next to the station, Canadian Pacific Transport Twin Coach No. 17 honours the timetable-advertised Electric Lines Kitchener–Galt connection. Buses replaced the GRR/LE&N interurban electrics in April 1955 and CPT Twins continued to meet passenger trains at Galt until June 19, 1961. **William D. Middleton**

CP's original Dayliners, RDC1's 9050, 9051 and 9052 race Windsor–Toronto No. 630 through the pastures west of Lisgar, Ontario, approaching what is now Winston Churchill Boulevard in Mississauga, on July 4, 1955. **Robert Sandusky**

or take to the skies aboard a Canadian Pacific Airlines Super DC-6. Something about a public timetable that included not just a railway map of Canada and North America but a map of the world emblazoned with a CP crest and underscored by the words "bridging two oceans, linking four continents." Something about the mere fact that it was possible to step up to the ticket wicket and book a coach seat to Toronto, or sleeping car space on an overnight train to Montreal, or a lower berth through to Saint John or Vancouver, or to circumnavigate the globe by land, air and sea—all under the Canadian Pacific flag.

Canadian Pacific was bigger than life. It was CP Steamships' legendary "White Empress" fleet of ocean liners on trans-Atlantic, transpacific and round-the-world sailings. It was Canadian Pacific Airlines' Super DC-6's and "jet-prop" Bristol Britannias on scheduled flights across Canada, and to Europe, Hawaii, Australia, New Zealand, Mexico, South America and the Orient, "the wings of the world's greatest travel system." It was palatial hotels from St. Andrews, New Brunswick, to Victoria, British Columbia. It was express trucks and telegraphs and Great Lakes steamships and ferries

on the Bay of Fundy and the British Columbia coast, and connecting buses and "private wire" teletype service. Above all, Canadian Pacific was Canadian, and the most Canadian of its institutions was the Canadian Pacific Railway.

For a small-town boy growing up in the late Fifties, Canadian Pacific was a 10-mile ride in the back seat of our old Morris Minor, a stop at the Dairy Queen for a chocolate-dipped ice cream cone and the evening arrival of train 22, the Chicago–Montreal *Overseas*, at the CPR station in Galt.

The *Overseas*. The name carried an air of prestige, excitement and the promise of adventure. And the train itself was true to the implications of its name. An introduction to the *Overseas* was all it took to persuade me that, when it came to travel, Canadian Pacific was as good as its word.

A Seth Thomas clock marked time with soothing rhythm, but the tension heightened as its pointed hands inched ever closer to the "8:30 p.m." chalked in the DUE column of the arrivals and departures board outside the waiting room door. With pulse-quickening reports, the operator pounded the validator, banging blue-ink impressions on tickets. Each one issuing passage on No. 22 to another fortunate soul. It was the stuff of dreams.

Outside, a maroon-and-cream Twin Coach lettered Canadian Pacific Transport Company pulled up to a platform sign marked "Bus Only." The last vestige of passenger service on CP's Electric Lines subsidiaries, the Grand River Railway and the Lake Erie & Northern, the oddly styled bus was one of a small fleet of CPT Twins that met each train and provided connecting service to Preston, Freeport, Centreville and Kitchener.

The Twins were a pale substitute for the GRR and LE&N interurban cars they displaced. As such, the bus received only a grudging glance. After all, in the simple logic of a boy's world, that bus and its kin were to be blamed for the disappearance of the electric cars I was too young to remember. Time would erase the animosity, but not before the interlopers, too, had vanished.

Happily, the Electric Lines were still electric, and energized catenary was still strung over the wye and most of the Galt

Some dreams never come true. On July 3, 1971, RDC2's 9110 and 9115 pull into Galt with the last run of Windsor–Toronto No. 338. In less than 12 hours, the operator will O.S. the last scheduled passenger train to call at Galt and hang out the freight-only sign for good. **Greg McDonnell**

yard. In the distance, a zebra-striped steeple-cab worked under the wire, feeding on 1,500-volt D.C. current, shuffling boxcars and hoppers, but never venturing close enough to the station for a good look. The sound of a faraway horn shifted attention from the motor to the moment as No. 22 called out for the Blenheim Road crossing on the edge of town.

Hopes of steam on the *Overseas* were dashed in the air horns' blare, but the excitement was undiminished. In the early evening light, No. 22 descended upon Galt with all the pomp befitting a train carded by the World's Greatest Travel System. Gleaming in the twilight, an A-B of maroon-and-grey F's rumbled over the Grand River bridge and across the Water Street overpass with a dozen or more passenger cars in tow.

All goose bumps and adrenalin, I watched as the *Overseas* slid past; 567 engines throbbing, traction motors whining, brakeshoes grabbing at the wheels of baggage and RPO cars, streamlined and heavyweight coaches, a diner and sleepers— at least one of them a stainless-steel New York Central car running through from Chicago. Wisps of steam and brakeshoe smoke traced polished maroon and fluted stainless-steel car-

sides as Dutch doors and traps banged open and step boxes hit the wooden platform. Uniformed trainmen and sleeping car porters emerged and passengers hurried past. Through plate-glass windows, I watched white-jacketed waiters in the dining car, and eyed—with no small measure of envy— roomettes, bedrooms and sections neatly made up and awaiting occupants.

I was in awe. I was a believer.

All too soon, the *Overseas* got underway for Toronto and Montreal. As the kerosene markers faded in the distance, the Twin Coach fired up for its next run, the Royal Mail truck headed back to the post office and a bright red baggage cart rattled along the platform as the baggageman dragged his burden to the baggage house. As the *Overseas* headed into the night, an old green Morris Minor bumped along the back roads to Kitchener. In the back seat, a boy dreamed of one day boarding No. 22 with a sleeping car ticket and passage to experience first-hand all that was great about the world's greatest travel system.

While I dreamed of luxuriant travel in Tuscan heavyweights, I became well acquainted with Budd RDC's—Dayliners, in CP parlance—scooting along the Galt Sub on schedules once held down by Jubilees and lightweight coaches; plying "the Bruce" to Owen Sound and the old main from Toronto to Havelock. They were humble conveyances by any standard, but by virtue of their operating economies, the Dayliners were the salvation of many a train that might otherwise be discontinued.

The times, as Dylan wrote, were a-changin'. By the mid-Sixties, passengers were a money-losing proposition and the CPR made no secret of its desire to rid itself of the financial and operating burdens imposed by the passenger train. Train-off notices and petitions for discontinuance were tacked up on waiting room walls from Annapolis Royal to Qualicum Beach. The passenger train had fallen from grace. "I can see no future in it," said CPR Chairman and President N. R. Crump.

From the Maritimes to British Columbia, everything from the most prestigious name trains to the most obscure mixed

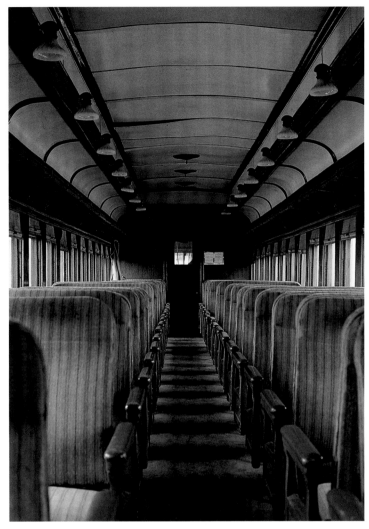

Little changed in nearly a half-century of service. CP 1303, the railway's last heavyweight coach in revenue service, works the last surviving CPR mixed train, Dominion Atlantic Windsor–Truro, Nova Scotia, No. 21, on April 24, 1975. Empty rows of green plush walkover seats lend credence to the discontinuance notices posted on the windows an walls of DAR stations. **Greg McDonnell**

trains faced discontinuance. On April 26, 1964, the *Overseas* and its westbound complement, No. 21, the *Chicago Express,* were replaced by Dayliners. The famed pool agreement governing joint CN/CP passenger services between Toronto, Ottawa, Montreal and Quebec City was abolished on October 31, 1965, and even Montreal–Toronto successors,

the *Royal York* and *Chateau Champlain,* were gone by January 23, 1966. The legendary *Dominion* made its last transcontinental run on January 9, 1966, and its centennial year stand-in, the *Expo Limited*, rolled into Windsor Station in Montreal for the last time on November 1, 1967.

Ranks of out-of-work passenger cars crowding the coach yard tracks at John Street in Toronto and the Glen in Montreal were indicative of the bleak future facing not only the passenger train, but those whose livelihood depended upon it. The rusting wheels, broken glass and fading maroon paint on the idled cars translated to uncounted furlough notices for train crews and carmen and upholsterers, porters, cooks and ticket agents; to trains that would never come back and whistles that would no longer sound in the night.

Line numbers left in place revealed details of last runs and final assignments; step treads worn smooth, tired, plush upholstery and the patina on handrails and door hardware revealed more. The old cars oozed an aura of history and humanity from every crack and crevice. Standing in the darkened corridor of an old sleeper, or walking the dusty aisle of a road-weary coach conjured up images of *The Dominion*, the *Great West Express*, or some unnamed local rolling through a winter night with snow swirling up around the windows. There was the whistle of the Hudson up front mixing with the clatter of six-wheel trucks on jointed rail, the murmur of a half-dozen conversations and the hushed tones of dead-heading crews playing cards in a smoky corner section. If those mahogany-panelled walls could talk, they could recite the history of a nation and dictate the stuff of a thousand novels.

On July 3, 1971, I stood on the platform at Galt as CP RDC2's 9110 and 9115 pulled into town with No. 338, the morning Dayliner to Toronto. The *Overseas*, the *Chicago Express*, maroon heavyweights, RPO's, through cars from Chicago and connecting buses to Kitchener were long gone. Indeed, the A&D board at Galt, which had listed no fewer than ten trains short years before, now held just two: Windsor–Toronto No. 338 and its westbound counterpart, No. 337. In less than 12 hours, they too would be gone.

Ticket in hand, I made my way up the aisle of the 9110 and took up position in a walkover seat near the front of the car. As the twin 275-hp Detroit Diesels slung beneath the floor accelerated No. 338 out of town, memories of that first encounter with the *Overseas* came flooding back, but, the ticket I was holding was not for the trip of those childhood dreams. It was a ticket to ride the last run of the last scheduled eastbound passenger train to call at Galt.

Chills ran down my spine as No. 338 paraded into Toronto for the last time, the engineer tugging triumphant blasts on the horn all the way from Parkdale to Union Station. In a cacophony K3LA's, single-note Air Chimes and other horns, CN and CP switchers, other passenger trains and transfers tooted back in salute. Sectionmen, switch tenders and tower levermen waved and the conductor walked the aisle, calling "Toronto Union" for the last time. "Keep them," he said of the tickets that had gone uncollected. "Keep them as souvenirs."

By the 1970s, CPR's once impressive passenger timetable had been reduced to little more than a pamphlet. However, if the timetable was underwhelming in size, it was over-whelming in content. Cutbacks and cancellations notwith-standing, Dayliners continued to ply the rails in five provinces, from the shores of the Bay of Fundy in Nova Scotia, to the old-growth forests of Vancouver Island. Daily trains operated to both coasts: the Montreal–Saint John *Atlantic Limited* and the Montreal/Toronto–Vancouver flagship, *The Canadian*. And a single surviving mixed train ambled along the Windsor–Truro branch of CP's Nova Scotia subsidiary, the Dominion Atlantic Railway.

Hoping to stay one step ahead of abandonment petitions and notices of discontinuance, I went looking for the legacy of the World's Greatest Travel System. What I found was Canada.

Even in the eleventh hour, travel by CPR remained fun-damental to the Canadian experience. What could be more Canadian than watching the prairie unfold from a seat in a dome car named *Riding Mountain Park*; or riding through rural Nova Scotia on the green plush walkover seats of a

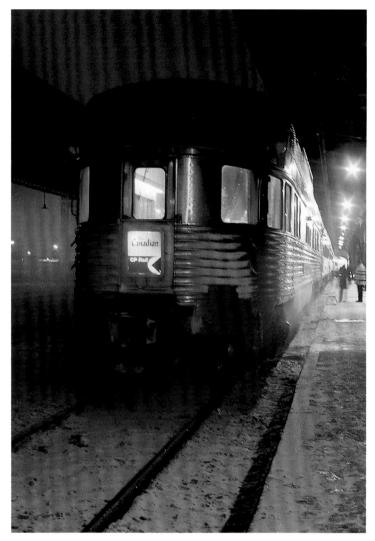

Carrying the illuminated tail sign of one of the finest passenger trains in North America, dome-observation car *Riding Mountain Park* punctuates *The Canadian* at Winnipeg, Manitoba, February 15, 1976. **Greg McDonnell**

heavyweight coach tied to the tail end of Dominion Atlantic mixed train No. 21. Or how about seeing the sun rise over breakfast in the dining car as the *Atlantic Limited* hurries through the snow on the last lap into Montreal; or watching from a Skyline dome as the maroon-and-grey E8 ahead explodes through drifts and battles blizzard conditions with No. 154, the midday train from Montreal to Quebec City;

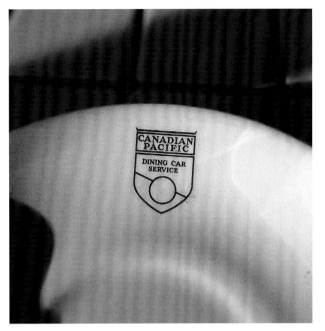

A legacy of the glory days of the World's Greatest Travel System. Dining car china in the Orangeville bunkhouse, August 1973.
Greg McDonnell

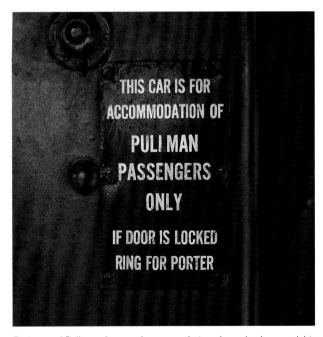

Porters and Pullman days are long gone, but work service heavyweight sleeper 411249, formerly T-class sleeping car *Trapper*, carries a reminder at John Street in Toronto, Ontario, on February 19, 1974.
Greg McDonnell

or looking out at the cold black waters of Gitche Gumee as *The Canadian* slips along the rocky shore of Lake Superior?

True to form, the CPR made a graceful exit from the passenger trade, but the inevitable end came on September 29, 1978, as VIA Rail Canada assumed operation of all remaining intercity CP passenger trains. Venturing as far as time, ticket money and the liberties of a CPR rules card would allow, I had most of those dreams once spawned on the platform at Galt fulfilled before the curtain came down. But, the fantasy of the *Overseas*—reliving the glory days of the World's Greatest Travel System at the tables of heavyweight diners, on the plush cushions of parlour cars and in the mahogany-panelled compartments of heavyweight sleepers—proved a dream too far. The closest I could come was dinner in the Orangeville bunkhouse on Depression-era china marked with the Canadian Pacific Dining Car Service crest, and examining old heavyweight sleepers and diners downgraded to OCS (On Company Service) duty with steel gangs, work trains and auxiliary outfits. Some dreams never come true.

Some dreams do.

Forty-some years down the road, the *Overseas* is again on my mind as the haunting wail of bagpipes echoes through the lower level of the Palliser Hotel in Calgary on a fall 2001 morning. To the tune of *Scotland the Brave*, Maureen and I join a small group of passengers as the lone piper leads us up a curving staircase, through the Canadian Pacific Railway Pavilion, and to a waiting train of Tuscan heavyweights.

Like a vision, the seven-car train shimmers in the morning sun. A red-coated Mountie stands at attention on the rear platform of CP business car *Mount Stephen*. Flanking the step wells and doorway, uniformed crew members, white-jacketed wait-staff and chefs welcome us aboard, and Maureen and I are ushered to the compartment that will be ours for the next four days: Room 1 in the car *Strathcona*. It is not a dream. It is, as proclaimed by the drumhead affixed to the railings of *Mount Stephen*, the *Royal Canadian Pacific*. And it is a dream come true.

From the tip of the beaver-crested nose of CP FP7 1400, to the brass railings and ornate drumhead on the tail of *Mount*

Stephen, the *Royal Canadian Pacific*—all 807 Tuscan-painted linear feet of it—is no ordinary train. With a pristine A-B-A of maroon-and-grey F's (CP 1400, 1900 and 1401), baggage/generator car 95 and heavyweights *Killarney*, *Strathcona*, *N. R. Crump*, *Van Horne*, *Royal Wentworth*, and *Mount Stephen*, the *RCP* boasts an extraordinary consist that in pedigree, appointment and presence more than earns the train its *Royal* accreditation.

Indeed, the *Royal* in *Royal Wentworth* is no coincidence. Turned out by CP's Angus Shops in Montreal in August 1926, the 84-foot-long business car was given the name *Wentworth* in honour of Edward Wentworth Beatty, CPR president at the time. In 1939, Mr. Beatty's car traded its Tuscan dress for two-tone blue and aluminum paint to serve on the 1939 Royal Train of Their Majesties King George VI and Queen Elizabeth. Remodelled and reconditioned for the occasion, *Wentworth* was assigned to the Prime Minister of Canada, William Lyon Mackenzie King. In celebration of the 60th anniversary of its Royal Train service, *Wentworth* was re-christened *Royal Wentworth* in 1999 and assigned to *RCP* service when the train debuted on June 22, 2000.

To settle into a plush chair in one of the Circassian walnut-panelled, art deco rooms of *Mount Stephen* is to sit where, on a trip from the Quebec Conference to Washington, D.C., in war-torn 1943, Winston Churchill sat, studying papers, writing speeches and considering strategies that would alter the course of world history. Diners in the 1926-vintage Angus-built car are served in the same dining room that played host to the Duke and Duchess of Windsor (the former King Edward VIII and Wallis Simpson), Princess Elizabeth and the Duke of Edinburgh (later Queen Elizabeth II and Prince Philip) and Princess Margaret.

Feeling the presence of Churchill and following in the footsteps of royalty, we settle into plush armchairs in the lounge of *Mount Stephen* and watch Calgary disappear on the horizon as Passenger 1400 West embarks on the first leg of the four-day three-night, 650-mile Golden/Crowsnest Excursion. As suburban acreage gives way to unspoiled foothills, Maureen and I move to the rear platform to take in the clean air and splendid scenery.

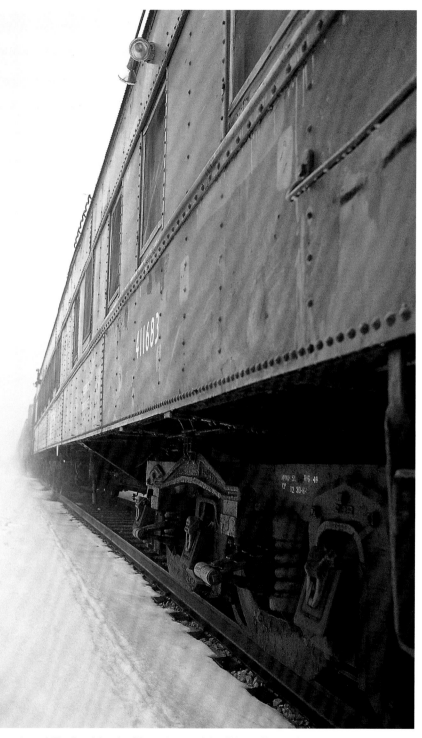

The halcyon days of *The Dominion*, the *Mountaineer* and the *Chicago Express* but a memory, retired OCS "Cook-Diner" 411683, built as heavyweight diner *Wallingford*, awaits its fate in the fog at Welland, Ontario, on March 9, 1990. **Greg McDonnell**

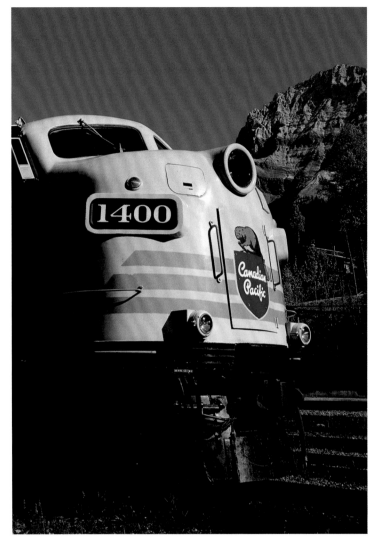

Recreating a famous Peter Ewart painting and 1952 CPR poster, FP7 1400 strikes a classic pose on October 5, 2001, pausing at Field, British Columbia, with the *Royal Canadian Pacific*. **Greg McDonnell**

There is splendour on both sides of *Mount Stephen*'s picture windows as we roll through Lake Louise and over the Divide, sipping Burrowing Owl Pinot Gris 1998 and dining on grilled lobster tail with angel hair pasta and chive beurre rouge, followed by medallions of pork tenderloin with roasted red bell pepper and sage sauce. Dessert (Bond de Fruit, with fresh fruit and cream) includes a spin through the Upper and Lower Spiral Tunnels, followed by a stop at Field and an afternoon hike along the shore of Emerald Lake. "If we can't export the scenery," Van Horne once mused, "we shall have to import the tourists."

Sitting out on the open verandah of *Strathcona* and savouring a glass of Glenmorangie as the train negotiates the canyons of Kicking Horse Pass is about as good as it gets. The Tuscan heavyweights slip in and out of the afternoon shadows as they trace the blue-green glacial waters of the Kicking Horse River. The clock turns back with every revolution of *Strathcona*'s steel wheels; but for the absence of double-slotted Decapods, it might just as well be 1929.

As it is, to be riding a train of heavyweights drawn by an A-B-A of maroon-and-grey F's in the 21st century is nothing short of a miracle. "Something very special happens when people board this train," says *RCP* managing director David Walker. Amen, brother, amen!

Billed as a "timeless journey," the *Royal Canadian Pacific* exceeds all expectations. Indeed, insulated from the stress and distractions of the outside world by windows of thick plate glass and walls of heavy steel and rich wood panelling, passage aboard the *RCP* offers a transcendental journey. Time is inconsequential, the date indeterminate and a watch good for little more than ascertaining when it's time to dress for dinner. Reason enough to carry a good watch, though, for evening dining on the *RCP* is semi-formal. *A jacket and tie is the norm for gentlemen, except during unusually hot weather. For ladies an evening dress is recommended.*

In the *RCP* world of crisp linens, polished silver and elegant china, impeccable service, fine cuisine and vintage wines, time passes easily. The tariff is not for the faint of heart, but the experience goes beyond that which money can buy,

If anything can compete with the pure satisfaction of riding an open-air platform, listening to the chant of 567's echoing through evergreen forests and looking out at snow-capped peaks reaching for the azure sky, it's a three-course lunch prepared by chef Pierre Meloche and served in the dining room of the *Mount Stephen* as the *RCP* climbs towards the Continental Divide.

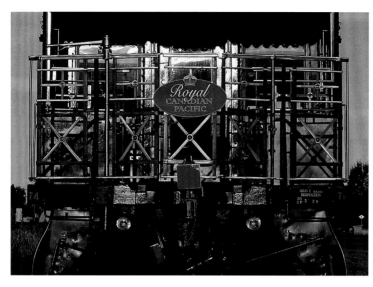

Business car *Mount Stephen* carries the *Royal Canadian Pacific* tail sign at Okotoks, Alberta, on October 8, 2001. **Greg McDonnell**

and memories—amortized over a lifetime—come cheap. Included in the fare are memories of a moonlit walk along Lake Windermere after feasting on herb-crusted rack of lamb at the dining table in *Royal Wentworth*; waking to a gentle tug on *Strathcona*'s drawbar as the *RCP* gets underway from Invermere; crossing rivers running red with salmon, curving around McGillvary Loop at dusk, passing the Frank Slide in the eery light of dawn and racing into a spectacular prairie sunrise. The magic of music in *Mount Stephen*—Tobi Jurchuk on violin, Don Glasrud on guitar and the low rumble of a passing coal train. Pachelbel's *Kanon in D* never sounded sweeter than in a 75-year-old heavyweight camped for the night on the shore of Crowsnest Lake. The high emotion of standing on the edge of the wind-swept cliff at Head-Smashed-In Buffalo Jump and silently absorbing the learning experience and cultural sensitivity of one of the finest interpretive centres in the world. The *RCP* experience is all this… and so much more.

The Calgary skyline rises from the prairie as the *RCP* hits the home stretch on a sunny Monday morning. There's time for one last cup of coffee and some quiet contemplation on

Strathcona's open verandah. The *Overseas* has been gone for going on 40 years, Canadian Pacific may have sold off its airline, ferries and passenger ships and relinquished the intercity passenger trade, but as long as the *Royal Canadian Pacific* is carded out of Calgary between June and October, the CPR can continue to hold honest claim to title as the world's greatest travel system. And dreams can continue to come true.

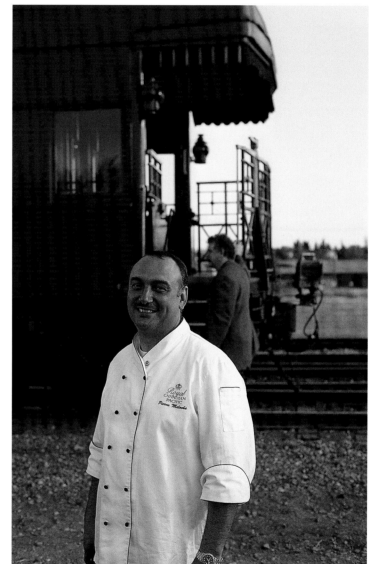

Royal Canadian Pacific chef Pierre Meloche. **Mark Perry**

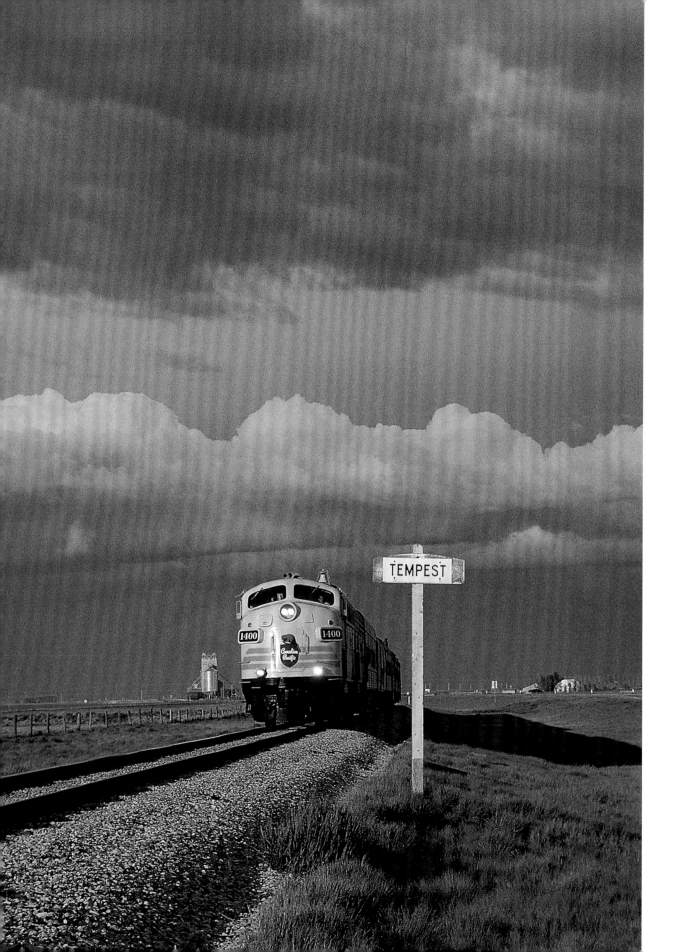

Timeless. The time is 1945 and the date is June 2, 2001, but the scene at Tempest, Alberta, is timeless as FP7 1400 and F9B 1900 head a six-car rare-mileage *Royal Canadian Pacific* charter under threatening prairie skies.
Dave Stanley

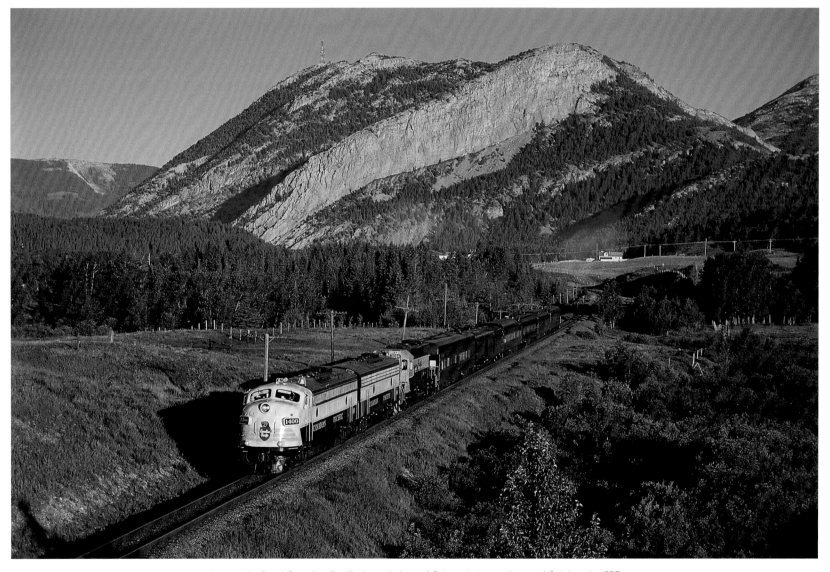

... as long as the Royal Canadian Pacific *is carded out of Calgary between June and October, the CPR can continue to hold honest claim to title as the world's greatest travel system.* A breathtaking vision in the early morning sun, the *Royal Canadian Pacific* validates the claim as it departs Crowsnest behind F's 1400, 1900 and GP38-2 3084 on July 15, 2000. Painted Tuscan and grey for *RCP* service, the GP38-2 serves as required as a reserve unit for the luxury train. **Robert Sandusky**

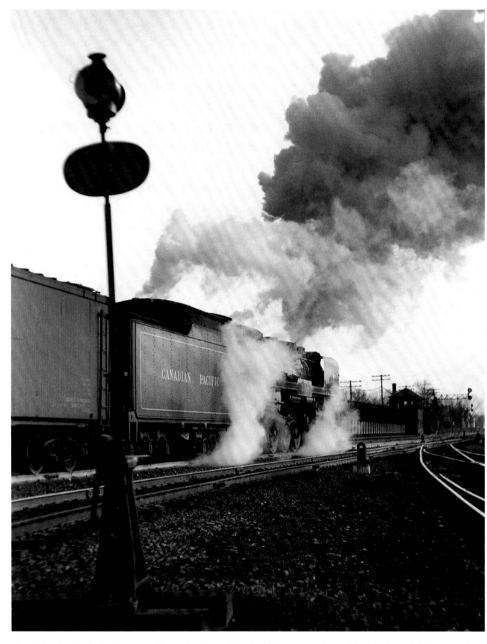

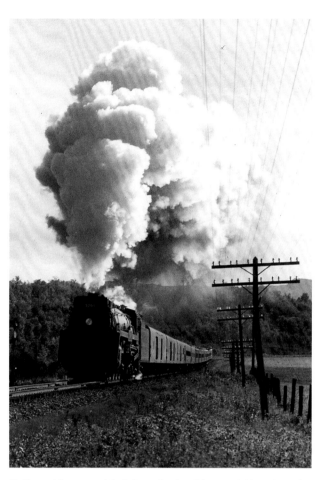

Trailing a 13-car consist of streamlined and heavyweight equipment —and punctuated by a brand-new Park-series dome-observation car for the yet-to-be launched transcontinental *Canadian* —K1a 3101 races Saint John–Montreal train No. 41 between Eastray and South Stukley, Quebec, on August 29, 1954. **Jim Shaughnessy**

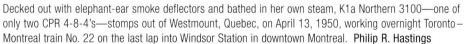

Decked out with elephant-ear smoke deflectors and bathed in her own steam, K1a Northern 3100—one of only two CPR 4-8-4's—stomps out of Westmount, Quebec, on April 13, 1950, working overnight Toronto–Montreal train No. 22 on the last lap into Windsor Station in downtown Montreal. **Philip R. Hastings**

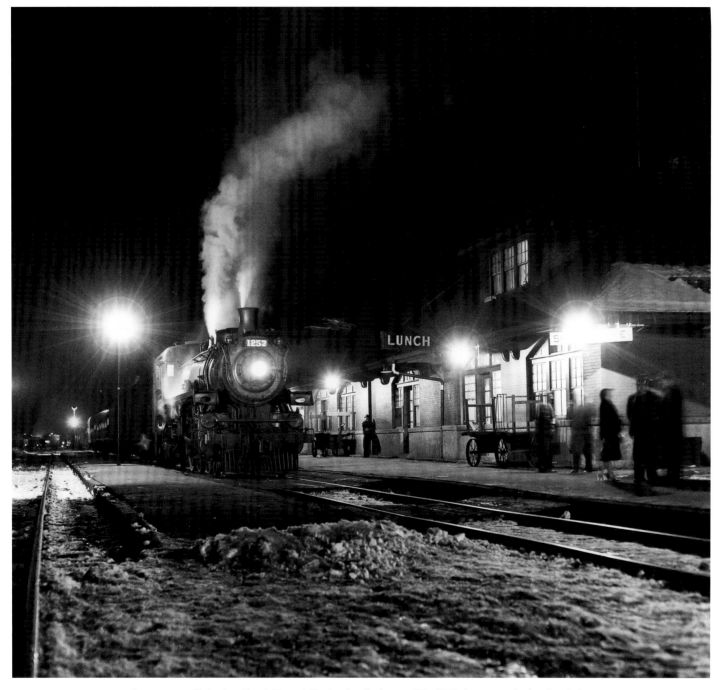

Passengers mill about on the platform at Sherbrooke, Quebec, as G5c 1257 simmers on the head end of all-stops Montreal–Megantic local No. 40 on February 22, 1957. **Jim Shaughnessy**

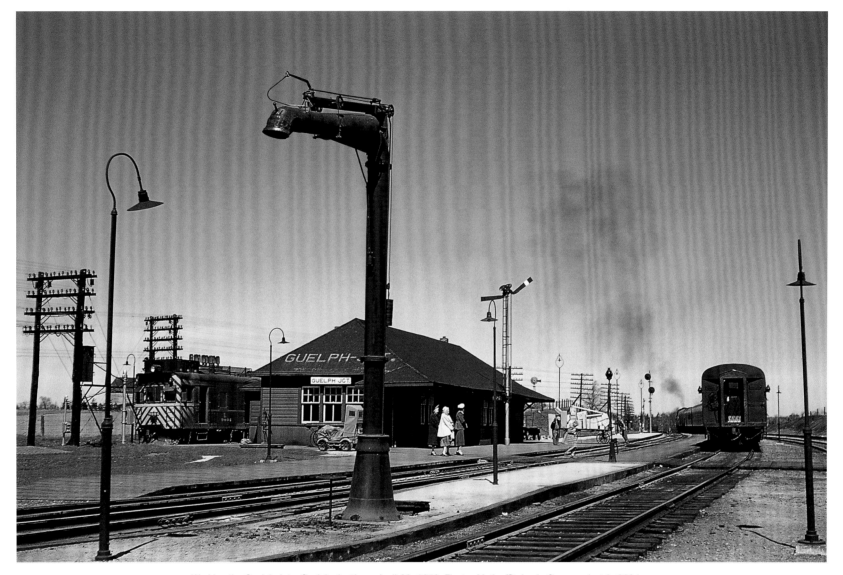

Working the Guelph Jct.–Guelph shuttle on April 26, 1958, Electro-Motive/St. Louis Car gas-electric 9004 idles behind the station at Guelph Jct., Ontario, as No. 38 departs for Toronto behind an RS10. One of two CP gas-electrics built by EMC/St. Louis in June 1930, the veteran car will have its work load dramatically reduced the next day, as the number of daily trips between the Junction and Guelph will be reduced from 12 to 4. The Junction shuttle was completely discontinued on April 30, 1961. **Robert Sandusky**

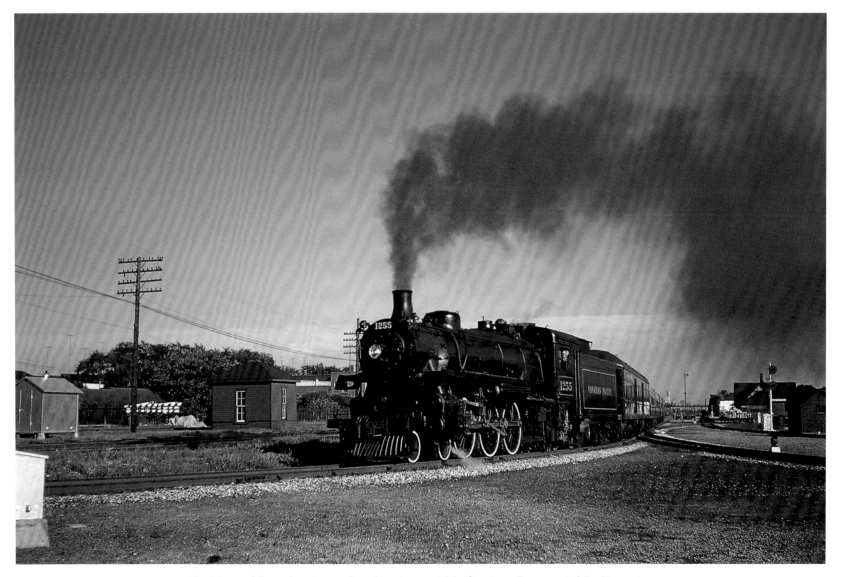

The labours of the engine wipers and coach yard crews at John Street roundhouse are in full evidence at West Toronto, Ontario, on August 15, 1958, as No. 317, the *Bala Special*, departs with pristine G5b 1255 leading an equally spotless maroon consist. **Robert Sandusky**

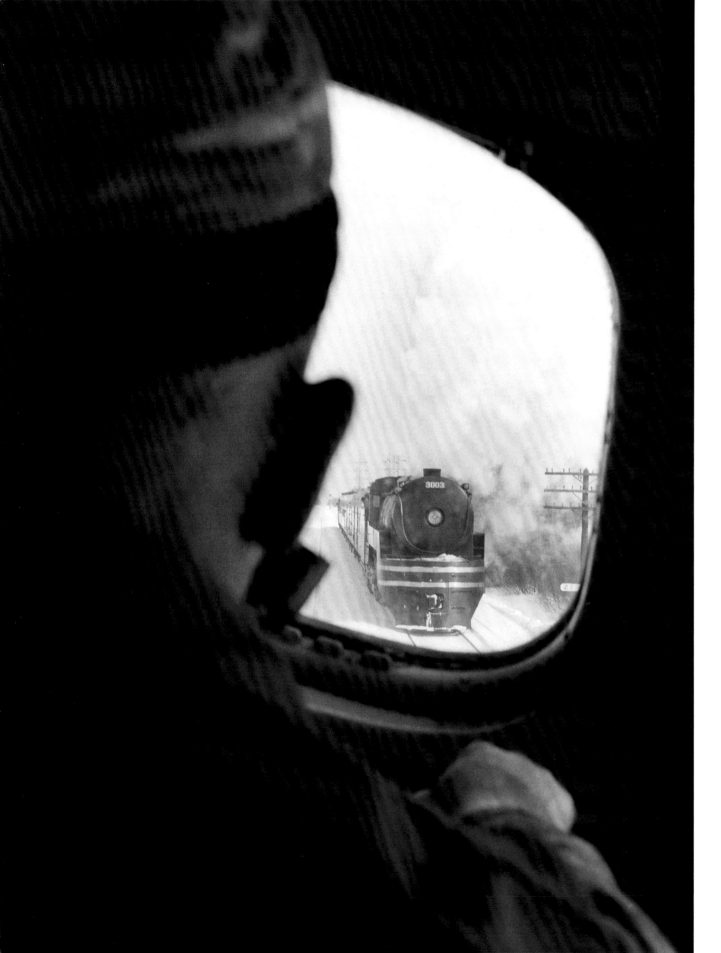

Clinching his pipe and staring ahead with steely determination, the engineer on No. 354, the Montreal–Quebec *Frontenac*, widens out on the throttle of FP9 1412 as Jubilee 3003 pulls in the clear at Vaucluse, Quebec, with westbound No. 349 on March 5, 1955.
Philip R. Hastings

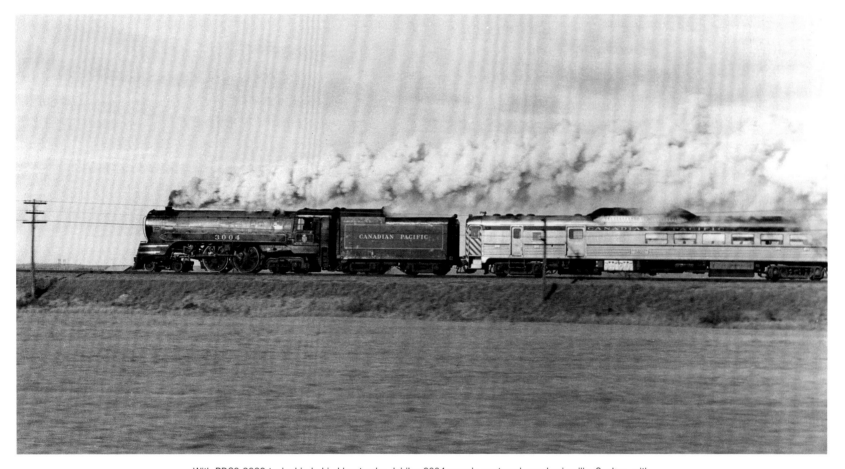

With RDC3 9023 tucked in behind her tender, Jubilee 3004 speeds westward near Louiseville, Quebec, with Quebec–Montreal train No. 349 on November 26, 1955. In order to accommodate passengers travelling to Grey Cup weekend festivities in Montreal, conventional coaches have been coupled behind the train's regularly assigned Dayliners and the MLW-built F2a 4-4-4 delegated to handle the mixed consist. The results of the game, played in Vancouver's Empire Stadium, will not sit well with many of No. 349's passengers and crew: Edmonton Eskimos 34, Montreal Alouettes 19. **Jim Shaughnessy**

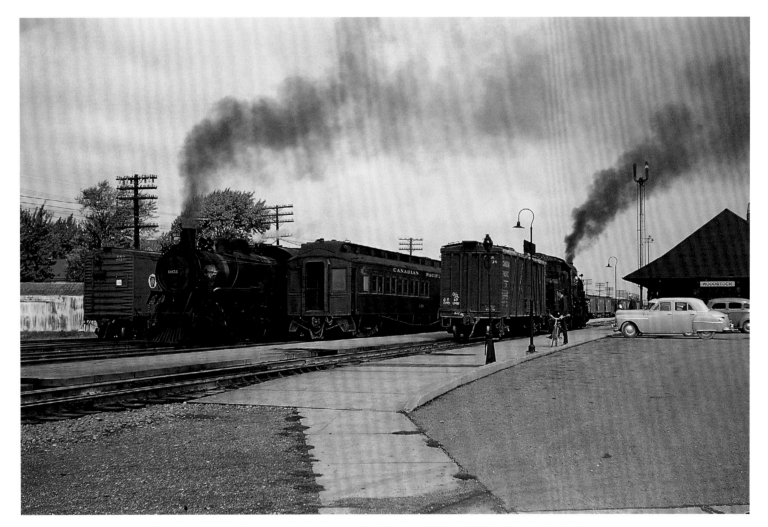

Leaning on his bicycle, a young boy looks on as Ten-Wheelers 1051 and 1087 switch out mixed train consists at Woodstock, Ontario, on September 24, 1955. **Robert Sandusky**

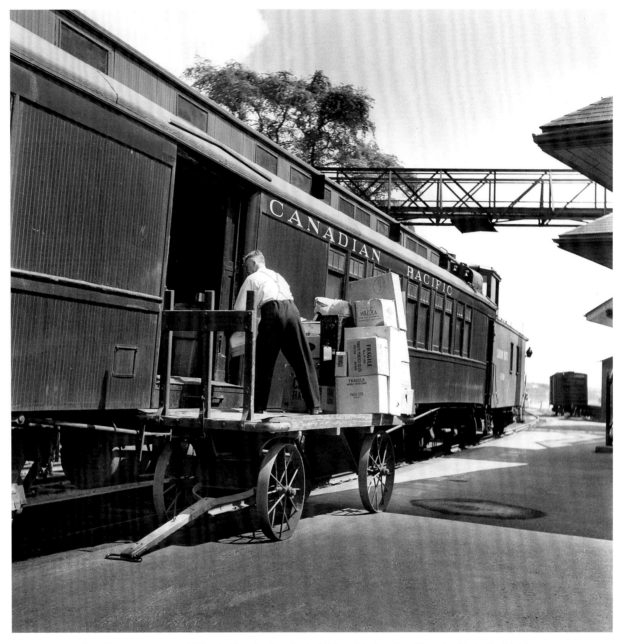

Boosting the revenues of CP subsidiary Quebec Central, Vallee Jct.–Lac Frontière mixed train No. 34 takes a mountain of express aboard the ancient but pristine combine coupled ahead of the wooden van at Vallee Jct., Quebec, in May 1959. **Jim Shaughnessy**

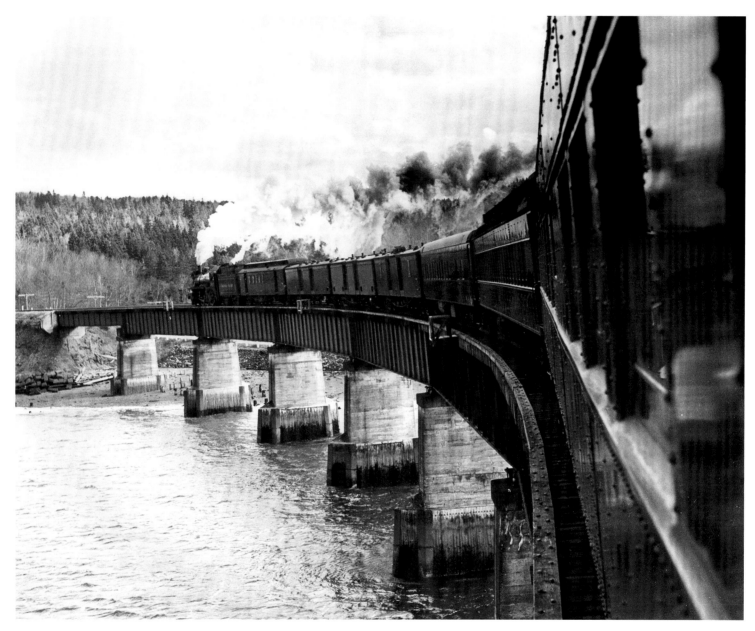

Riding high above the Fundy tidewaters, G2u Pacific 2617 leads Dominion Atlantic train No. 98 over the Bear River bridge at Bear River, Nova Scotia, on November 4, 1953. **Philip R. Hastings**

Notebook in hand, *Trains* magazine editor David P. Morgan savours the experience as a freight led by D10g 929 glides past the windows of the heavyweight buffet-lounge-observation tied to the tail end of DAR 98 at Kingston, Nova Scotia, on November 4, 1953. **Philip R. Hastings**

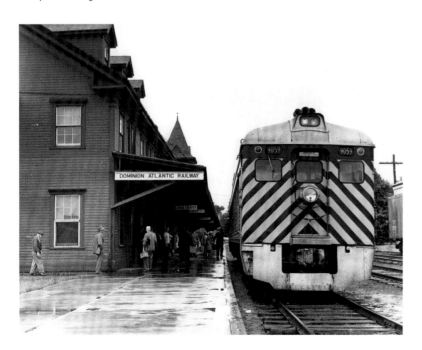

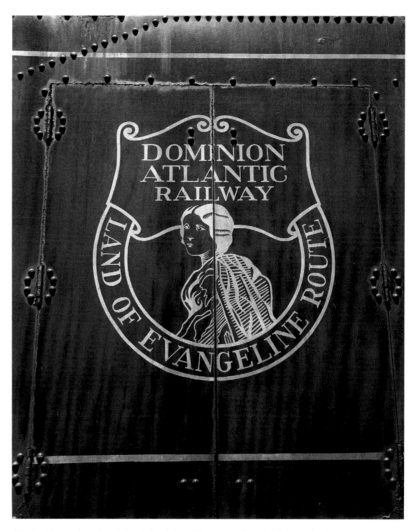

Elusive Evangeline. Dominion Atlantic's seldom seen "Land of Evangeline Route" crest adorns the tender of G2s Pacific 2551. **Jim Shaughnessy**

A pale substitute for G2 Pacifics, flat-roofed express cars and heavyweight coaches and buffet-lounge-observation cars, Dominion Atlantic RDC1 9059 pauses at DAR division point Kentville, Nova Scotia, on July 14, 1962. Esthetics aside, the economies of Dayliner operation kept passenger service alive on the DAR until VIA discontinued the Halifax–Yarmouth RDC's on January 15, 1990, spelling doom for most of the DAR. **Jim Shaughnessy**

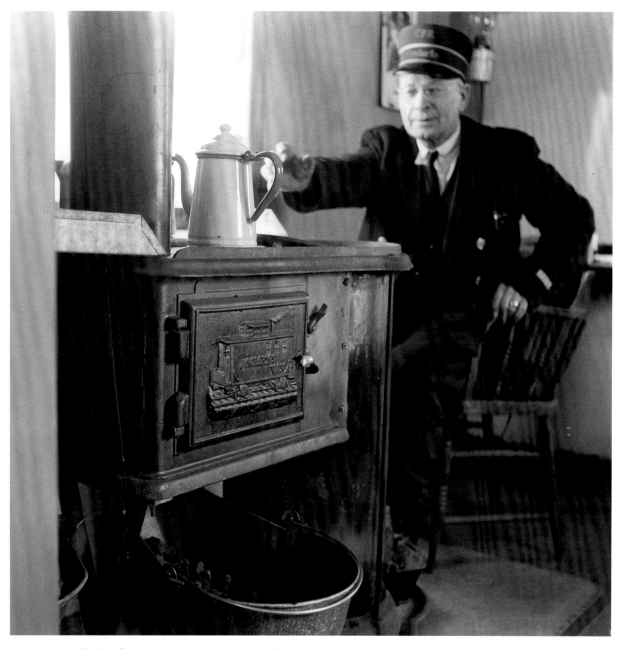

Working Brownville Jct., Maine, to Megantic, Quebec, mixed No. 117—better known as "the Scoot" — conductor D. Washburn reaches for the teapot on the coal-fired stove of his assigned steel van on March 8, 1955. **Philip R. Hastings**

Snow is piled station-board-high as the Scoot pauses at Boundary, Quebec, an appropriately named train-order office near the Quebec–Maine border, on March 8, 1955. **Philip R. Hastings**

Scooping the Scoot. The head-end brakeman waits to climb aboard G5b 1225 as the Scoot pulls out of the siding at Kyleton, Maine, having pulled in to let Second 951 past on March 8, 1955.
Philip R. Hastings

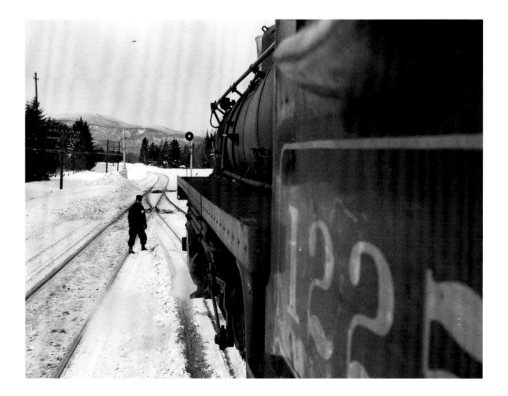

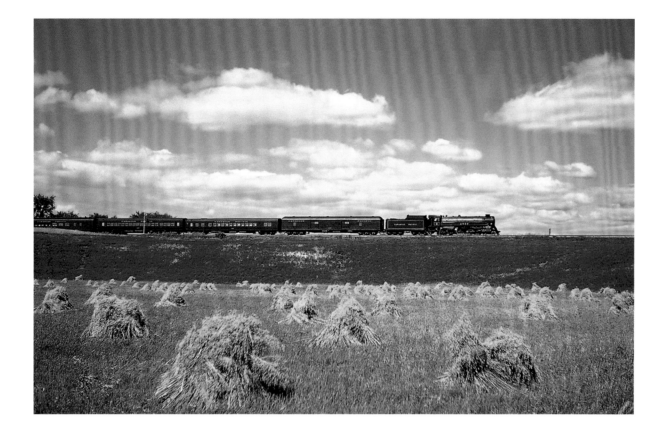

Travelling through scenery associated more with Saskatchewan than southern Ontario, Royal Hudson 2857 steams past the stooks outside Woodbridge, Ontario, with summer-only Mactier–Toronto train No. 26, August 5, 1957.
Robert Sandusky

Silhouetted in the shadow of her own steam, D10h 1004 trundles along the Teeswater Sub near Petherton, Ontario, with mixed train No. 753 on March 30, 1957. Just six cars—a CNR boxcar, a Pacific Fruit Express reefer, three empty stock cars and a combine— separate the Ten-Wheeler and wooden van on the Orangeville–Teeswater train. **Robert Sandusky**

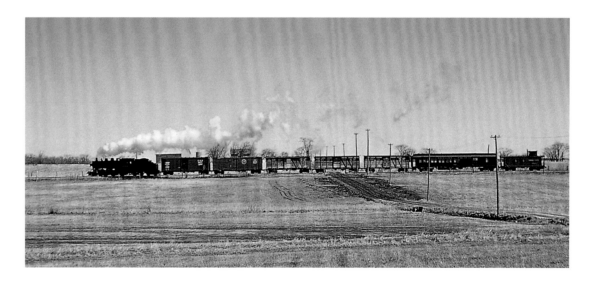

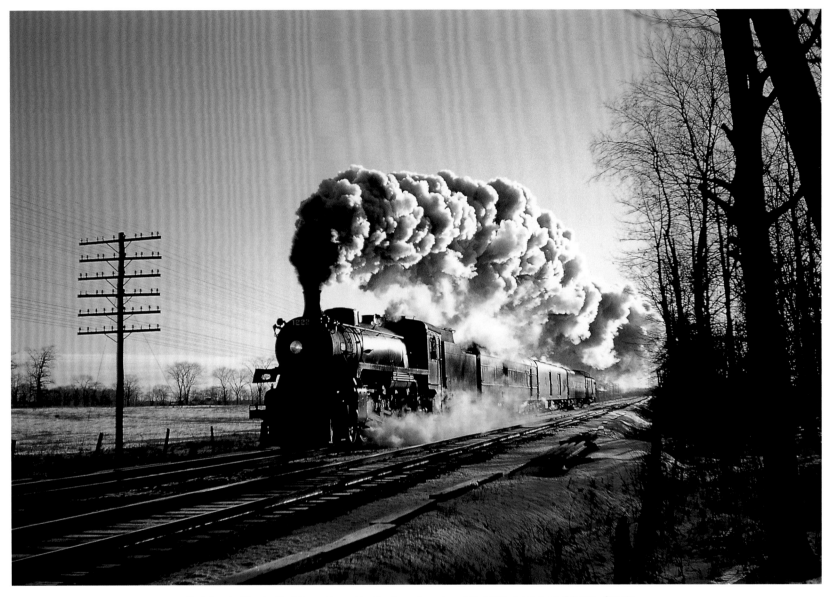

Sprinting to Streetsville Jct., and bound for the Bruce branches, G5b 1222 rips through Erindale, Ontario, with Toronto–Owen Sound No. 305 on February 8, 1958. **Robert Sandusky**

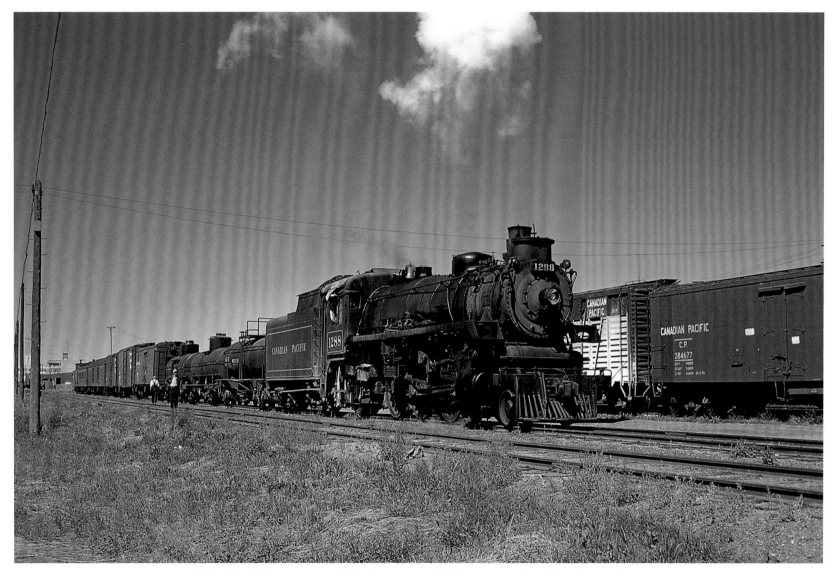

A little celebrated steam stronghold, CP's Saskatchewan District stabled more than 100 active steam loco-motives in the summer of 1959. One of 34 steam engines still assigned to duty on the Saskatoon Division, G5d 1288 stands at Prince Albert, Saskatchewan, on July 31, 1959, ready to depart with Monday-Wednesday-Friday mixed train No. 642 to Nipawin. Even this late in the steam season, at least four G5's were assigned to Prince Albert for mixed train service on the White Fox, Tisdale, Meadow Lake and Prince Albert Subdivisions.
Robert Clarke

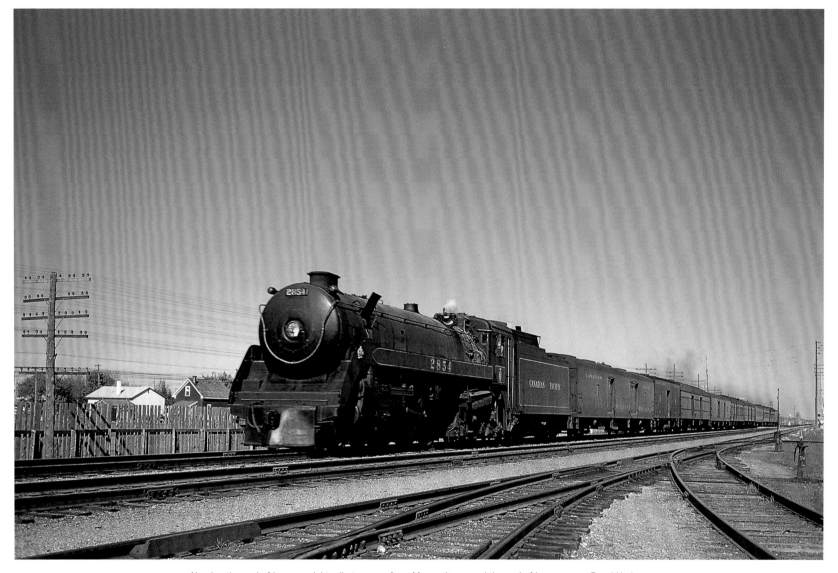

Nearing the end of her overnight, all-stops run from Moose Jaw—and the end of her career—Royal Hudson 2854 drifts past Weston on the last lap into Winnipeg, Manitoba, with No. 44 on May 31, 1959. Steam lasted on Winnipeg–Moose Jaw maids-of-all-work 43 and 44 until at least August 1959. The assignment was less than prestigious, but their performance on the mainline locals was memorable, including 80-mph-plus running on the double track between Whitewood and Broadview, Saskatchewan. **Ruth E. Hillis**

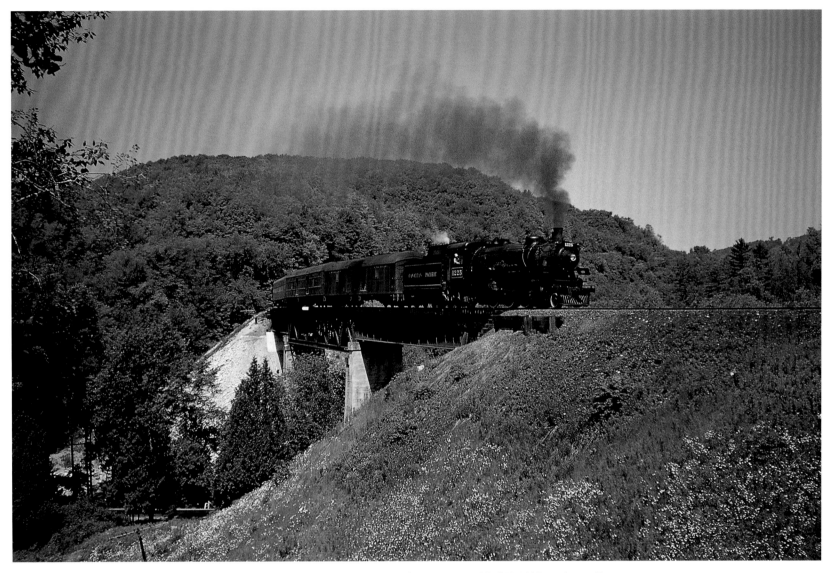

A long way from the International of Maine and the Scoot (see page 37), G5b 1225 accelerates Toronto-bound No. 706 over the West Credit River after a flag stop at the Forks of Credit station on June 28, 1955.
Robert Sandusky

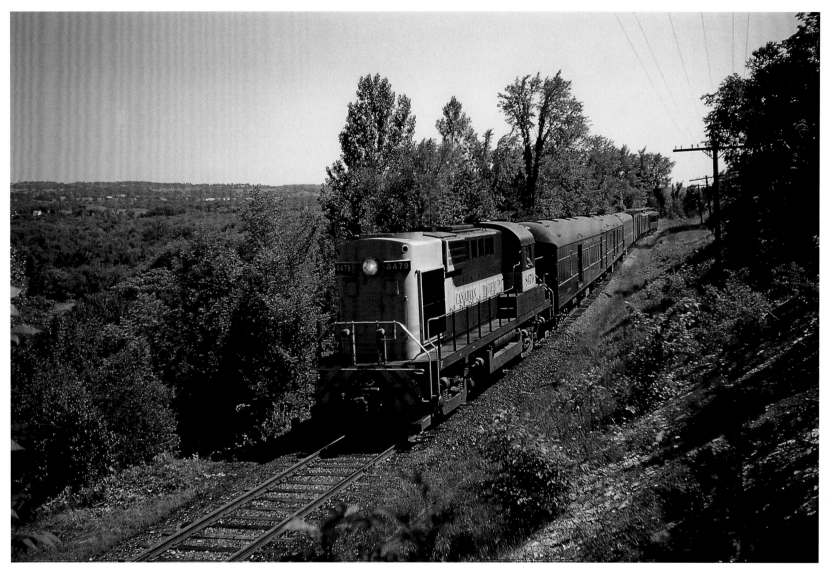

Steam is on the wane and No. 705 is in the charge of boiler-equipped RS10 8479 as it rolls north of Inglewood, Ontario, on June 28, 1955. Bringing up the markers of the seven-car train is wooden business car No. 35, destined for an inspection trip on the Elora Sub. **Robert Sandusky**

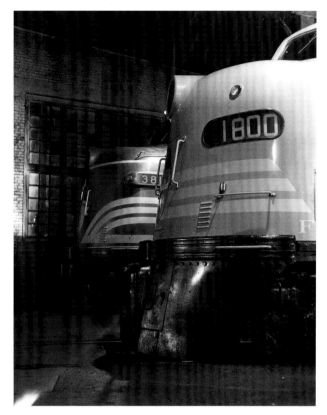

Assigned to CP/B&M Montreal–Boston pool service on the daytime *Alouette* and the overnight *Red Wing*, CP E8A 1800 and B&M E7A 3811 share adjacent stalls at the Glen on August 25, 1957. **Jim Shaughnessy**

Her tires neatly striped and battleship-grey boiler jacket wiped down, Royal Hudson 2828 slumbers in the roundhouse at the Glen Yard in Westmount, Quebec, on April 27, 1957. **Jim Shaughnessy**

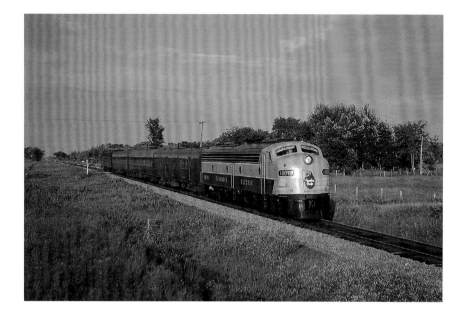

Bumped from Montreal–Boston service by Dayliners (and the discontinuance of the overnight *Red Wing*), E8 1801 whisks No. 235, the evening Montreal–Ottawa train, along the M&O Sub between Navan and Blackburn, Ontario, on July 23, 1962. No. 235's short consist includes a baggage-RPO car, two 2100-series coaches and a heavyweight parlour car. **James A. Brown**

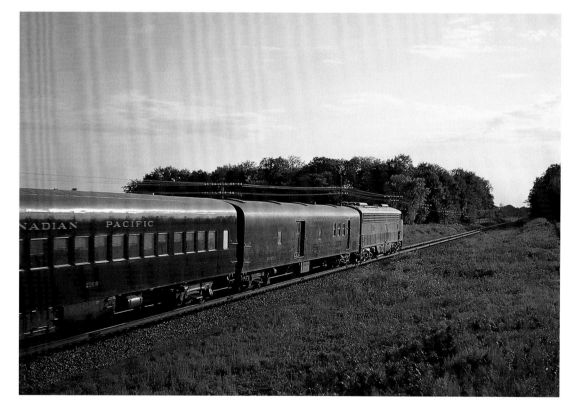

Dayliners have replaced steam on Toronto–Owen Sound trains 705–706, as evidenced by RDC1 9051 and an RDC2, paused at Brampton, Ontario, on October 13, 1956, with Toronto-bound No. 706. However, steam is not dead on the Bruce. Working the southbound wayfreight, G1v 2238 stands in the clear, waiting by the freight house for No. 706 to leave town. **Robert Sandusky**

Making their scheduled flagstop, RDC1's 9056, 9051 and 9049 pause briefly at Dorval, Quebec, at 2117, August 7, 1970, with No. 259, the evening Lakeshore local to Vaudreuil. **Greg McDonnell**

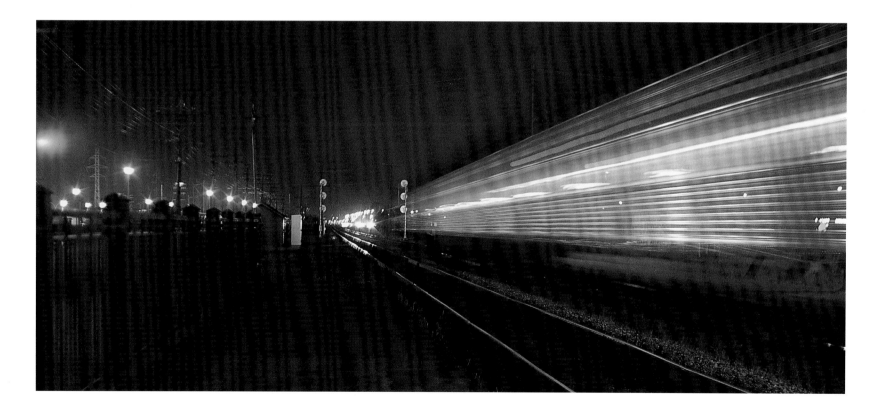

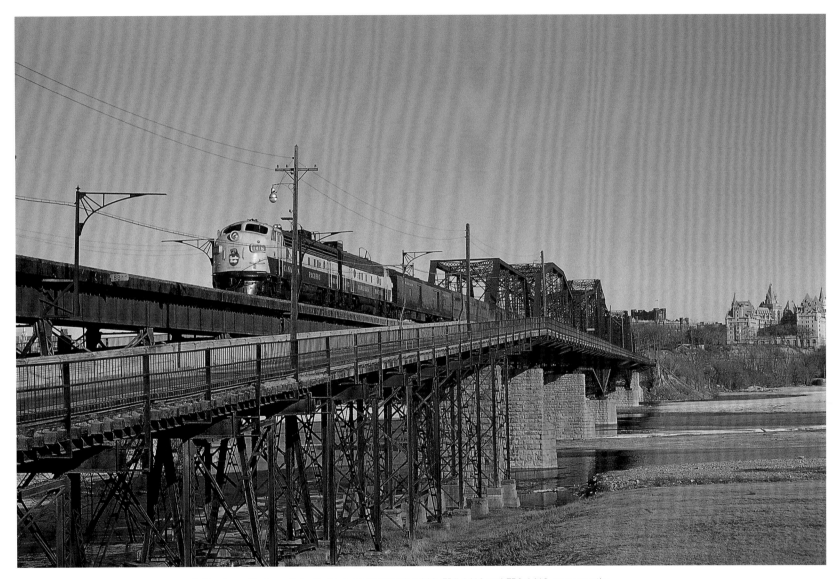

Exiting the nation's capital with No. 1 on March 19, 1966, FP7 1416 and FP9 1413 ease over the Alexandra Bridge, crossing the Ottawa River with the Vancouver-bound *Canadian*. **Bill Linley**

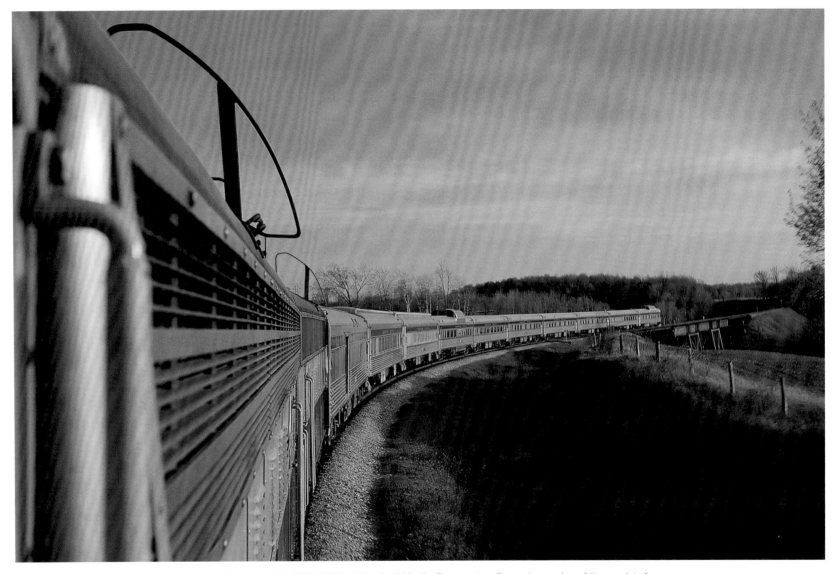

Leaning from the cab of FP7 1423 on May 6, 1962, Jim Brown gets a fireman's-eye view of the consist of the Toronto section of *The Canadian* as No. 11's *Park* car clears the Baxter bridge, crossing the Nottawasaga River just north of Ypres, Ontario. Tucked between the baggage car and Skyline dome on the train's head-end are a pair of U-series sleepers; elderly heavyweights dressed up with stainless-steel fluting and silver paint to match the train's streamlined Budd equipment and provide tourist-class sleeping car accommodation on *The Canadian*. **James A. Brown**

As the clock ticks closer to departure time on October 25, 1977, passengers board No. 11, the Toronto–Sudbury section of *The Canadian,* at Toronto Union Station. **Greg McDonnell**

Preparing for departure on October 25, 1977, the dining car attendant prepares table settings in the diner *Acadian,* on No. 11, the Toronto section of *The Canadian.* **Greg McDonnell**

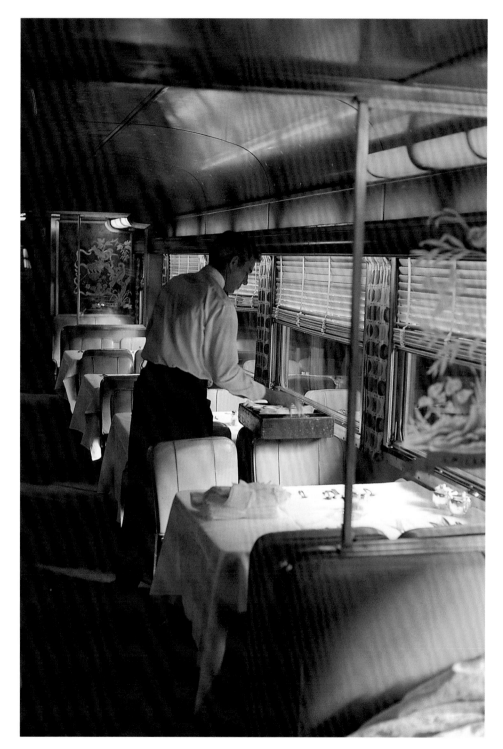

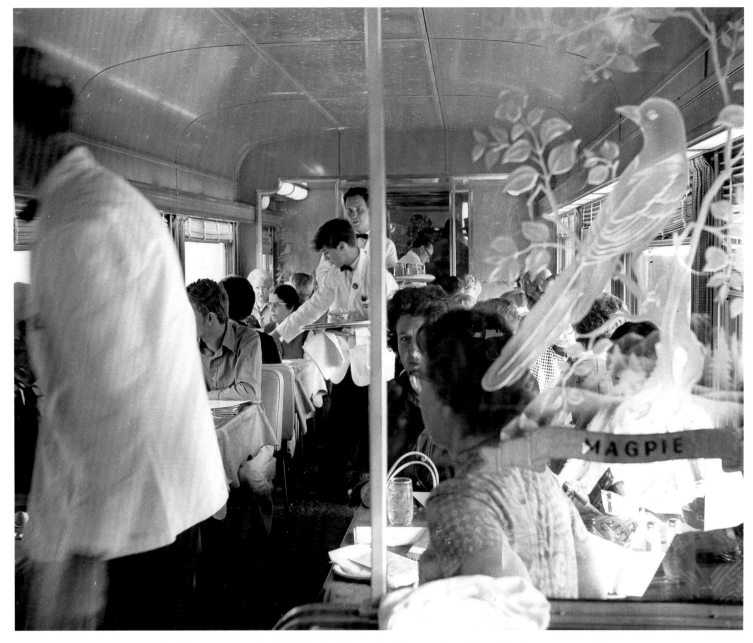

Etched in the glass partition of Budd-built dining car *York*, the magpie portrait couldn't be more appropriate as the eastbound *Canadian* speeds across the Saskatchewan prairie on September 18, 1971. There may be red ink in the passenger department ledgers, but No. 2's dining car crew ensures that *The Canadian* maintains its reputation as one of the world's finest trains. **Philip R. Hastings**

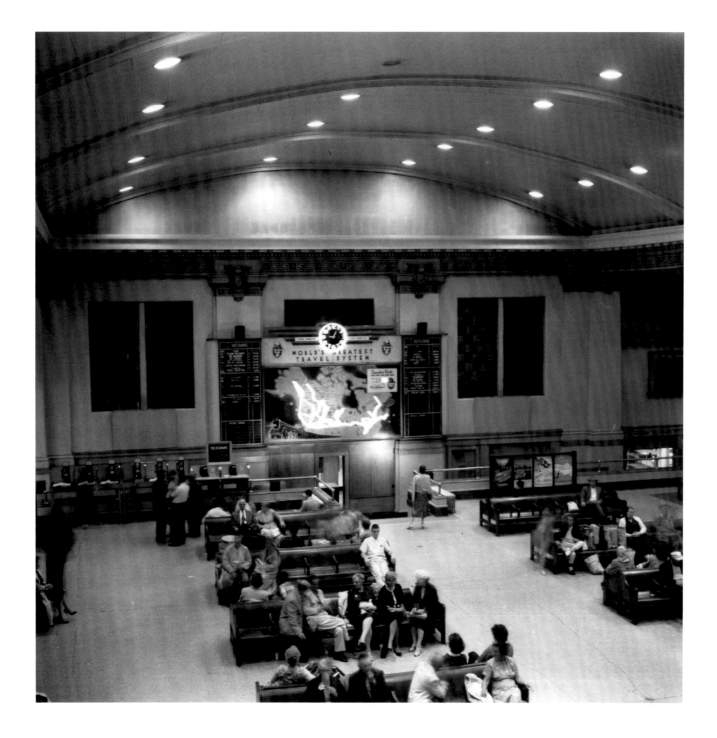

Steam's last stand. Late on a rainy summer evening—and even later in the steam season—semi-streamlined G3h Pacific 2433 waits to depart Winnipeg, Manitoba, with overnight Moose Jaw local No. 43 on August 19, 1959. Steam will soon surrender Nos. 43 and 44 to diesels, including boiler-equipped CLC Train Masters built in the same Kingston works from which 2433 emerged in November 1944. **William D. Middleton**

Preparing No. 43 for departure, car knockers load the ice bunkers of air-conditioned heavyweight sleeping car *Ripples* at Winnipeg, Manitoba, August 19, 1959. One of 29 R-class sleepers (eight sections, one drawing room, two compartments) built by Canadian Car & Foundary and Angus shops in 1929, *Ripples* was originally named *Revelstoke*, but renamed in September 1954 in anticipation of delivery of Budd-built sleeper, buffet-lounge, dome-observation *Revelstoke Park*.
William D. Middleton

(Left) World's Greatest Travel System. Lighted lines trace Canadian Pacific rail and domestic air routes on the system map that dominates the waiting room wall of CP's Winnipeg, Manitoba, station on August 19, 1959. Flanking the map, information boards marked "incoming" and "outgoing" list a dozen trains that call on the Beaux Arts Classical-style station completed in 1904. The count includes no less than three daily transcontinentals—the flagship *Canadian*, the *Dominion* and unnamed locals 5 and 6; the CP-SOO *Winnipegger* to Minneapolis–St. Paul, the *Great West Express* to Saskatoon, Winnipeg–Moose Jaw all-stops locals 43 and 44, and locals and mixed trains to Kenora, Winnipeg Beach–Riverton, and Lac du Bonnet–Great Falls. A designated Provincial Heritage Site, the North End station has been vacated by CP and is now the Aboriginal Centre of Winnipeg.
William D. Middleton

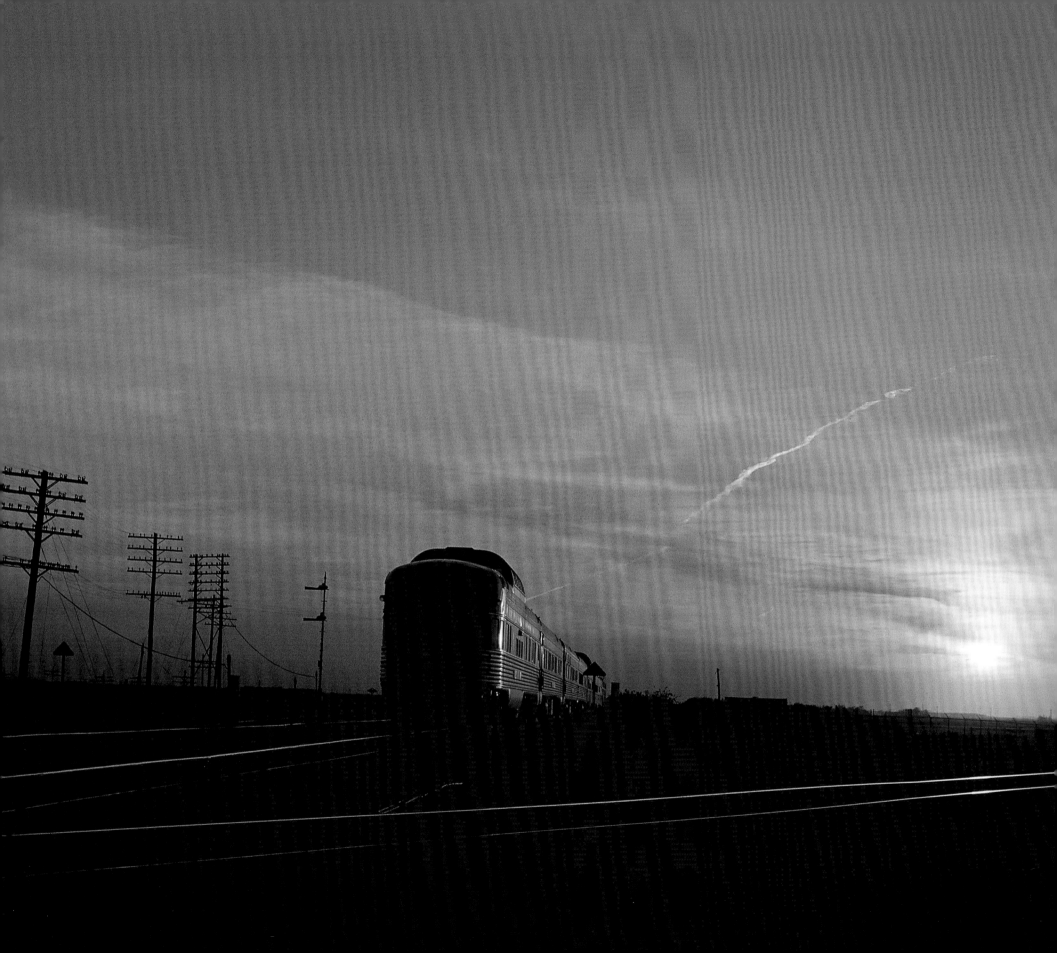

If we can't export the scenery, we shall have to import the tourists.
Adhering to Van Horne's adage, FP7 1429, F9B 1917 and GP9 8527
bring train No.1, *The Canadian,* into Banff, Alberta, on October 8, 1964.
James A. Brown

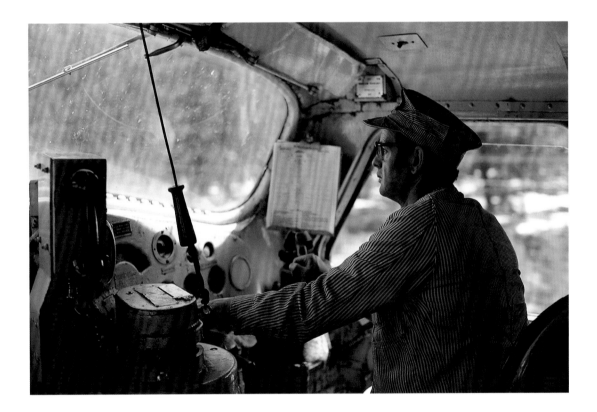

Deftly working the throttle and brake of FP7 4070,
legendary CPR hogger Floyd Yeats handles the eastbound
Canadian between Massive and Castle Mountain, Alberta,
on May 13, 1973. The fourth of seven children, Floyd,
whose father was a locomotive engineer and once
worked on the 0-6-6-0's on Field Hill, was born in 1919
in a house just west of the east switch at Field, British
Columbia. In the family tradition, the four Yeats boys
went railroading; Floyd hired on as an engine wiper at the
Alyth roundhouse in Calgary in 1938. He was promoted
to locomotive fireman in May 1941, but interrupted his
CPR career to go to war, serving in the RCAF from 1942
to 1946. Yeats was qualified as a locomotive engineer
in the spring of 1947 and worked out of Calgary, west
to Field and east to Medicine Hat until his retirement in
1979. A respected railroader and good friend of the
photographer, Floyd passed away in June 2000.
Doug Phillips

(Left) Steel rails and stainless steel glisten in the setting sun as the westbound *Canadian* clears
the CN diamond at Woodman, Manitoba, in June 1976. Silhouetted in the sunset, upper
quadrant semaphores still guard the interlocking once presided over by operator-leverman
Earl Birch. **Stan J. Smaill**

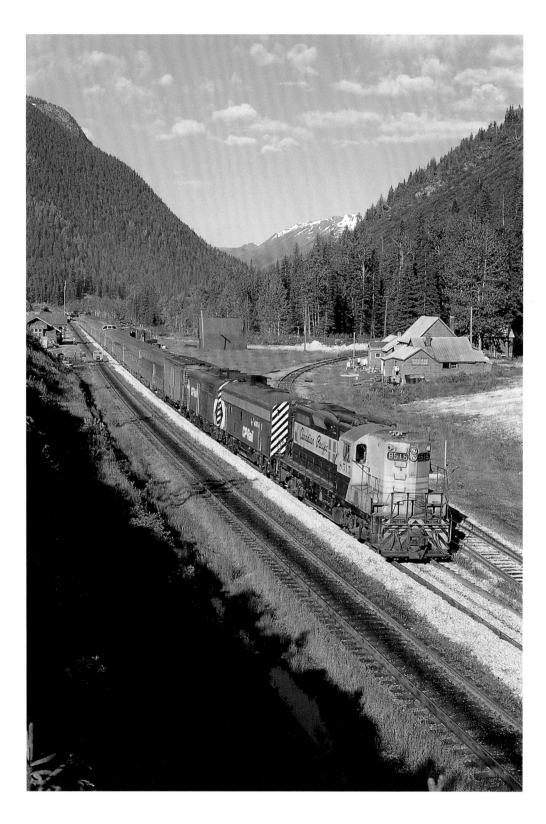

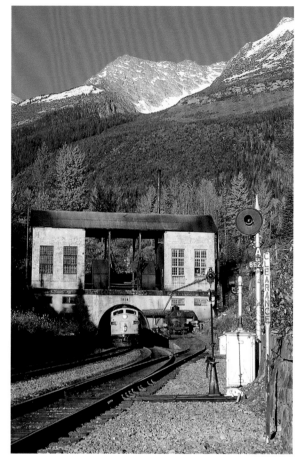

Heading up train No. 7, FP9 1406 emerges from the west portal of the Connaught Tunnel at Glacier, British Columbia, on October 12, 1964. **James A. Brown**

Parked by the station at Glacier, British Columbia, the track patrol's motorcar holds the main as No. 2, the eastbound *Canadian*, eases up the siding, approaching the Connaught Tunnel with maroon-and-grey passenger GP9 8515 leading F9B 4474 and FPA2 4094 on July 27, 1972. Once regulars on mail trains 7 and 8, MLW cabs were a rarity west of Calgary by the 1970s. **Philip Mason**

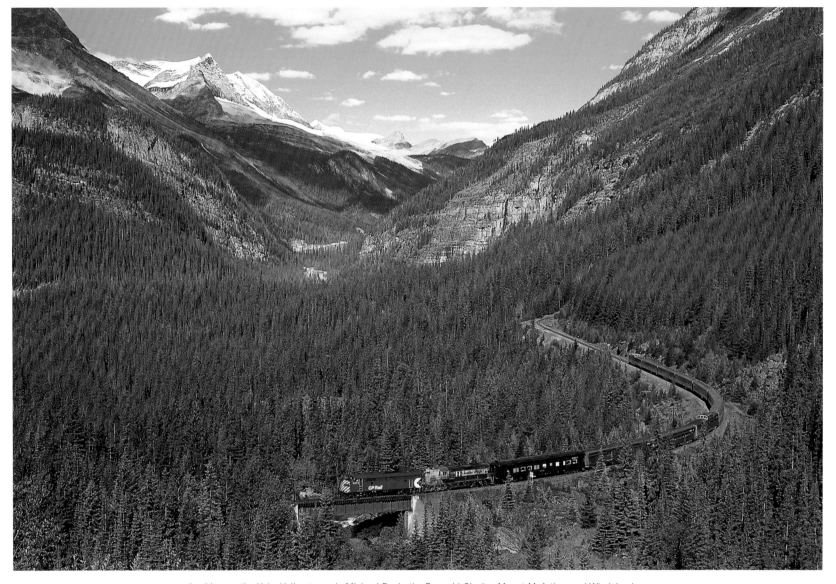

Looking up the Yoho Valley towards Michael Peak, the Emerald Glacier, Mount McArthur and Whaleback Mountain, dome seats pay a premium as FP9 1411 and GP9 8526 wheel the westbound *Canadian* through Yoho, British Columbia, in August 1977. The best seats in the house, however, are on the rear platform of the business car *Van Horne*, tucked in behind the power on No. 1. **Philip Mason**

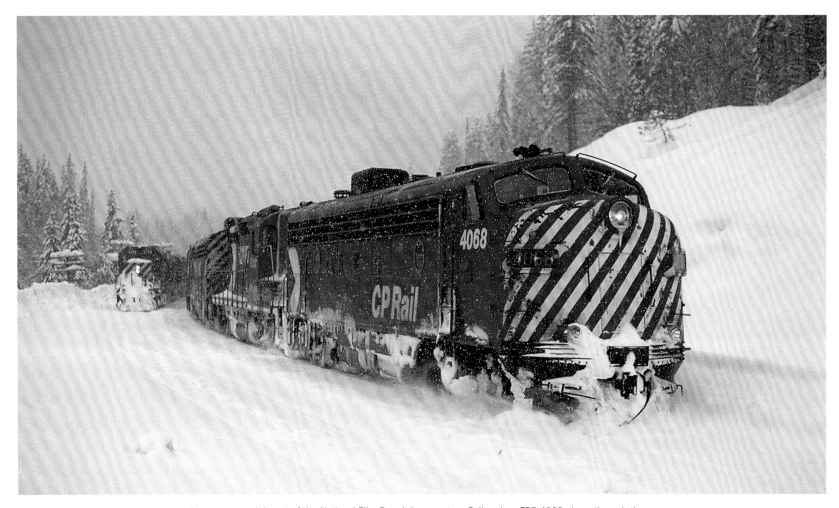

In a scene reminiscent of the National Film Board documentary *Railroaders*, FP7 4068 plows through the siding at Rogers, British Columbia, on February 3, 1978, leading the eastbound *Canadian* past an empty coal train headed by SD40-2 5758. The snow-packed face of the 5758 is evidence of an encounter with a small avalanche after exiting the Connaught Tunnel. Photographer Phil Mason, working as head-end brakeman on the coal empties with engineer Bill Taylor and conductor Jimmy Rodan, paused from shovelling snow from the nose of 5758 long enough to record the passage of No. 2. Recalling the 1958 NFB film, Mason writes: "Remember the businessman eating his breakfast in the dining car and peering downward at the passing track workers with benign disinterest? I remember feeling like the lineman in that shot, as the diner was serving breakfast as it went by me, camera in one hand, broom in the other." **Philip Mason**

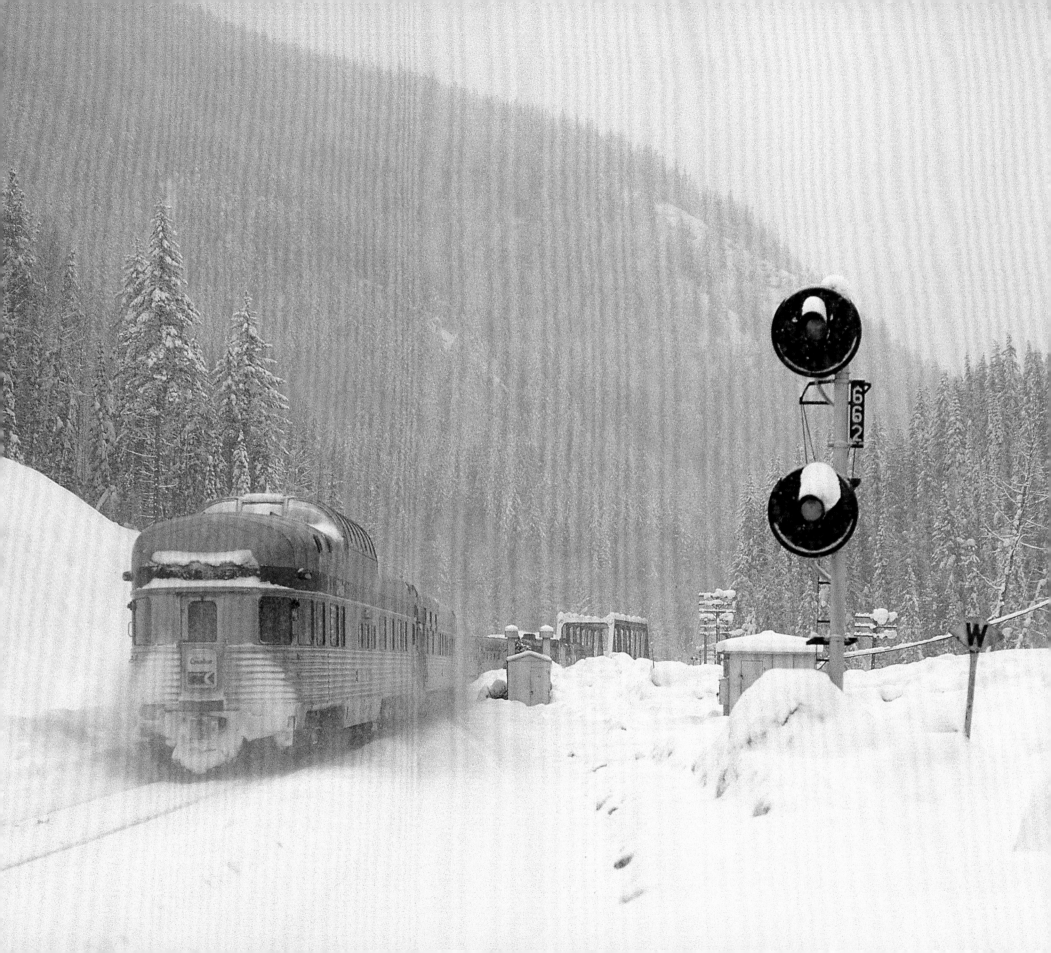

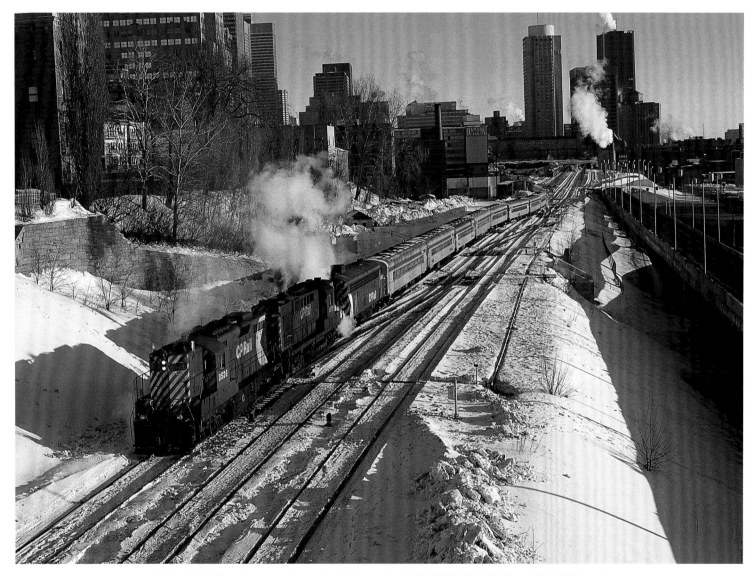

Trailing eight 800-series commuter coaches, boiler-equipped GP9 8528, RS10 8572 and FP7 4066 depart Windsor Station in Montreal, Quebec, with a ski train to Labelle at 0810, February 5, 1978. **Greg McDonnell**

VIA lettering can't hide the heritage of Budd-built sleeper *Chateau Cadillac* on No. 58 at Toronto Union Station on January 10, 1990. The ghostly outline of the beaver crest on the car's stainless-steel flanks bears irrefutable testament to the car's CPR ancestry. **Greg McDonnell**

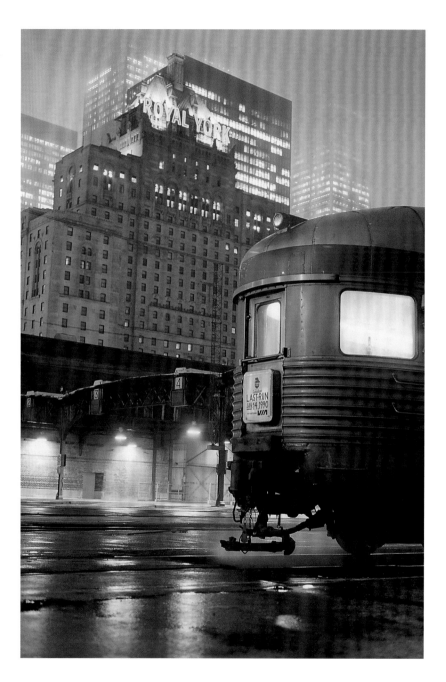

Ending 105 years of transcontinental passenger service on the CPR, VIA No. 10, the last eastbound *Canadian* regularly scheduled to operate over Canadian Pacific rails stands at Toronto Union Station on January 17, 1990. Carrying an unofficial drumhead to mark the occasion, former CP *Strathcona Park* basks in the glow of another CP flagship: CP Hotels' *Royal York*. VIA Rail Canada assumed operation of all remaining intercity CP passenger trains on September 29, 1978, but operation of *The Canadian* remained essentially unchanged until its routing was shifted to CN as part of major cutbacks that took effect on January 15, 1990. Still one of North America's premier long-distance trains, *The Canadian* continues to operate between Toronto and Vancouver, but on CN. It just isn't the same. **Greg McDonnell**

Posed in numerical order as they wait for the morning commuter rush, CP FP7's 4070, 4071 and 4072 slumber at Vaudreuil, Quebec, on December 16, 1982. **Greg McDonnell**

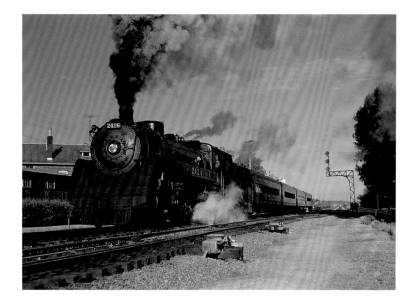

CP's Lakeshore commuter service between Rigaud and Vaudreuil, Quebec, and Windsor Station in Montreal was one of the most spectacular and celebrated last stands of steam. Working the early-morning commuter rush into Montreal, G3h 2426 marches out of the yard at Vaudreuil, Quebec, with train No. 272, while another G3-powered train waits its turn on a pleasant June 1959 morning. **Paul Meyer**

Another last stand. CP's last two active RS10's, 8570 and 8577 finished their careers on Lakeshore commuter trains leased to SCTCUM, the government agency that had assumed operation of the service. Bathed in her own steam on an icy afternoon, RS10 8577 threads the crossovers at Vaudreuil, Quebec, with No. 50's bilevels at 1600, December 16, 1982. **Greg McDonnell**

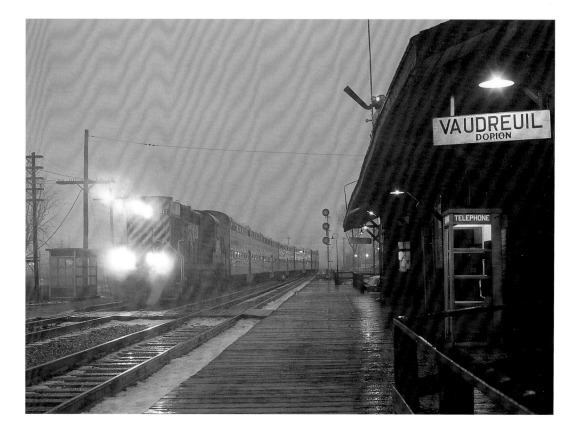

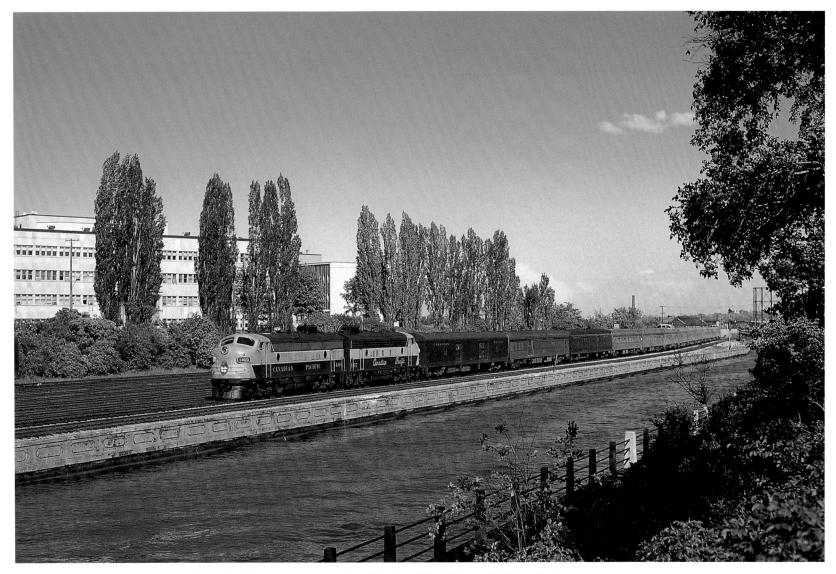

Skirting the Rideau Canal with the pride of the fleet, FP7's 1400 and 1417 bring *The Canadian* into Ottawa, Ontario, on June 8, 1966. **Bill Linley**

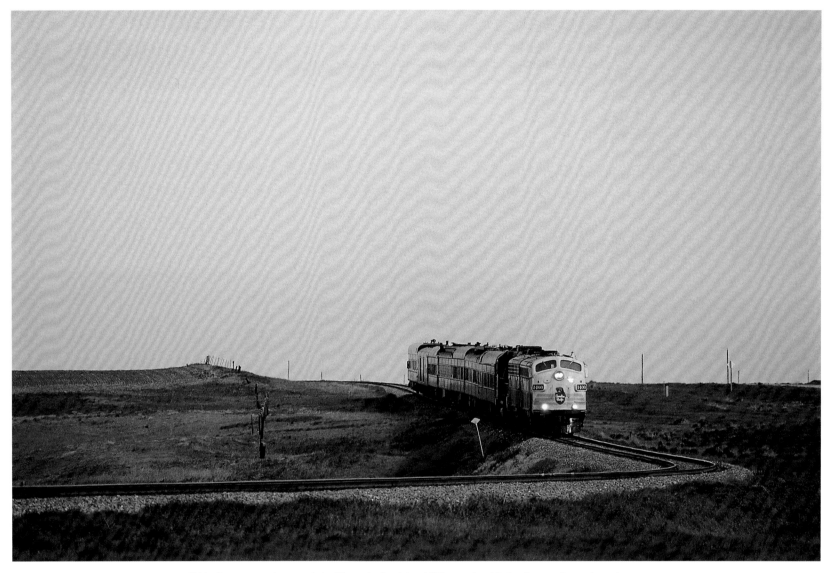

Thirty-five years and uncounted millions of miles later, 1400—restored to her former glory—is again assigned to the pride of the fleet, CP's luxurious *Royal Canadian Pacific*. Working a rare-mileage *RCP* charter, 1400 leads F9B 1900 and GP38-2 3130 over the undulating profile of the Stirling Sub south of Wilson, Alberta, at 0855, June 3, 2001. **Dave Stanley**

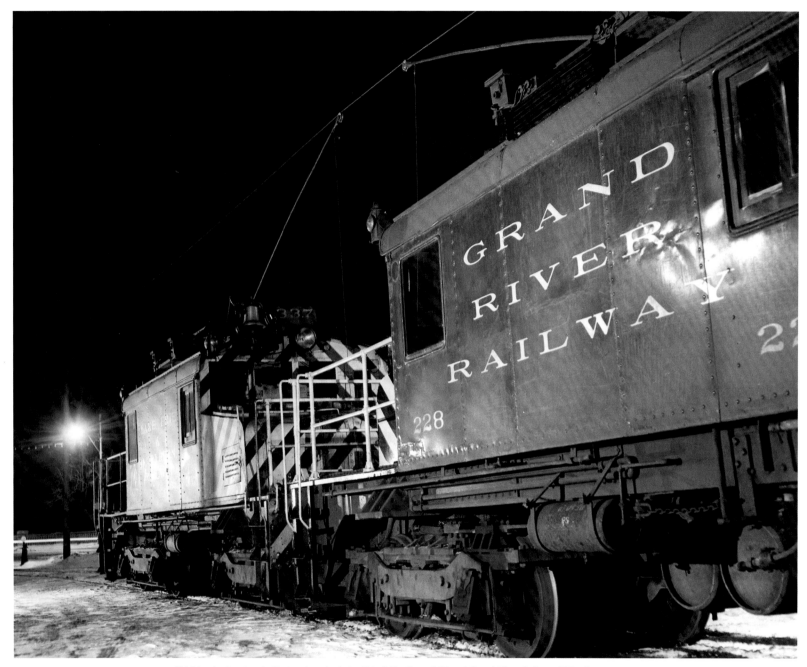

Old friends. Preston-built steeple cabs Lake Erie & Northern 337 and Grand River Railway 228 wile away
a cold winter night in front of the GRR shops in Preston, Ontario, on February 21, 1959. **Jim Shaughnessy**

Electric Lines

The Canadian Pacific Railway served my hometown by proxy, coming to Kitchener under the auspices and energized catenary wires of its Electric Lines subsidiary, the Grand River Railway. Lettered for the GRR—as well as for sister road, Lake Erie & Northern—the zebra-striped steeple-cab electrics that ambled past my grandmother's house on Union Boulevard and crossed the street just a few doors down from our own house on Glasgow were like old friends.

Headquartered in Preston, the Grand River Railway and the Lake Erie & Northern formed a 70-mile electrified interurban line extending from Waterloo to the shores of Lake Erie at Port Dover. The GRR ran north from Galt and included a 4-mile branch to Hespeler, while the LE&N ran south from Galt to Port Dover via Paris, Brantford and Simcoe.

Like all good interurban lines, the GRR and LE&N did their share of street-running. Boyhood encounters with Baldwin-Westinghouse motors parading up Victoria Street with cars for Kaufman Rubber, or leading long trains down the middle of Caroline Street in Waterloo, or sneaking up Water Street in Galt with a car or two for

Preston, Ontario, July 27, 1979. **Greg McDonnell**

67

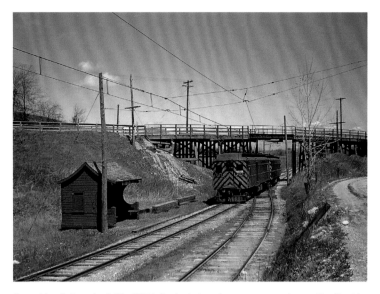

Bound for Galt on April 23, 1955, the last day of passenger service on the Electric Lines, GRR 624 and 864 pass the LE&N shelter at Dutton, Ontario. **Robert Sandusky**

industrial customers on the west side, were the highlight of many a family outing.

Buses took over passenger service on the Electric Lines on April 24, 1955, but the steeple-cabs soldiered on for another six and a half years. The 1,500-volt current running through the greenish copper overhead was shut off for good when GRR 228 and LE&N 337 returned to Preston from Waterloo on October 1, 1961.

More than the overhead disappeared with the dieselization of the Electric Lines. The maroon-and-grey SW8's and SW1200RS's that replaced the steeple-cabs were lettered Canadian Pacific, bringing an end to the long tradition of GRR- and LE&N-lettered equipment. However, the gold-leaf stencilling on the door of the Preston headquarters would read "General Offices, Grand River Railway, Lake Erie & Northern Railway" for a quarter-century more.

Dieselization had little effect on the Electric Lines' operating autonomy, and railroading on the Preston-based line was conducted in the same friendly, down-home manner as always. For a kid growing up in Kitchener in the Sixties,

that equated an open invitation to climb up in the cab of Joe Hauser's polished maroon-and-grey SW1200RS, or aboard Bruce Gowing's wooden CP van as the train worked from Preston to Waterloo and back on any given Saturday.

Indeed, my friend Peter McGough and I spent countless Saturdays in the cabs of Preston-based "Pups" 8160, 8161 and 8162 as they switched 40-footers of LCL at the GRR freight sheds near Victoria Park in Kitchener and wandered up the backstreets to Waterloo. After lunch in the van we'd head south, interrupting the traffic on Caroline Street as we stopped to switch Seagram's Distillery, Carling's Brewery and the Bauer warehouse before meandering past 92 Union and back through Kitchener.

The Preston shops—lettered Grand River Railway right to the end—were closed in September 1986, and the last LE&N train south of Galt ran on July 31, 1990. On July 6, 1993, the Grand River was officially cut back to Kitchener as veteran Electric Lines SW1200RS's 8161 and 8162 led the last GRR train out of Waterloo.

Long ago absorbed by parent CP, the Electric Lines have receded from a 70-mile interurban to an 11-mile spur from Galt to Kitchener. Nonetheless, the little line is busier than ever. Several times each day, long trains of autoracks loaded with Cambridge-built Toyotas and Lexus SUV's ease down the 2.5-percent grade from Hagey to Preston and squeal over the curved bridge across the Speed River on the way to Galt. The Pups that ruled the line for most of its diesel days have all but surrendered their turf to rebuilt GP9's and GP38-2's.

Road jobs on the former GRR are the near exclusive domain of the Geeps, while a pair of 1200's are assigned to Hagey to switch Toyota. On occasion, particularly Saturdays, the Pups are permitted to stretch their legs and work a turn to Galt.

Maroon paint, wooden vans and street running are long gone, but after four decades, it's still a thrill to find a pair of Pups at work on the Electric Lines on a Saturday morning. Joe Hauser would be pleased.

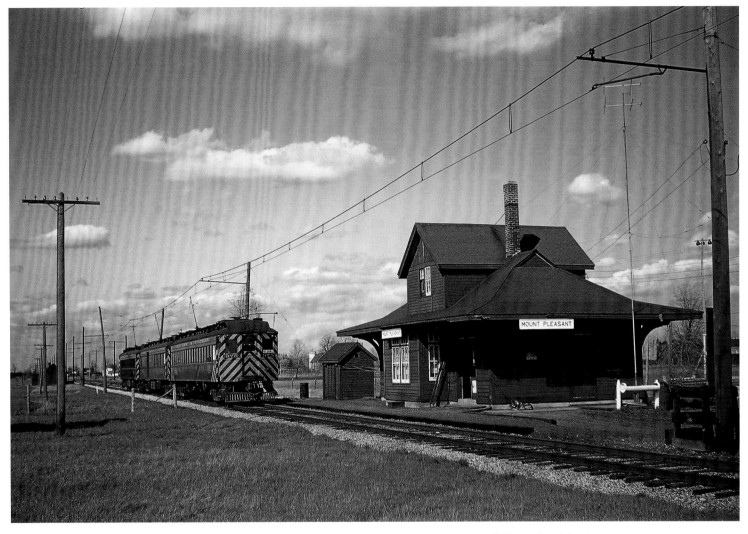

Just hours before the end of passenger service on the Electric Lines, LE&N 975, GRR combine 624 and GRR 864 pause at the LE&N station at Mount Pleasant, Ontario, with a midday Port Dover train on April 24, 1955. All three cars were scrapped at Preston in 1956. **Robert Sandusky**

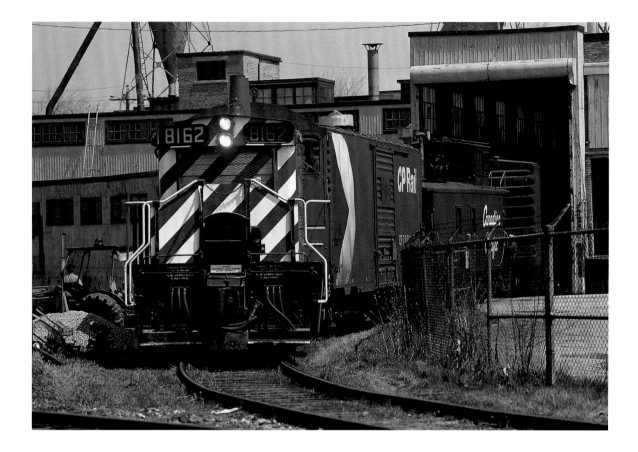

Squeezing through tightly curved industrial trackage once trod by steeple cabs, SW1200RS 8162 reaches into the Bauer factory on Caroline Street in Waterloo, Ontario, to retrieve a Rock Island boxcar on May 11, 1978. **Greg McDonnell**

End of the line. Coming up Caroline Street in Waterloo, Ontario, for the last time, SW1200RS's 8161 and 8162—assigned to the Electric Lines for most of their lives—approach William Street at 2100, July 6, 1993. Within an hour, the crew will return south with a single bulkhead flat, and trains will never again work the street trackage in downtown Waterloo. **Greg McDonnell**

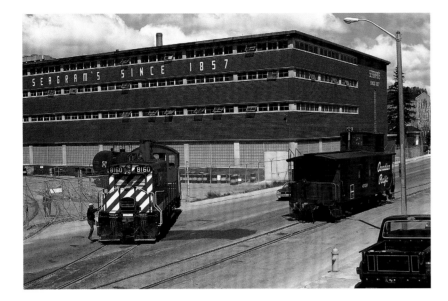

Assigned to the Electric Lines since dieselization, SW1200RS 8160 works the Seagram's distillery siding, while Gowing's pristine wood van holds the main on Caroline Street in Waterloo, Ontario, on June 14, 1978.
Greg McDonnell

Brakeman Raymond Clarke looks on as Bruce Gowing, conductor on the Electric Lines day job to Waterloo, works at the desk of his assigned wooden van, CP 437238, on March 30, 1978. **Brad Jolliffe**

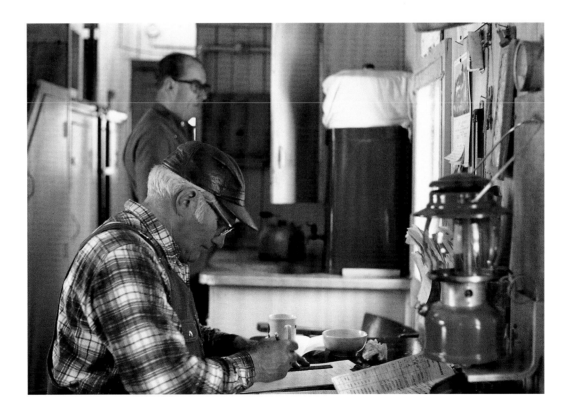

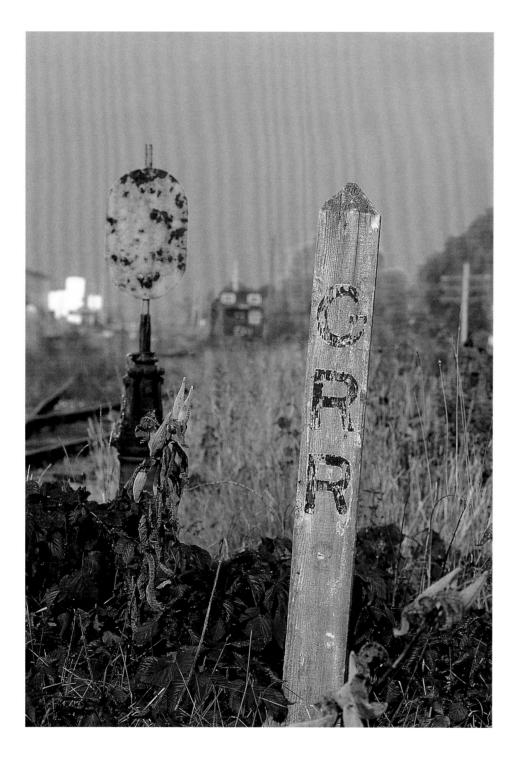

Back to nature. Wildflowers bloom beside rusting 85-pound Algoma rail on the siding at Preston, Ontario, on June 13, 2001.
Greg McDonnell

Standing next to an ancient Grand Trunk switch stand, a weathered wood post stencilled GRR marks the CN/CP interchange at Galt, Ontario, October 12, 1984. **Greg McDonnell**

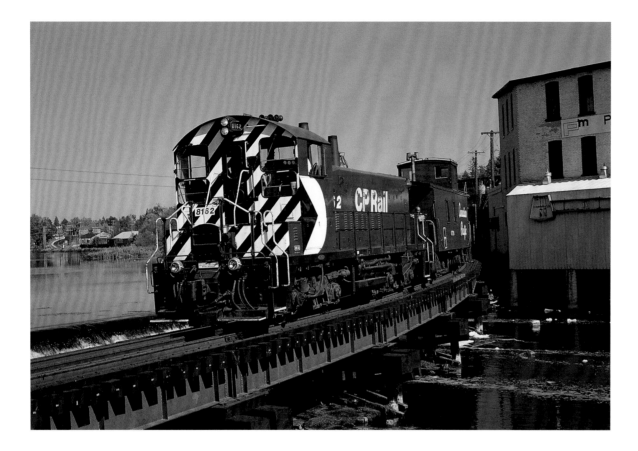

Headed for the shop at the end of their shift, the day Waterloo crew crosses the Speed River bridge at Preston, Ontario, with SW1200RS 8162 and van 437238 at 1505, September 27, 1979. **Greg McDonnell**

Maroon paint, wooden vans and street running are long gone, but after four decades, it's still a thrill to find a pair of Pups at work on the Electric Lines on a Saturday morning. Bringing loaded autoracks down the hill from Toyota, SW1200RS Pups 1276 and 1268 curve along the Speed River in Preston, Ontario, at 1120, September 28, 2002. **Greg McDonnell**

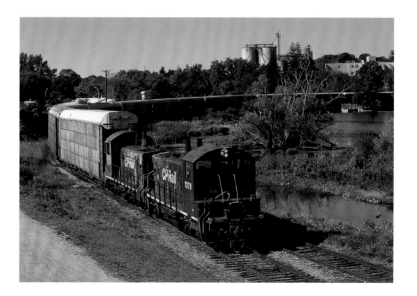

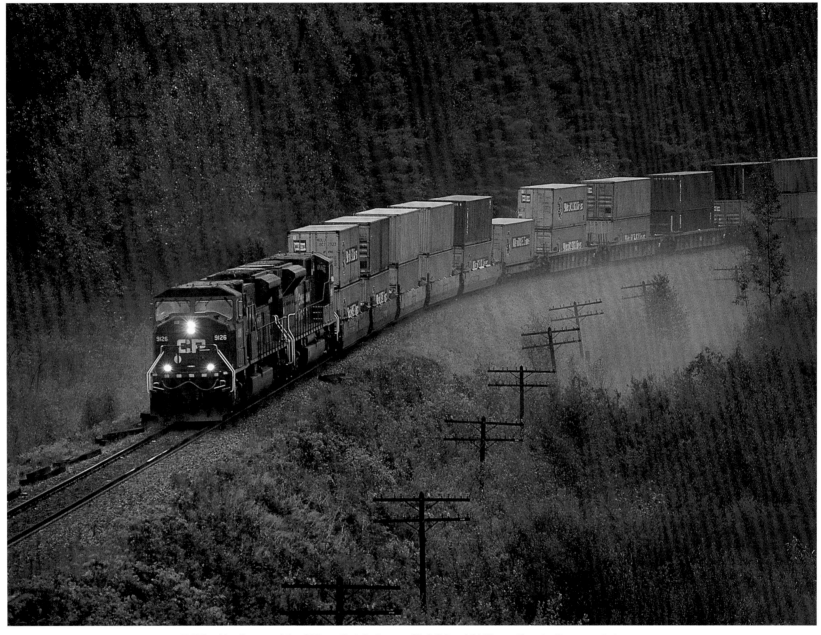

Fulfilling Van Horne and the CPR syndicate's dreams, CP 9126 and 9149 urge Toronto–Vancouver train 493-26 west of Craigellachie, British Columbia, on August 29, 1999. **Greg McDonnell**

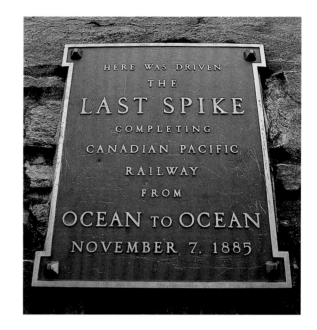

Stand Fast, Craigellachie!

The metallic ring of steel on steel echoes through the forest of the Eagle Pass at Craigellachie, British Columbia, as a sledgehammer strikes the head of a plain iron spike. Shrugging off the bone-chilling dampness of a gloomy November morning, Donald Smith wields the spike maul with an uneasy grip. Pressed shoulder to shoulder, a group of track workers, railway officials and financiers crowd in—all eyes on Smith, the maul and a single spike jutting from a muddy tie. It is unlikely that the distinguished-looking Smith, with his neatly trimmed white beard, perfectly blocked top hat and tailored overcoat, has ever handled such a crude implement. Nonetheless, every swing pounds the spike deeper into the rough-hewn tie and brings the hopes and dreams of a young nation ever closer to fruition. With a final blow, Smith drives the spike home, anchoring the splice-bar that joins rails linking east and west. At 9:22 a.m., November 7, 1885, the Canadian Pacific Railway, the long-promised iron road from sea to sea, is reality. Canada—until this moment "little more than a geographic expression"—is at last united in spirit and in fact.

Craigellachie. The name is drawn from a great promontory in the valley of the River Spey near Banffshire,

Craigellachie, British Columbia, September 21, 2001. **Greg McDonnell**

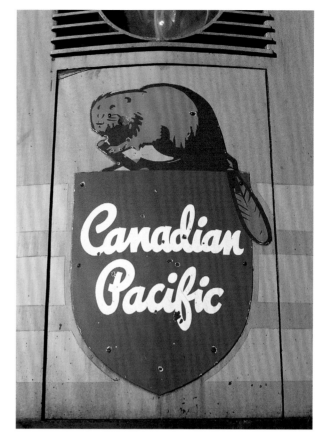

North Toronto Station, Toronto, Ontario, August 7, 2000. **Greg McDonnell**

FA2 4049, December 17, 1971. **Greg McDonnell**

Scotland, not far from the birthplace of Donald Smith and his cousin, CPR president George Stephen. It had been a sentinel rock and rallying place of the Clan Grant in the days when the clans battled one another. For Stephen and Smith, descendants of the Grants, it remains an inspirational symbol of defiance and solidarity. In the darkest days of the railway's construction, at a time when the CPR was not only at the centre of a political firestorm, but burdened with debt, beset with heavy costs and on the verge of financial ruin, Stephen travelled to Britain and secured an eleventh-hour loan from a Scottish institution. He cabled the news to Smith in a dispatch that contained only three words, but in quoting the defiant rallying cry of the clan, spoke volumes: "Stand fast, Craigellachie."

So it is, that in the mud and cold of a miserable November morning, the driving of the ceremonial last spike of the CPR is carried out in a desolate clearing at a place called Craigellachie. In accordance with Van Horne's decree, there is no golden spike, no pomp or pageantry, and nary a politician present. Those who are in attendance have all paid their dues: Van Horne, Smith, Fleming, Cambie and Rogers; Ross, Eagan, Haney and McKenzie; even the track workers, who, just hours earlier, had feverishly worked by electric light to spike down the last yards of track. To a man, they've invested blood, sweat and personal fortune in one of the greatest engineering feats in North America.

The spike set, Smith relaxes his hold on the heavy maul and for a moment, the congregation stands in silence—

perhaps in awe of the overwhelming magnitude of the accomplishment. It is a brief pause that affords time for quiet reflection of the human cost and the herculean, even heroic, efforts expended to span the nation with two thin bands of iron; time to give consideration to the tens of thousands of railroaders, navvies and Chinese labourers who blasted uncounted millions of tons of rock, bored tunnels, built bridges and laid down track through bottomless muskeg, through towering mountain ranges and across endless miles of prairie.

A spontaneous eruption of cheers and the exultant shriek of locomotive whistles shatters the silence. Called to speak, Van Horne responds with a historic speech of just fifteen words: "All I can say is that the work has been well done in every way."

Simmering patiently, Baldwin-built 4-4-0 No. 148 stands at the head of the special train that has carried Van Horne and his party of dignitaries from Montreal. As the brief ceremony winds down, the conductor of the special makes the call an entire country has been waiting to hear: "All aboard for the Pacific!"

The engineer tugs on the throttle, steam fills the venerable Baldwin's cylinders, and its 60-inch drivers ease the train into motion—bound for the Pacific tidewater on a railway that many said couldn't, or at least shouldn't, be built; a railway blasted, bored, bridged and spiked through some of the most forbidding terrain anywhere; a railway that spans the continent from ocean to ocean, consummates Confederation and defines the nation.

One hundred and eighteen years after Donald Smith drove home the last spike, the Canadian Pacific Railway stands as one of the most enduring of all Canadian institutions. Canadian Pacific has been a quintessential element of the Canadian experience. From prairie settlers heading west in wooden colonist cars with Canadian Pacific spelled out on their letter boards, to the throngs of Depression-era unemployed who rode the rods and rooftops of CPR boxcars in desperate search of work; from soldiers riding off to two World Wars in Tuscan-red troop trains (and those fortunate enough to ride home again), to generations of

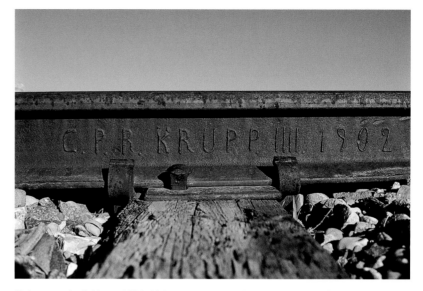

Eighty-pound rail, Krupp 1902, Makepeace, Alberta, January 22, 2000. **Greg McDonnell**

children who caught their first glimpse of the Rockies with their faces pressed up against the curved glass of *The Canadian*'s domes; from the navvies who struggled to scratch a railway line into the diamond-hard Precambrian rock on the north shore of Lake Superior, to the railroaders who wrestle 14,000-ton grain trains over legendary mountain grades. From Yarmouth, Digby and Saint John, to Vancouver, Victoria, Cowichan and Courtenay, the initials C.P.R. have been etched in stone, stamped in metal, inscribed on silverware, cast in steel, painted on car-sides and indelibly imprinted in the Canadian psyche.

Through it all, the spirit of Craigellachie, the defiance, tenacity and fierce sense of independence, has characterized the CPR, as well as those in its service.

That spirit is manifest on a steamy August afternoon as a headlight cuts through the mist that enshrouds Eagle Pass in the wake of a violent thunderstorm. Rain-slicked rails glisten in the headlight's glow and the booming of distant thunder gives way to the throbbing howl of turbocharged 16-710G3C diesels as a pair of bright red SD90MAC's materialize from the mist that hugs the ground and billows about the treetops just west of Craigellachie. Past and present

CP 244397, Lake Louise, Alberta, September 22, 2001. **Greg McDonnell**

Beaver and shield reborn. CP 3069, September 29, 1997. **Greg McDonnell**

are indivisible as the massive locomotives grind westward, tracing the historic footsteps of the 148. Their prowess and performance undreamed of when the diamond-stacked Baldwin accelerated Van Horne's special out of Craigellachie for the Pacific, the 425,000-pound, 4,300-horsepower behemoths are, nevertheless, kith and kin of the diminutive 4-4-0. Emblazoned on their rain-streaked flanks, SD90MAC's 9126 and 9149 proudly carry the same initials worn by the 148 and the name spelled out on the varnished letter boards of the passenger cars tied to its tender: CANADIAN PACIFIC.

Throughout the 20th century, the independence and identity of even the mightiest of the continent's railroads have vanished in wave after wave of buyouts, mergers and megamergers. One by one, the steel empires of the great railroad magnates, Gould, Harriman, Hill, Vanderbilt and Van Sweringen, were folded into systems and supersystems. With them went names steeped in history and synonymous with the glamour and romance of the golden years of railroading: New York Central, Pennsylvania, and New Haven; Burlington, Baltimore & Ohio, Chesapeake & Ohio, Louisville

& Nashville and Nickel Plate; Erie, Lackawanna and Wabash; Western Pacific, Northern Pacific and Missouri Pacific; Grand Trunk and Great Northern, Seaboard and Southern, even Santa Fe, Southern Pacific and the Rio Grande. At the dawn of the 21st century, precious few of the old guard remain. But, with the steadfast determination and unfailing conviction of the Clan Grant, the CPR has held its ground.

Upholding over a hundred years of tradition, CP 9126 and 9149 wear the company's beaver-and-shield crest as a badge of honour as they urge Toronto–Vancouver train 493-26 over the home stretch of its 2,717-mile journey. Hung on their drawbars is 6,594 feet and 4,505 tons of intermodal traffic— single and double-stacked containers bound for Deltaport (a coastal intermodal terminal in suburban Vancouver) and billed to destinations on the far side of the Pacific.

Fulfilling Van Horne and the CPR syndicate's dreams of not only a transcontinental railway, but also transoceanic connection with the Orient, 493 marches westward. Eagle Pass echoes the exhaust of turbocharged EMD's, the steel-on-steel squeal of over a thousand wheels and a triumphant cry...

Stand fast, Craigellachie!

(Right) CP 269894 and 1905 Algoma rail, Maple Creek, Saskatchewan, February 6, 1997. **Greg McDonnell**

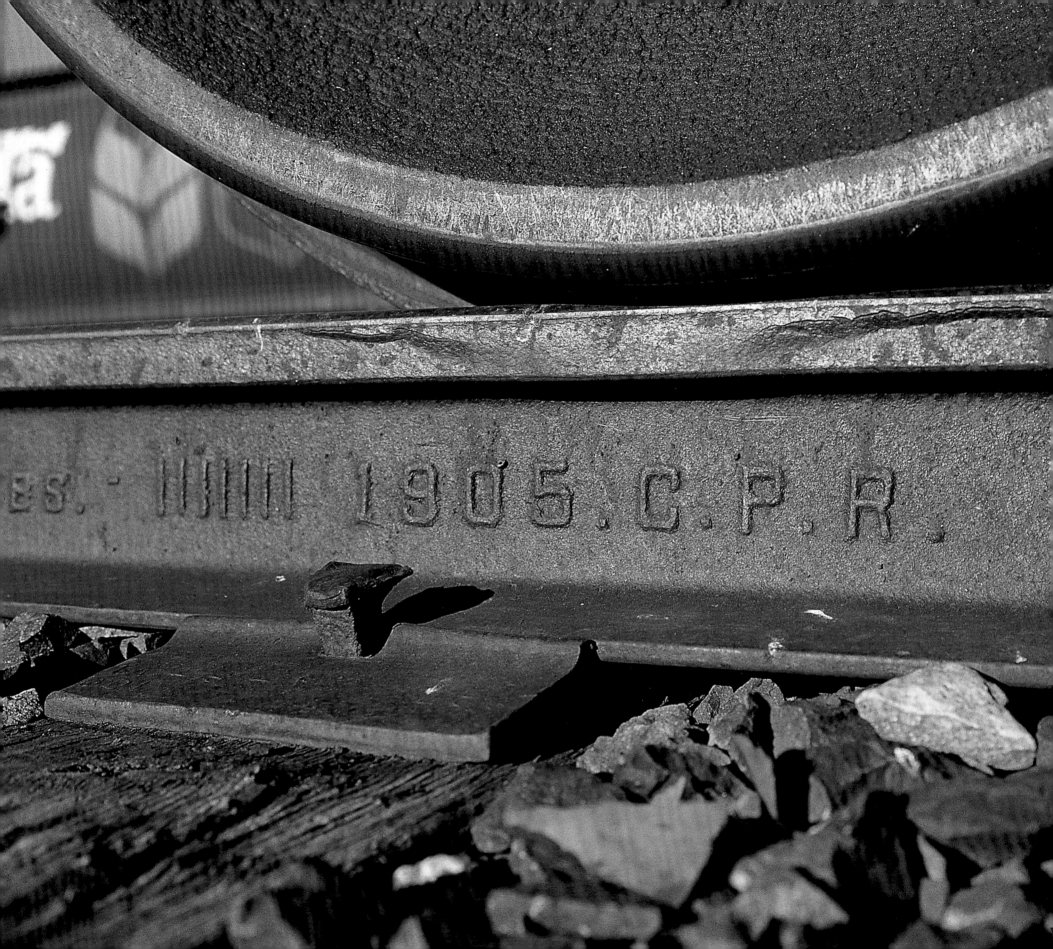

Mile zero. Windsor Station, Montreal, Quebec, December 18, 1985. **Greg McDonnell**

Standing at the corner of Angus Boulevard and Electricians Avenue, the hose tower of the shops' firehouse guards the main entrance of the legendary Angus shops complex in east end Montreal. **A. Ross Harrison**

In the hallowed halls of Angus Shops, where generations of workers have built and overhauled legions of CPR locomotives, from tiny 0-6-0's to SD40-2's, C424 4242 and SD40 5527 undergo Class 1 overhauls on September 22, 1990. Angus outshopped its last locomotive, RS18 1813, and closed on January 31, 1992. The shop was briefly reactivated in 1994 to strip retired MLW locomotives of usable parts, then closed its doors for good. **A. Ross Harrison**

The easy beat of a McIntosh & Seymour 539 marks time as S2 7096 idles outside the century-old station at Lyndonville, Vermont, on December 2, 1967. Built in 1867, the station was once the headquarters of the line's original owner, the Connecticut & Passumpsic Rivers Railroad. CP leased the line from B&M in 1926 and purchased it 20 years later. **James A. Brown**

One of three Alco S2's purchased in 1949 as part of CP's Wells River dieselization project, S2 7096 works on home turf, leading the wayfreight through Barton, Vermont, on December 2, 1967. **James A. Brown**

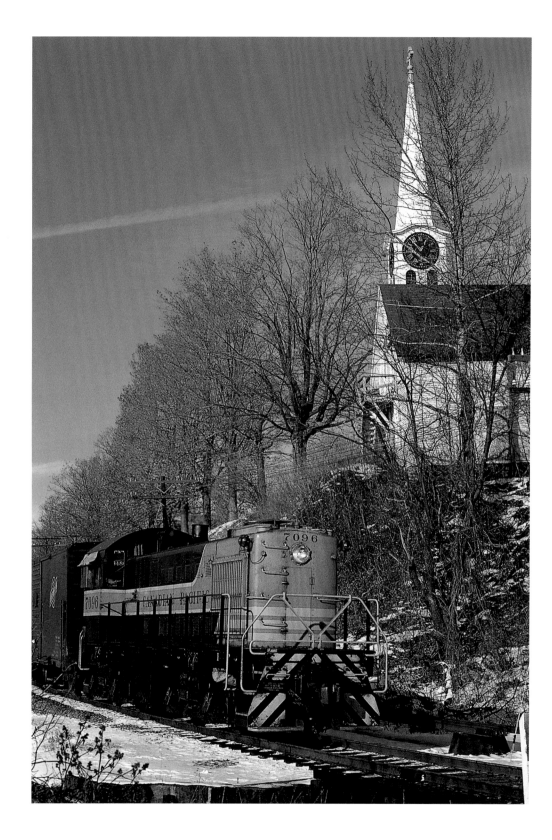

The screen door on CP 437277, the assigned van on the Lyndonville wayfreight, speaks of summer as RS2 8400 runs around her train in the old Connecticut & Passumpsic shop town of Lyndonville, Vermont. The main shipper in the old Yankee town on this August 1973 day is Concord Woodworking, an enterprise housed in the former C&P shops, visible to the left of the 8400. **Stan J. Smaill**

In 1983, after nearly 34 years of service, the venerable RS2's assigned to CP's Vermont lines were succeeded by Angus-rebuilt RS18's. Keeping company with Maine Central GP38 258, RS18 1801—rebuilt from 8764—idles at St. Johnsbury, Vermont, on July 23, 1983. **Scott A. Hartley**

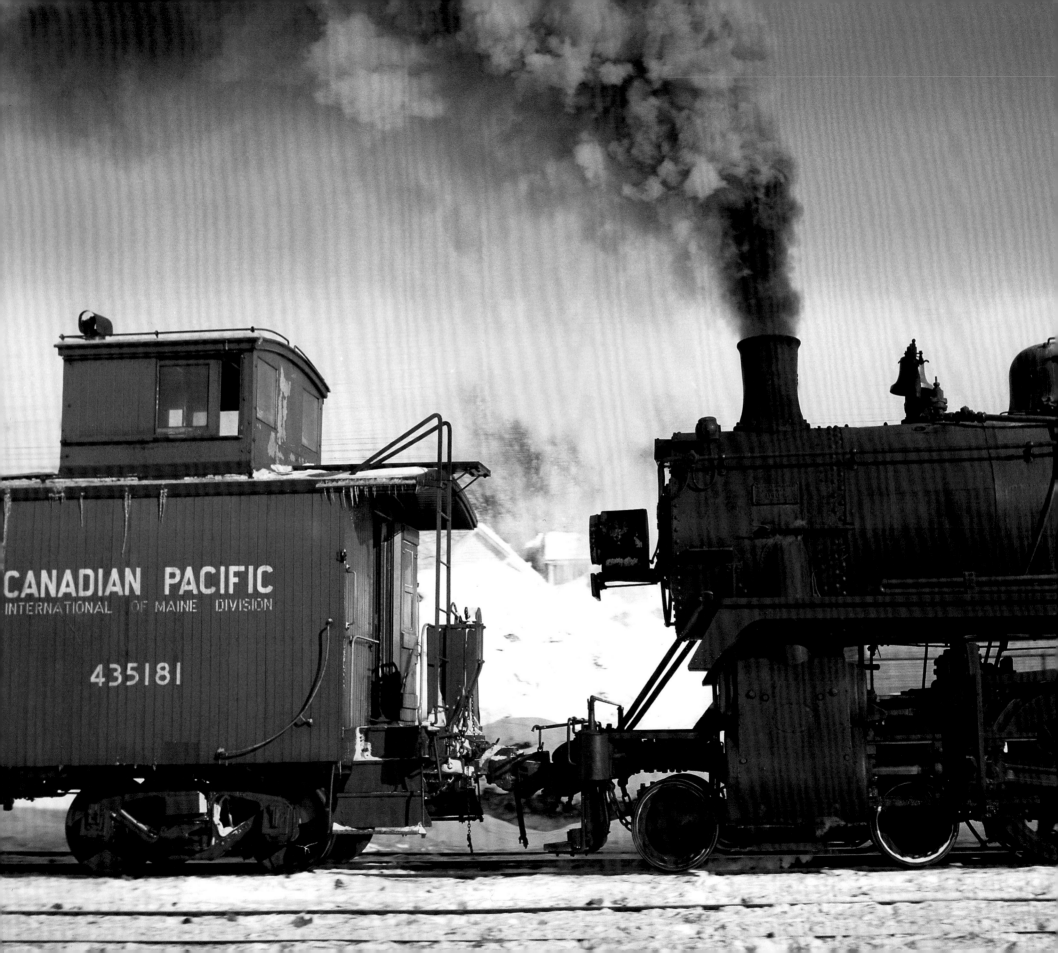

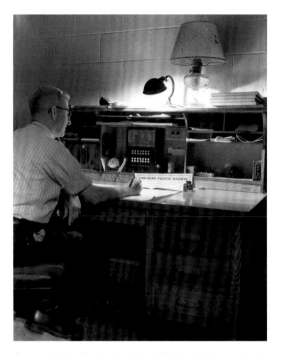

Surrounded by the simple tools of his trade, timecard and train sheets, telegraph selector, dispatcher's phone and ink well, dispatcher Jim Britt works second trick at Brownville Jct., Maine, on April 9, 1955. **Jim Shaughnessy**

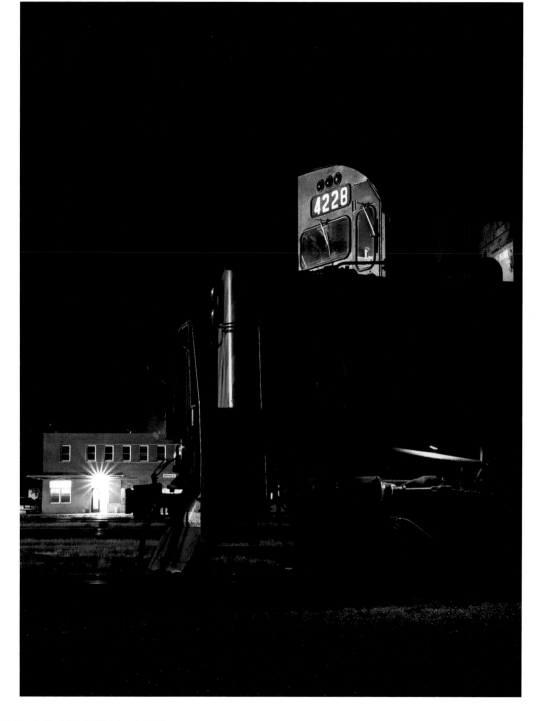

Her handsome profile highlighted in the yard lights at Brownville Jct., Maine, C424 4228 awaits the call to work No. 291 to Montreal on August 31, 1993. **A. Ross Harrison**

(Left) Working the yard at Brownville Jct., Maine, on March 8, 1955, Alco-built D10k 1075 takes hold of icicle-bedecked wooden van 435181, sub-lettered for its assigned territory, CP's International of Maine Division. **Philip R. Hastings**

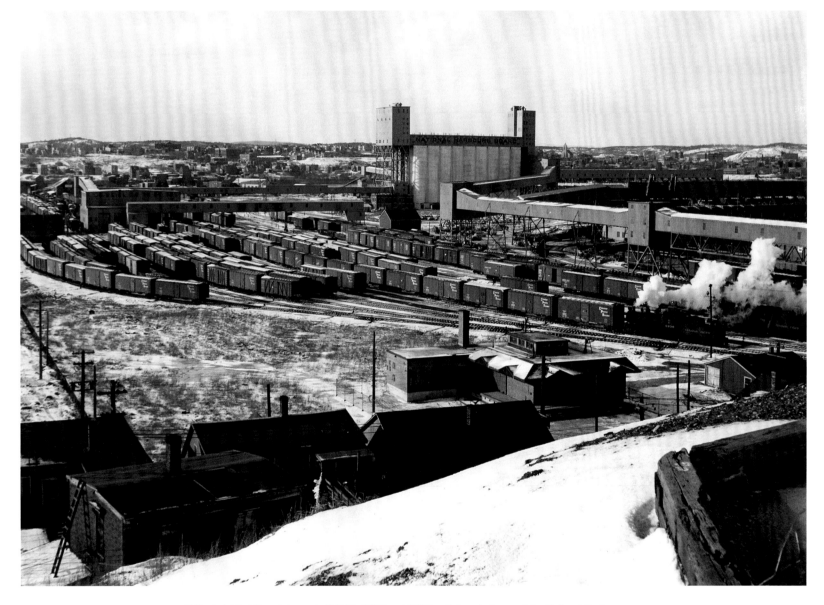

At the height of the winter rush, 0-8-0's 6936 and 6938 switch grain boxes at the National Harbours Board elevators at the port of Saint John, New Brunswick, in March 1955. Covering the annual traffic surge that occurred with the winter freeze-up, the photographer recorded this scene for an unpublished project entitled "Rails Move the River." **Philip R. Hastings**

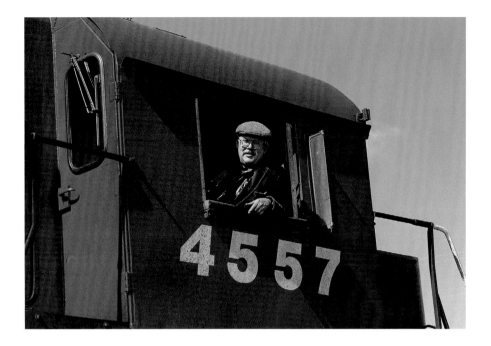

In March 1985, on the 30th anniversary of the Rails Move the River safari, Hastings returned to re-trace the Montreal–Saint John–Montreal journey, again riding freight trains over the circuitous CN/CP route. Ready to roll west on the head end of train No. 907, Dr. Hastings leans from the cab of M630 4557 at McAdam, New Brunswick, on March 29, 1985. **Greg McDonnell**

Conductor Ernie McDowell waves from the rear of van 434907—appropriately assigned to train 907—as Nos. 907 and 908 meet at Harvey, New Brunswick, at 1113 on March 29, 1985. Operating as Extra 4556 East, Saint John-bound 908 is in the charge of M630 4556, C630 4500 and C424 4226. **Greg McDonnell**

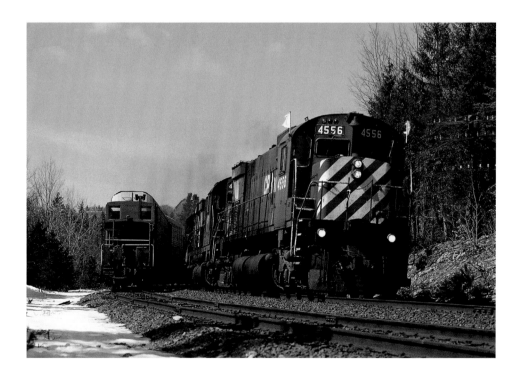

Clear board at London. The train order signal at the station in London, Ontario, is clear and the crossing watchman in the Richmond Street gate tower has the gates down in advance of an approaching westbound on December 27, 1975. The London station's days as a passenger depot are history, but on this cold winter night, it continues to house the dispatching offices for the London Division. **Jeff Mast**

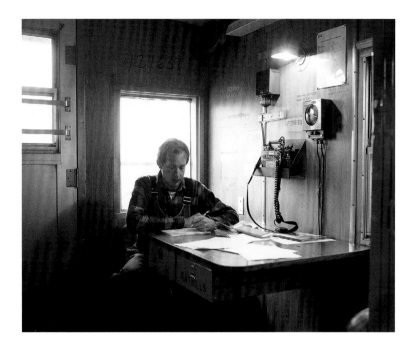

Working train 916, conductor Brad Jolliffe tends to his journal at the desk of van 434639 outside Galt, Ontario, on May 19, 1988. **Greg McDonnell**

Rolling into a winter sunset, an Angus-built van brings up the markers of Extra 4573 West at Puslinch, Ontario, on January 12, 1981.
Greg McDonnell

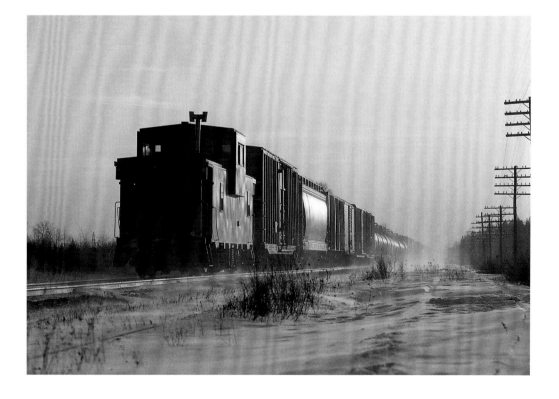

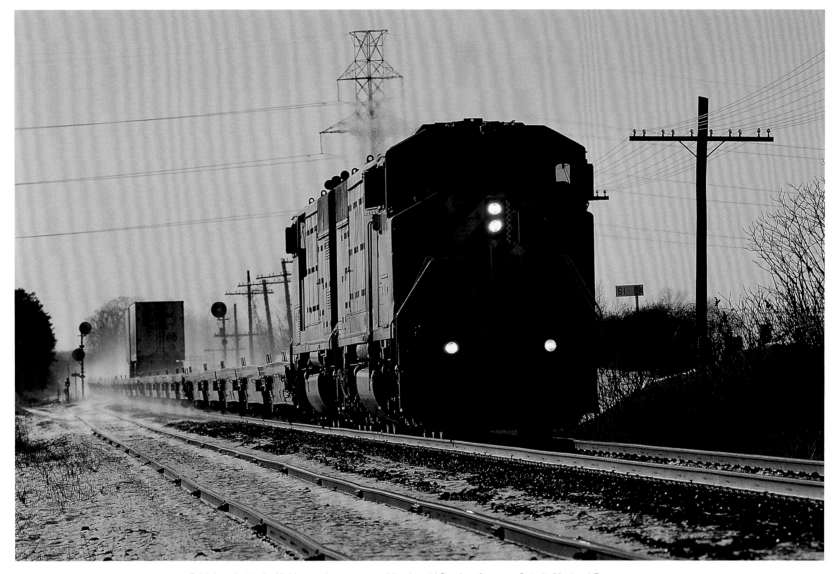

Cold day...hot train. Kicking up the snow on a bitterly cold Sunday afternoon, Detroit–Montreal Expressway train 124-18—one of the hottest trains on the railroad—sears through Orrs Lake, Ontario, behind SD40-2F's 9010 and 9020 at 1620, February 18, 2001. **Greg McDonnell**

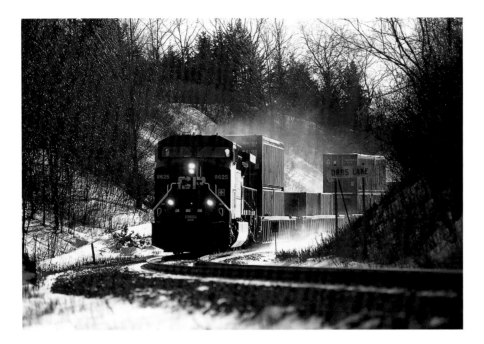

Snow swirls around Montreal-bound containers as AC4400CW 8625 exits Barries Cut, just west of Galt, Ontario, with No. 234 at 1615, February 9, 2003. **Greg McDonnell**

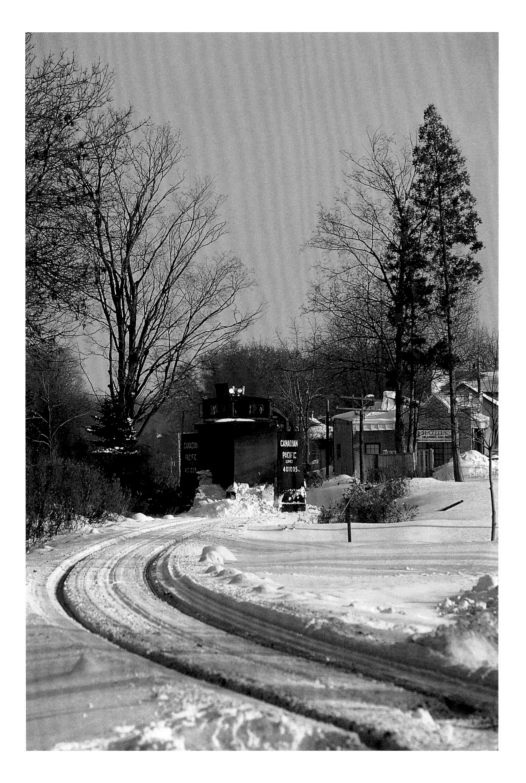

CP 401005, St. Thomas, Ontario, January 11, 2001.
Greg McDonnell

Coming into Kitchener, Ontario, through what was once known as
Centreville, Work Plow 1508, with wedge plow 401005 and Geeps
1508 and 8250, clears the Electric Lines on January 10, 2001.
Greg McDonnell

Plowing the Port Burwell Sub for the last time, Geeps 8243, 1508 and 1516 propel 1927-vintage wedge plow 401005 through the drifts south of Salford, Ontario, at 1645, January 17, 1999. The sun is setting —literally and figuratively—on CPR operations on the Port Burwell, as the line is about to be handed over to designated operator Ontario Southland. **Greg McDonnell**

Casting a near-perfect reflection, GP38-2 3046 passes the millpond at Campbellville, Ontario, with Detroit-bound RoadRailer train 529-19 on June 19, 1991. **Greg McDonnell**

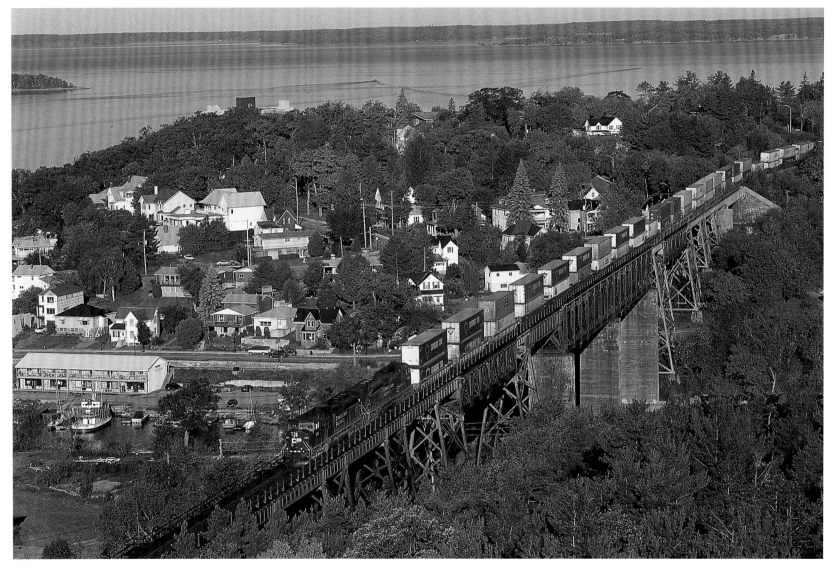

The fall colours are just starting to turn as SD90MAC's 9103 and 9149 soar high above Parry Sound, Ontario, with double-stacked intermodal traffic headed for Toronto on transcontinental hotshot No. 102 at 0852 on September 29, 2001. **William D. Miller**

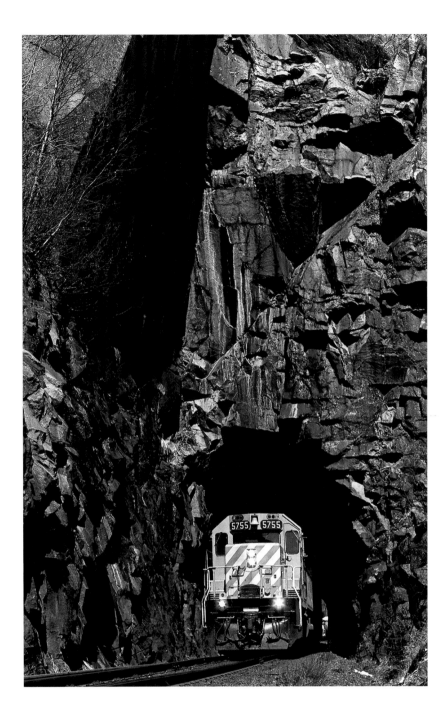

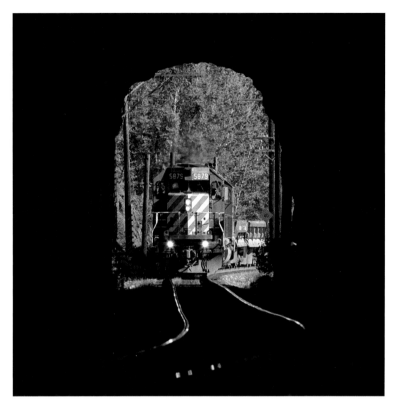

Framed in the tunnel at Mileage 27 on the Nipigon Sub, SD40-2's 5879 and 5736 head to the pit at Cavers, Ontario, on July 11, 2002, with a string of air-dumps to be loaded with riprap for the siding-extension program along the north shore of Superior. **A. Ross Harrison**

Giving credence to the contention that construction of the CPR line on the north shore of Lake Superior was tougher and more expensive that of the mainline through the Rockies, SD40-2 5755 and C630 4503 exit a tunnel carved through a towering rock wall at Jackfish Bay, Ontario, with train 955 on May 12, 1990. "Two hundred miles of engineering impossibilities," Van Horne said. The claim is undisputed. **A. Ross Harrison**

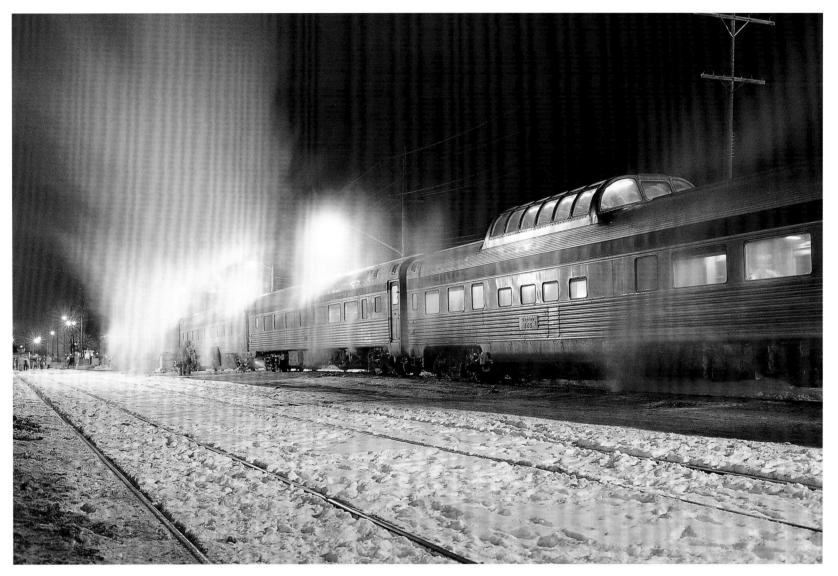

No more. Steam hangs in the cold night air on January 16, 1990, as VIA No. 10, the eastbound *Canadian*, calls on Thunder Bay, Ontario, for the last time. **Greg McDonnell**

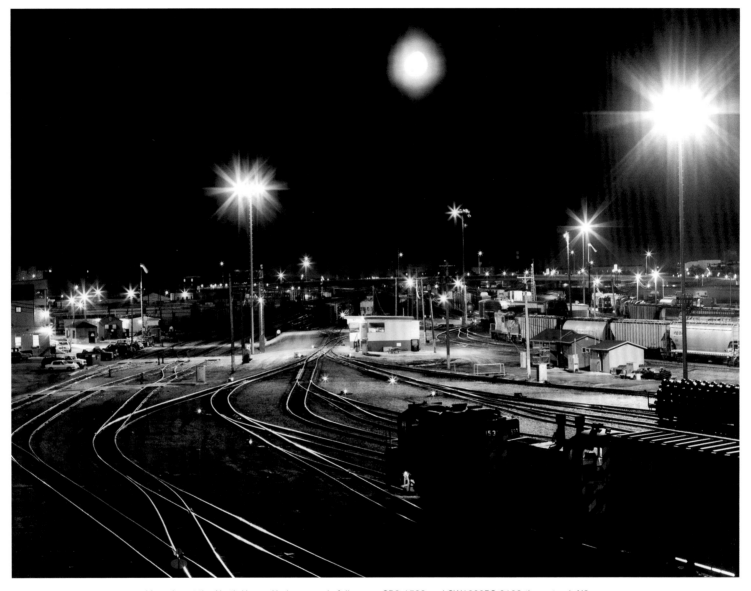

Moonrise at the North Hump. Under a nearly full moon, GP9 1533 and SW1200RS 8109 tie up track N3 on the North Hump at Winnipeg, Manitoba, on May 26, 1997. **A. Ross Harrison**

(Right) Crossing the Red. Framed in the steelwork of the Red River bridge, AC4400CW 9660 departs Winnipeg, Manitoba, with an eastbound potash train on December 10, 1999. **Greg McDonnell**

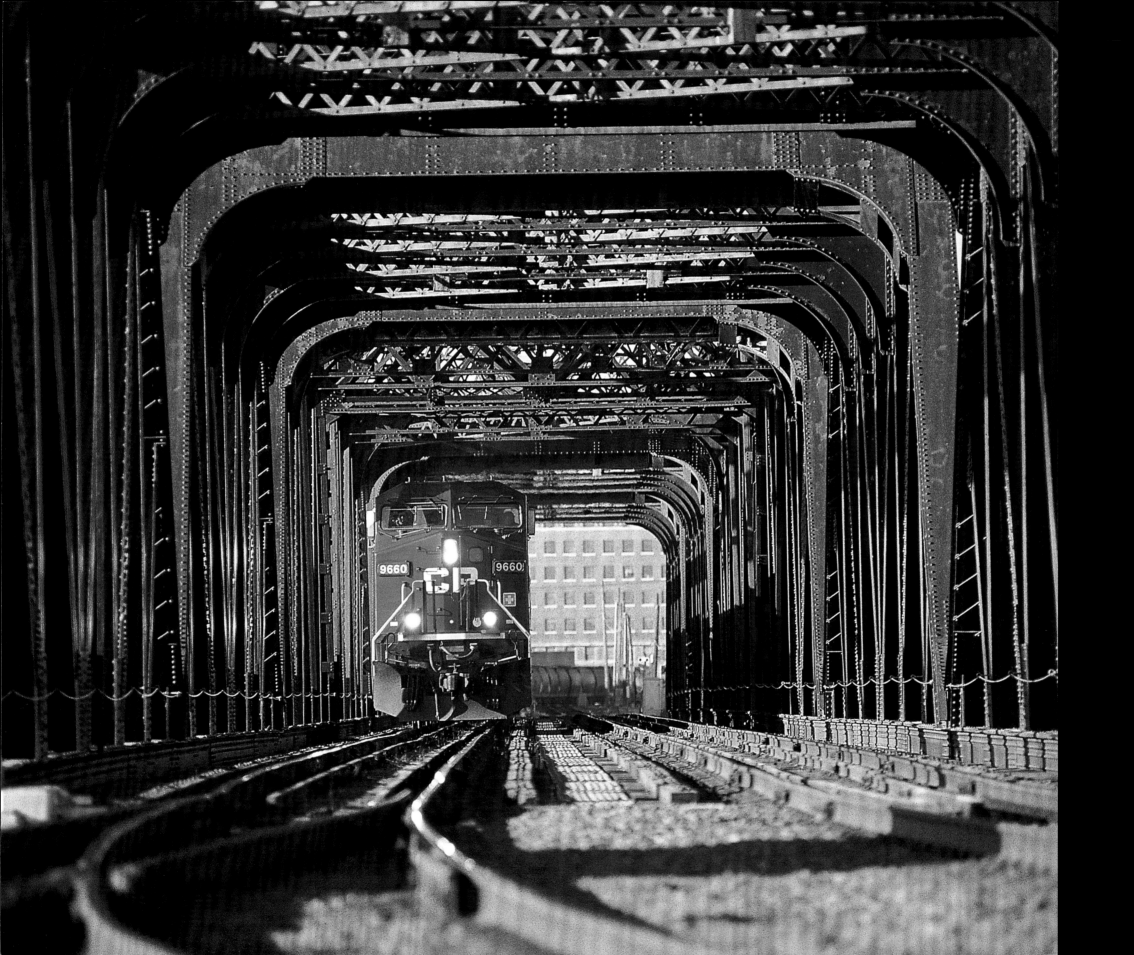

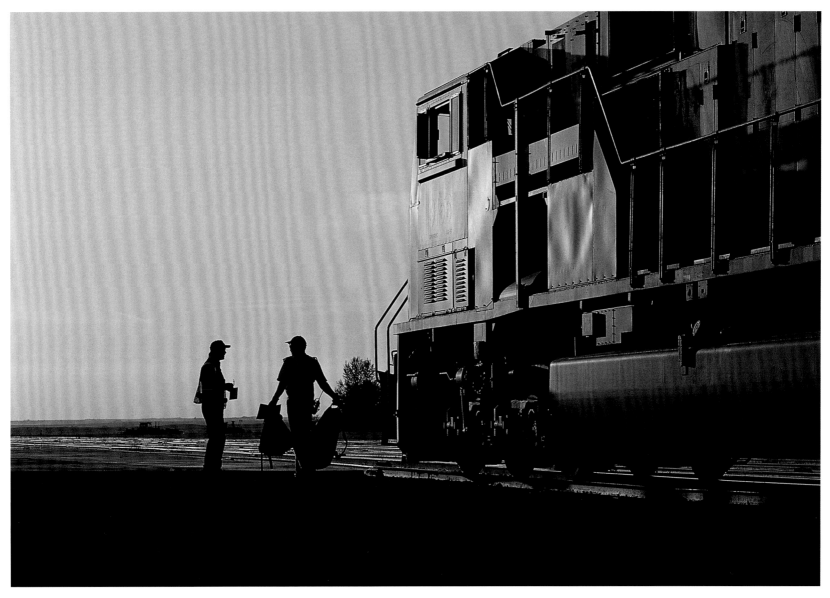

Preparing to get out of Wilkie, Saskatchewan, at sunset, the outbound crew of train 457-21 heads for the cab of SD90MAC 9156 at 1940, August 22, 2000. **Greg McDonnell**

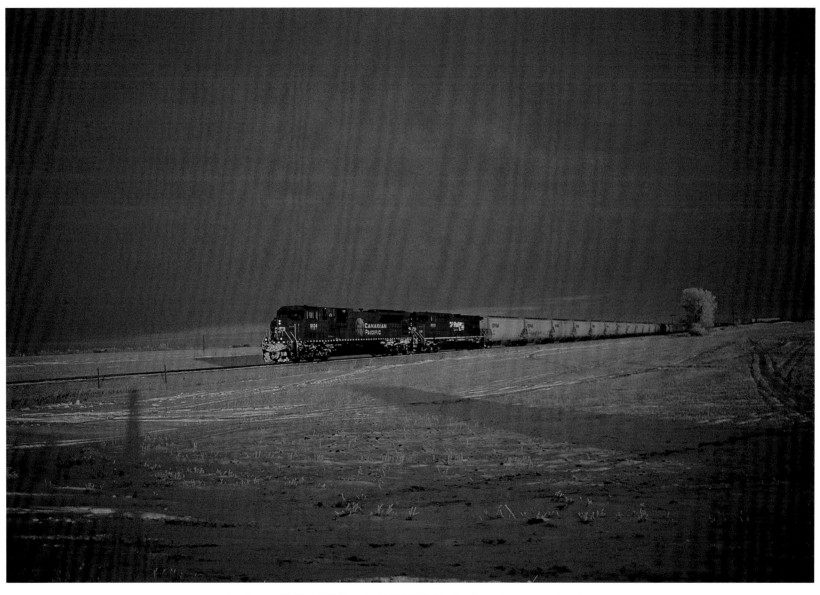

Westbound SD90MAC 9124 and AC4400CW 9525 slice the hoarfrost-covered prairie landscape with train 457 on December 30, 2000. **Robert J. Gallagher**

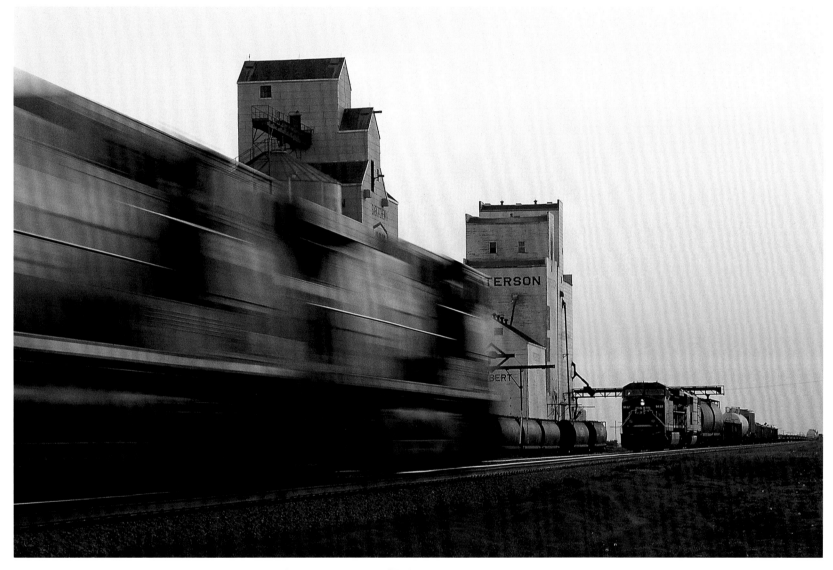

In the hole at Herbert. Running elephant-style, GE 9681 and a 9000 lead train 408 through the siding at Herbert, Saskatchewan, as a pair of GE's streak westbound with No. 429 at sunset on August 25, 2000.
Mark Perry

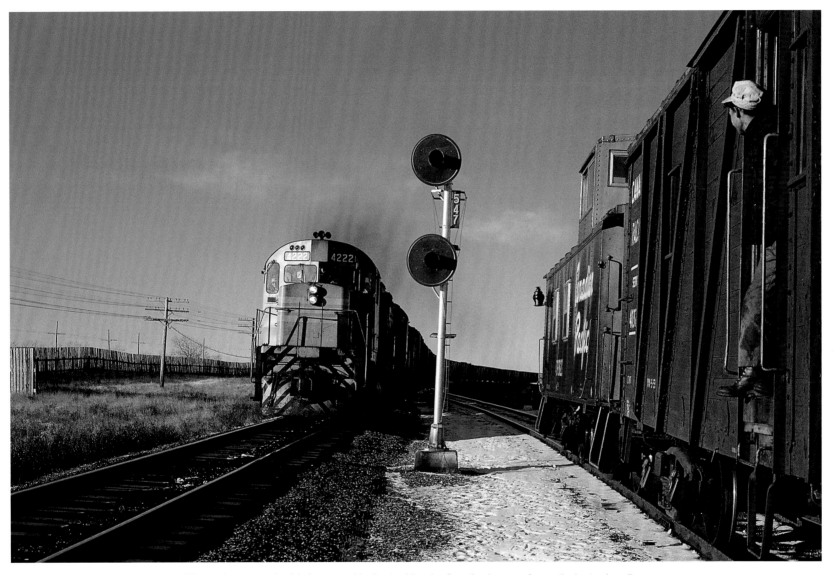

The steel gang wasn't a job, it was a paid adventure! Leaning from the doorway of a weatherbeaten boarding car, Grant Will "PK's" hotshot freight 902, led by C424 4222 and a mixed bag of four-motor hoods, as it barrels past an Extra East tucked safely in the clear at Chaplin, Saskatchewan, in December 1969. The eastbound drag is handling the boarding cars and machinery of Regional Steel Gang No. 2, moving under the escort of S.J. Smaill and G.B. Will. **Stan J. Smaill**

Marking the 4th Meridian east of Walsh, Alberta, January 22, 2001.
Greg McDonnell

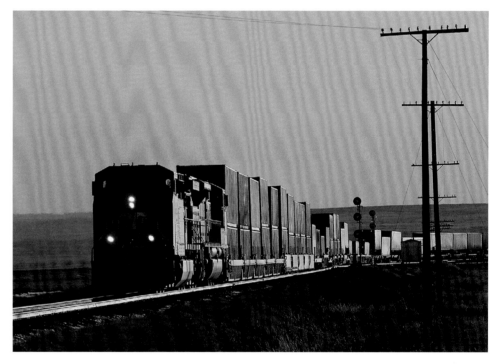

Glinting in the setting winter sun, Toronto-bound hotshot 404, with AC4400CW 9572 and CEFX SD90MAC 121 in the lead, crosses the 4th Meridian—and the Alberta–Saskatchewan border—east of Walsh, Alberta, at 1625, January 22, 2001. **Greg McDonnell**

(Right) Trudeau hoppers stretch to the horizon as Vancouver–Moose Jaw grain empties blur past the 4th Meridian sign marking the Alberta–Saskatchewan border east of Walsh, Alberta, on August 19, 2000. **Greg McDonnell**

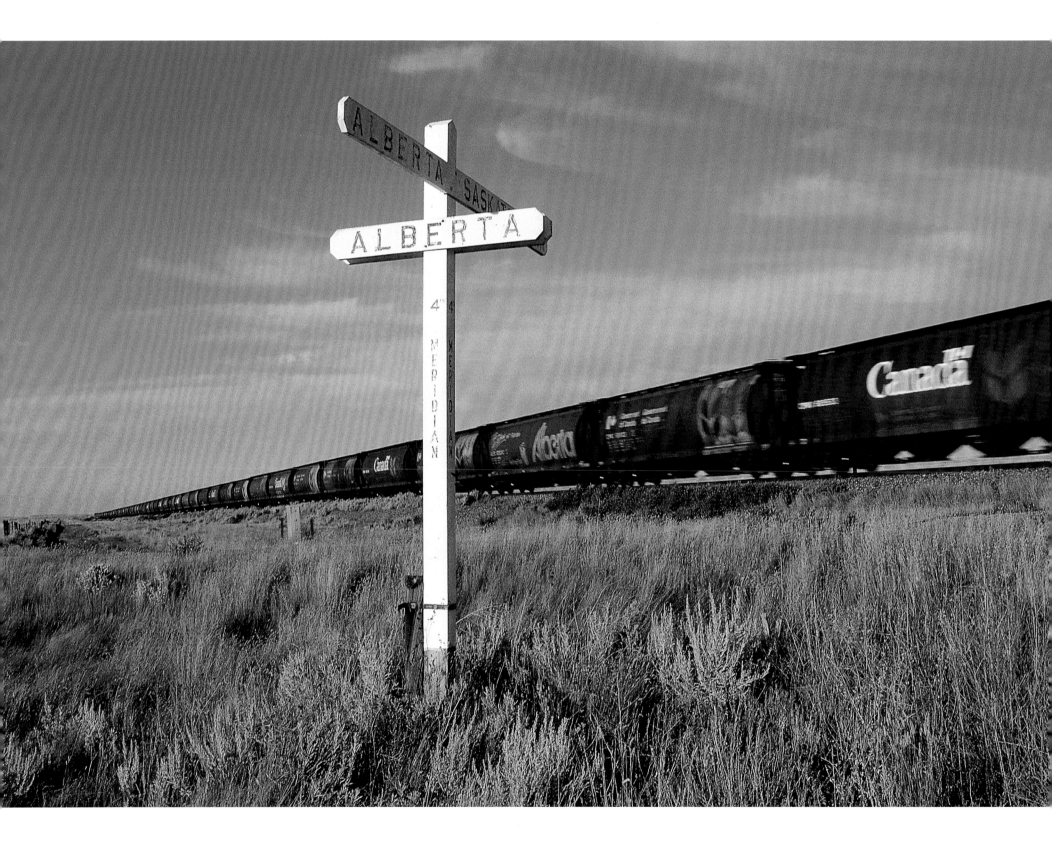

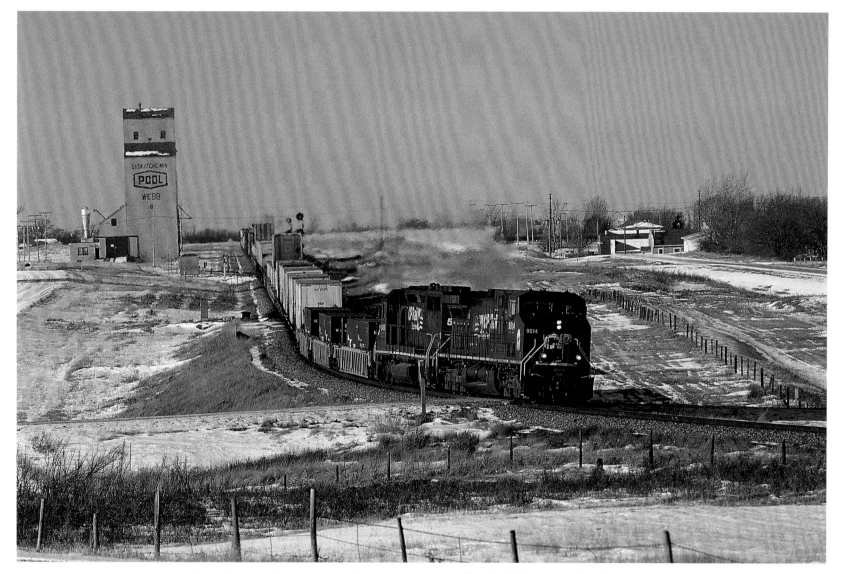

Montreal-bound with single- and double-stacked intermodal traffic, AC4400CW 9514 and SD40M-2 5490 lean into the curve at Webb, Saskatchewan, with train 482-22 at 1136 on January 23, 2001. **Greg McDonnell**

Who says they're flat and boring? Putting the lie to the greatest misconceptions of prairie railroading, train 359-21 threads the S-curve approaching Webb, Saskatchewan, with GE's 9601, 9564 and mid-train remote 9626 muscling 18,000 tons of Vancouver-bound grain over the rolling profile of the Maple Creek Sub at 1222, January 23, 2001. **Greg McDonnell**

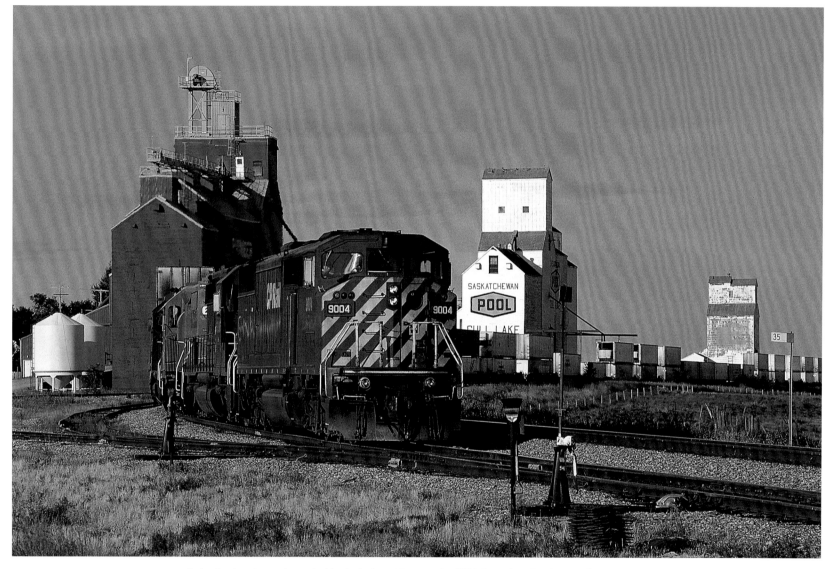

Grain elevators tower above double-stacked containers as the 9004 East takes the siding at Gull Lake, Saskatchewan, to meet a hot westbound intermodal on August 20, 2000. Trailing SD40-2F 9004, SD40-2's 5908 and 5971 bracket MPEX 2001, former Southern Pacific GP35 6312, rebuilt in Mexico for service at Inco in Copper Cliff, Ontario. **Greg McDonnell**

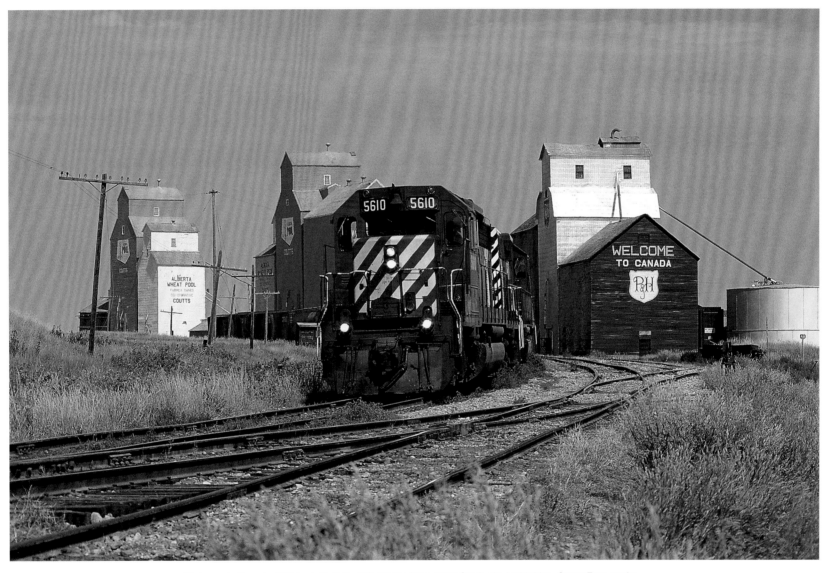

Welcome to Canada. Within sight of the U.S. border, Extra 5610 South, the Lethbridge–Coutts Turn, works the Alberta Pool and P&H elevators at Coutts, Alberta, on August 14, 1981. **Steve Patterson**

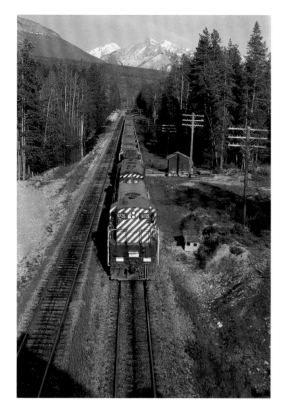

Highball Donald! The booming exhaust of Fairbanks-Morse opposed-piston diesels in full stride echoes over Donald, British Columbia, as H16-44 8726 and a sister—assisted by a GP9 still dressed in maroon and grey—highball through the one-time division point with westbound empties in June 1972. **Stan J. Smaill**

Quintessential CPR. SD40-2's 5823, 5569 and 5768 rumble across the famed Stoney Creek trestle with westbound grain on June 12, 1984. Deep in the train, radio-controlled helpers 5600 and 6031 respond to commands from the 5823, while six SD40-2's in the charge of the Rogers pusher crew shove hard on the rear. **Brad Jolliffe**

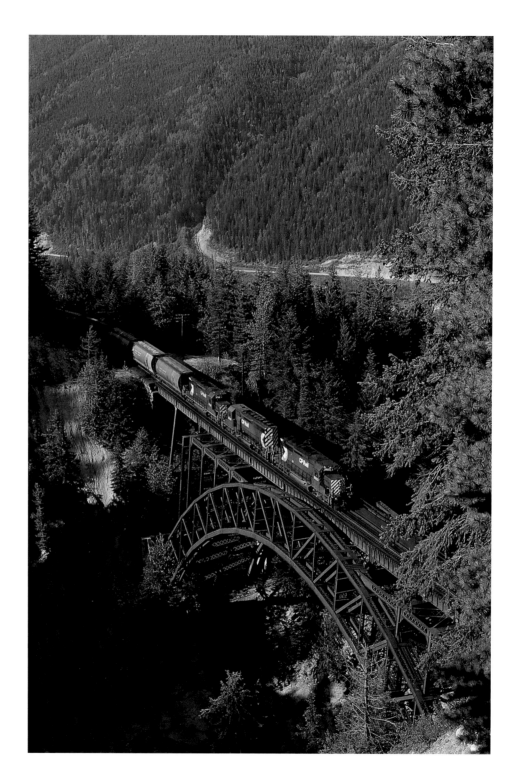

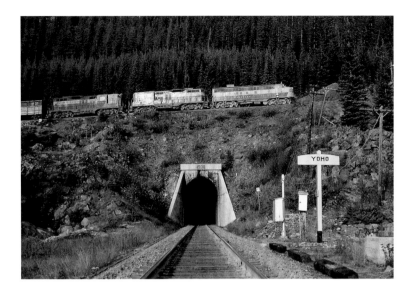

Passing the Yoho mileboard, the wooden van on the rear of Extra 4039 East disappears into the west portal of the Lower Spiral Tunnel on October 11, 1964. Moments later, the train reappears as FP7 4039 and a pair of GP9's grind overhead, completing the loop. Designed by engineering genius John E. Schwitzer, the Upper and Lower Spiral Tunnels were completed in September 1909, eliminating the legendary—and dangerous—4.5-percent grade of the Big Hill and reducing the gradient to 2.2 percent. **James A. Brown**

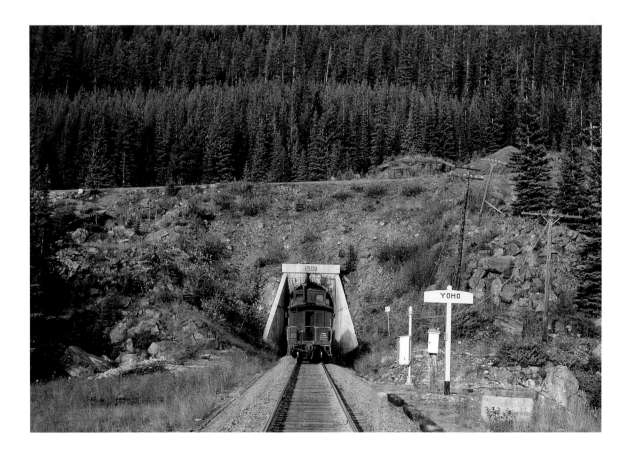

Labouring in the service for which she was purchased, M630 4551 leads SD40-2 5587, SD40 5524 and SD40-2 5575 into Revelstoke, British Columbia, on December 31, 1973, with No. 803, a westbound train of export Kootenay coal. **John Leeming**

Looking up MacKenzie Avenue in Revelstoke, British Columbia, GP9 8538 switches the yard on
September 8, 1981. **Steve Bradley**

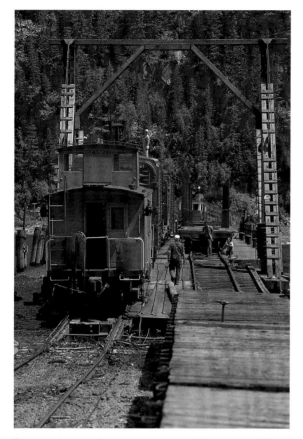

Crewmen decorate the cartops and deck of the barge as GP9 8637 loads itself, van 437249 and the consist of the Slocan local aboard the car float at Slocan City, British Columbia, on June 11, 1975. When the train is tied down, tug *Iris G* will sail the car float 20 miles up Slocan Lake to Rosebery, where the train will disembark and continue up the isolated 27-mile Kaslo Sub to Nakusp. **Steve Patterson**

Casting ripples in her wake, *Iris G* sets sail up Slocan Lake, bound for Rosebery, with 8637 and the Slocan local secured aboard the barge on June 11, 1975. Alas, the *Iris G* and the Slocan local sail no more. The last remnant of Canadian Pacific's once extensive network of steamships and ferries in the British Columbia interior, the Kaslo Sub and its unique car float connection were abandoned on December 31, 1988. **Steve Patterson**

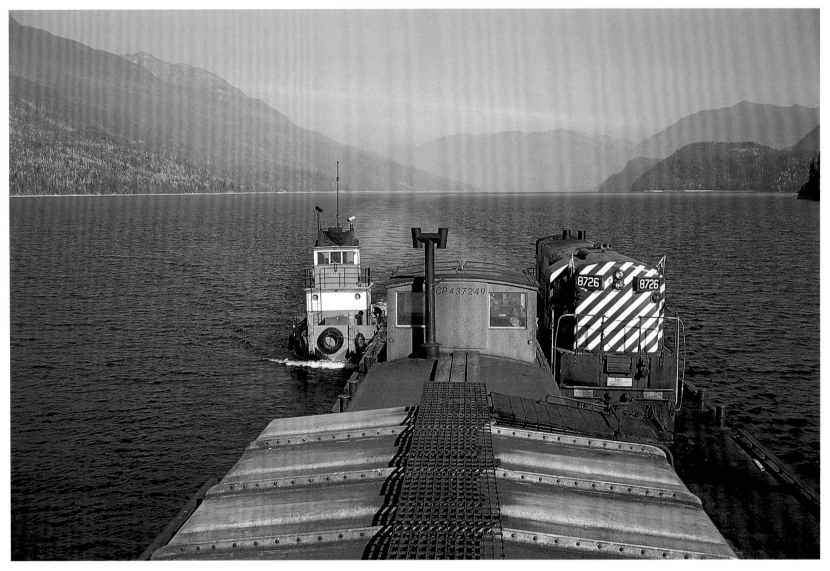

Viewed from atop a 40-foot boxcar, *Iris G* sails H16-44 8726 and the Slocan local southward on Slocan Lake, headed for the slip at Slocan City, British Columbia, on October 24, 1974. **John Leeming**

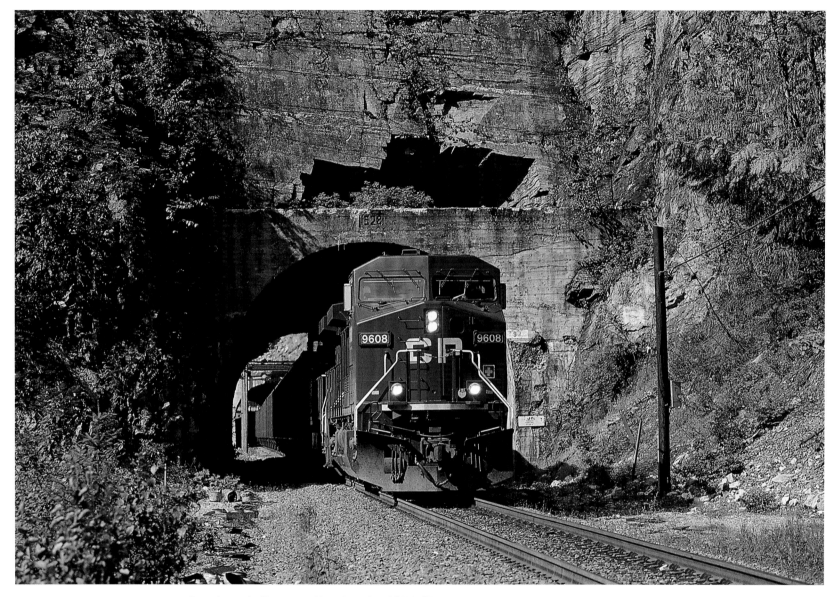

Returning to the Kootenays with coal empties, AC4400CW's 9608 and 8512 rumble through Eagle Pass, emerging from the tunnel at Mileage 9.3 Shuswap Sub, just west of Clanwilliam, British Columbia, with train 838-061 on August 28, 1999. **Greg McDonnell**

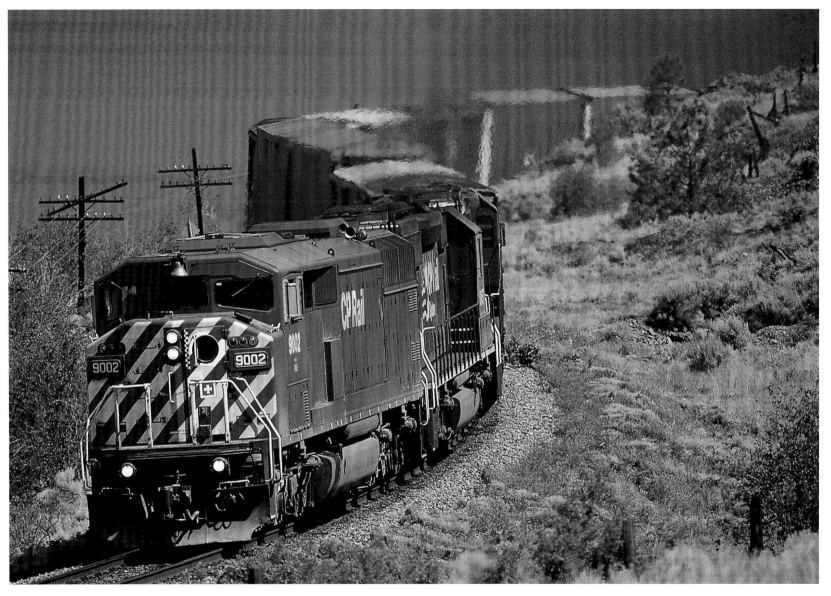

The pristine waters of Kamloops Lake shimmer in the background as SD40-2F 9002 and a pair of SD40-2's snake through the S-curves at Savona, British Columbia, with westbound tonnage on July 21, 2002.
Deane Motis

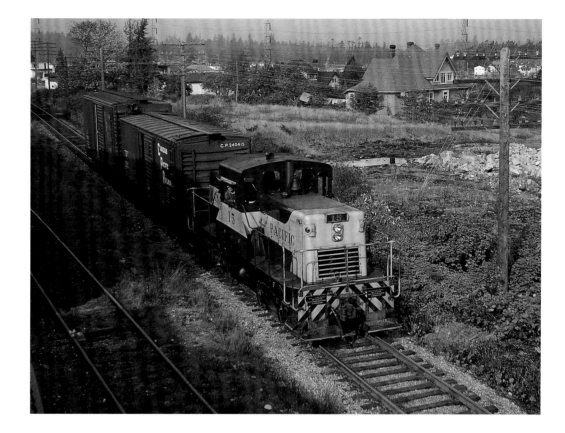

On the Esquimalt & Nanaimo, in territory better known as Canada's only bastion of Baldwin diesels, CLC-built diesel hydraulic switcher No. 15 meanders the back streets of Victoria, British Columbia, with a pair of empty boxcars on October 17, 1964. **James A. Brown**

One of the last survivors of CP's Baldwin fleet, DS44-1000 7072 trundles through Nanaimo, British Columbia, with a six-car local on October 13, 1981. Assigned to their native E&N turf to the end, CP 7070 and 7072, the last Baldwin-built diesels in the employ of a Class 1 railroad in North America, were retired in August 1982 and scrapped at Ogden Shops in 1983. Two of CP's 24 Baldwin diesels (DS44-1000's 7065-7075 and DRS44-1000's 8000-8012) have been preserved. DRS44-1000 No. 8000 has been restored and retained by CP for historical purposes, while DS44-1000 7069 was purchased privately after its retirement in 1978 and is stored in the John Street roundhouse in Toronto pending the establishment of a railway museum at the site. **David R. Busse**

Riding "the insular rails of the storied Esquimalt & Nanaimo," RDC3 9024 skirts the shore of Shawinigan Lake, with E&N train No. 2, at Shawinigan, British Columbia, on October 17, 1964. **James A. Brown**

Always the E&N. Esquimalt & Naniamo arrivals and departures board, Naniamo, British Columbia, August 23, 1977.
Scott Jolliffe

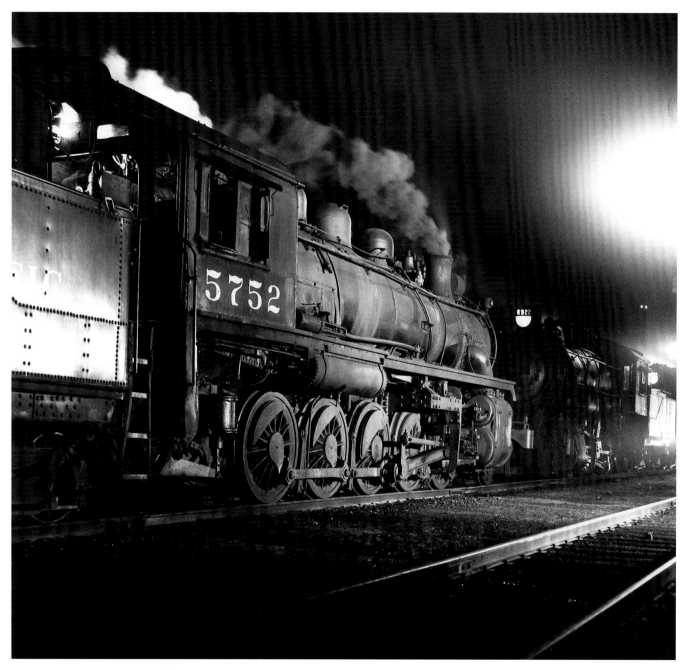

A long way from the Rockies and long ago rebuilt from her original 0-6-6-0 configuration, R2b 2-10-0 5752 stands face to face with 0-8-0 6922 on the shop tracks at St. Luc, Quebec, on August 25, 1956. Designed for duty in the Rockies, CP's six home-built 0-6-6-0's were constructed at Angus Shops in Montreal between 1909 and 1911 and converted to 2-10-0's in 1916 and 1917. Far from Field Hill, 5752 is finishing her days in Montreal transfer service, lugging trains up Hochelaga Hill and labouring in the shadow of the place of her birth. **Jim Shaughnessy**

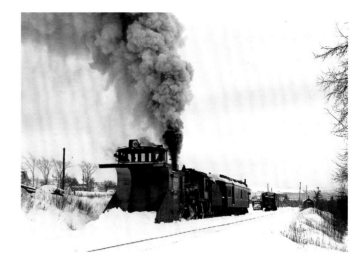

Sweating the Assets

Make no mistake about it, we are going to make these new assets "sweat" in the coming months and years. Rob Ritchie, April 20, 1999.

Sweating the assets. Rob Ritchie's words echo in my mind every time I watch a lone CP AC4400CW labour upgrade with all the tonnage the yardmaster dared hang on her drawbar. The 4,400-hp, A.C. traction GE AC4400CW's were among the "new assets" to which Mr. Ritchie referred in his remarks, made upon the April 20, 1999, release of the company's first quarter operating results.

"Following three years of significant investment in franchise renewal," the report read, "the company is concentrating on maximizing the utilization of its new locomotive fleet and other infrastructure assets." A single sentence from the president and CEO underscored the statement: "Make no mistake about it, we are going to

In the definitive sweating of assets, 75-year-old A2m 4-4-0 136—turned out of Rogers' Patterson, New Jersey, works in 1883—does double duty, plowing the Minto Subdivision while working daily-except-Sunday Norton–Chipman, New Brunswick, mixed train No. 559 on January 3, 1959. Pushing wedge plow 401007 and pulling an aged wooden combine, the old girl is taxed to the limit as she plows the siding at Belle Isle en route to Chipman. **Robert Sandusky**

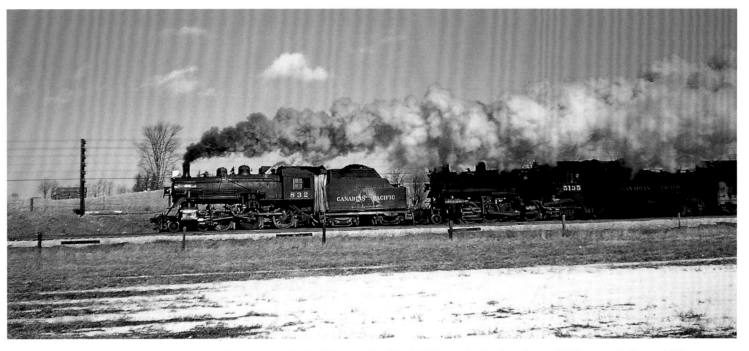

Charging through Streetsville, Ontario, on March 9, 1957, D10e 832 assists P1e Mikado 5135 on a London-bound extra. Built by Angus in August 1909, No. 832 will soon drop her fire for the last time, while 5135, built by MLW in August 1913, will remain on the roster until 1961. **Robert Sandusky**

make these new assets 'sweat' in the coming months and years." The words are Ritchie's, but they could just as easily have been uttered by almost any of his predecessors, from George Stephen or William Cornelius Van Horne, to Thomas George Shaughnessy or Edward Wentworth Beatty, or N.R. Crump. "Sweating the assets" is as much a CPR tradition as maroon paint and beaver crests.

In the steam season, sweating the assets meant squeezing every last ounce of serviceable life from aging locomotives: from construction-era 4-4-0's modernized in the early 1900s with piston valves and superheated boilers, to 2-10-0's converted in 1916–17 from Vaughan-design 0-6-6-0 articulateds built for service on the Big Hill; from M4-class 2-8-0's transformed into V4a 0-8-0's in the late 1920s, to 65 N2-class Consolidations elongated and rebuilt as P1n 2-8-2's in the late 1940s.

Right up to dieselization, sweating the assets was equated with pre-World War I-vintage, D10-class 4-6-0's triple-heading

tonnage up Magowan Hill out of Newport, Vermont; with ponderous 2-10-0's, built from the six Vaughan 0-6-6-0's, slugging transfer drags through the Montreal terminals; and with high-stepping G1 Pacifics—turned out by Angus Shops in 1914—working the famed Cockney Pool, assisting Mikes, standard and Royal Hudsons and even new diesels on eastward, westward and northward trains out of Toronto's Lambton Yard.

Hudsons (Royal and otherwise) worked regularly assigned passenger runs in excess of 800 miles. The H1 chalked up for No. 3 at Toronto's John Street roundhouse worked the 811 miles to Fort William without change, only to be quickly serviced and turned back east on No. 4. Out of Winnipeg, Hudsons relayed the Toronto and Montreal sections of *The Dominion* over the 823 miles to Calgary without relief. In the definitive sweating of assets, a trio of 1880s-vintage 4-4-0's remained in service out of Chipman, New Brunswick, through the 1950s. Their survival necessitated by 65- and 73-pound rail and light bridges on the branch to Norton,

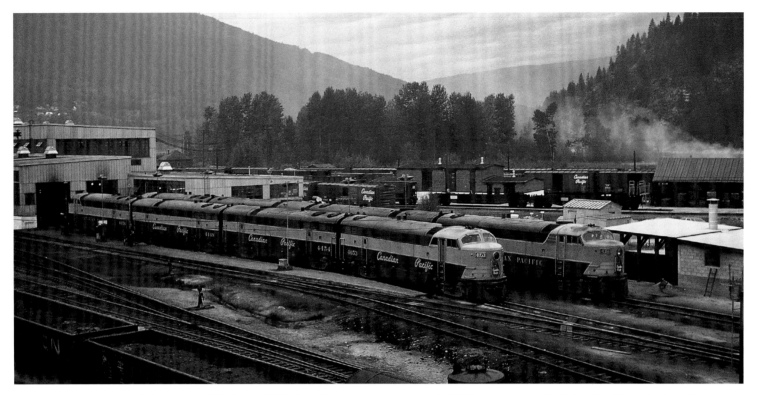

Nirvana for opposed-piston power, CP's Nelson, British Columbia, shop was home to the last Fairbanks-Morse design C-lines in existence by the early 1970s. In September 1969, the shop tracks at Nelson hold a sight to be seen nowhere else in the world...not one, but two A-B-B-A sets of C-lines! CLC-built CPA16-4 4053, CPB16-4's 4454 and 4449 and CPA16-4 4056 make up the first set, while the second set is headed by CFA16-4 4081.
Grant B. Will

CP A1e No. 29 (CPR DeLorimier Shops, September 1887), A2m No. 136 (Rogers, August 1883) and A2q No. 144 (DeLorimier Shops, March 1886) continued to ply the 44.6-mile Minto Subdivision until the arrival of a diesel replacement, 44-ton CLC diesel-hydraulic No. 22, in 1959. The last American Standards in the employ of a Class 1 railroad in North America, the elderly trio were accorded mythic status by the faithful, and inspired the still-legendary steam safaris of David P. Morgan and Philip R. Hastings.

Canadian Pacific stuck with steam longer than most North American roads, taking delivery of nearly 200 new steam locomotives, including 102 G5 Pacifics and 6 semi-streamlined T1c 2-10-4 Selkirks between 1944 and 1949. There were a total of 1,719 serviceable steam locomotives

on the CPR roster when Selkirk 5935—the railway's last steam engine—was outshopped from MLW in March 1949. The $275,868 and 447,000-pound T1c and her sisters would operate for barely a decade, but that decade, the decade of steam's last stand, would be one of the most celebrated and best documented seasons in the railway's history.

The end of CPR steam was dramatic theatre, from the famed 4-4-0's of New Brunswick, to double-headed Mikes working tonnage through Quebec's Eastern Townships; from Pacifics and Hudsons working their final days in Montreal commuter service, to Jubliees going out in a blaze of glory, topping 80, 90 and 100 mph with lightweight consists on Montreal–Quebec and Toronto–Windsor schedules; from D10's plying branches and secondary lines

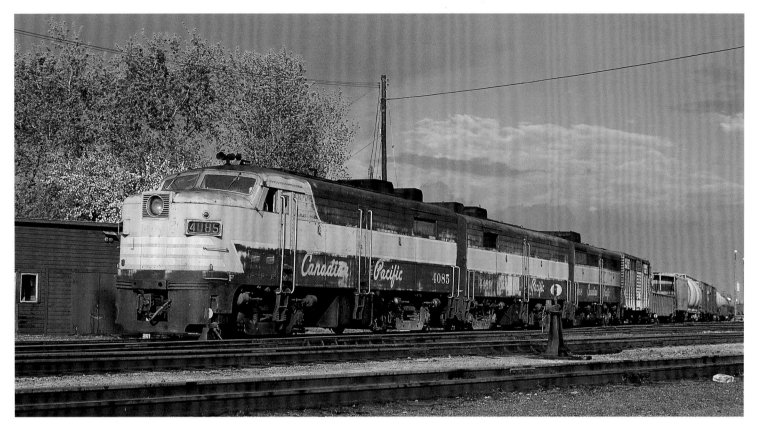

One for "JJG," Smiths Falls Division train dispatcher John J. Galvin. On a memorable afternoon in May 1974, Chalk River Sub train No. 911 departs Smiths Falls, Ontario, with FA2 4085 leading FB2 4469 and FB1 4408. An A-B-B of FA's "in the old" was enough to prompt photographer Smaill to cut short dispatcher training for the day in order to follow 911 into the sunset. To Smaill's surprise, mentor Galvin okayed the plan, even suggesting the bridge at Pakenham as a prime photo location. He offered a parting shot as SJS headed for the door: "Just like Chapman," JJG muttered, "one of those engine picture guys." **Stan J. Smaill**

from the Kootenays to the Maritimes, to Selkirks and semi-streamlined G3 Pacifics working their final miles on the prairies.

As the curtain came down, legions of the faithful and some of the most talented Canadian and American photographers were on hand to witness and to document the drama. There were those fortunate enough to have been present when Montreal-bound manifest No. 910 came pounding up the Don Branch and into Leaside with not one, but two N2 Consolidations assisting a heavy Pacific. Those who know the thrill of watching a G3 Pacific get underway out of Winnipeg with No. 43 on a rainy night,

or the banshee cry of a D10 whistling for the mileboard at Sharbot Lake, or the exhilaration of tugging back on the throttle of a Selkirk and feeling all 76,900 pounds of tractive-effort dig in to lift eastbound tonnage out of Field, they will never forget. The rest of us can consider ourselves fortunate that those who were there happily favour us with the memories. And that the likes of Jim Brown and Jim Shaughnessy, Phil Hastings and Bob Sandusky, Bob Clarke and Robert Hale, Don Wood, Paul Meyer and William Middleton had the foresight, determination and the God-given talent to preserve it all on film with unprecedented effort and artistry.

Little more than a decade after the last fires were dropped, the CPR was again the stage for a spectacular last stand—and a destination for a new generation of faithful—as the first-generation diesels that had banished steam short years earlier found themselves on borrowed time. In a remarkable parallel with the final years of the steam season, the faithful returned to many of the once-hallowed bastions of steam; to St. Luc and Saint John and Sherbrooke, to Smiths Falls and Sudbury and Streetsville, to Chalk River and Chatham, and to Guelph Junction and Galt and Woodstock. The players were different, but the drama was replayed as the CPR sweated the assets and wrung every last bit of life from aging FA's, RS3's, RS10's, F-units and 539-powered Alco-MLW switchers.

In the west, the storied Kootenay Division in southern British Columbia was opposed-piston paradise as the Fairbanks-Morse design, Canadian Locomotive Company-built H16-44's, Train Masters and C-line cabs that called CP's Nelson, British Columbia, shop home made a valiant last stand. The booming exhaust of opposed-piston diesels echoed through the mountains as C-lines and H16-44's engaged in a style of railroading little changed since the days of steam.

While CP sought the maximum return on its investment in the Kingston-built CLC's, diesel fans by the dozen made the pilgrimage to Crowsnest, Cranbrook, Yahk, Nelson and the far corners of the Kootenay Division to seek out, not just the rare F-M hoods, but the Holy Grail of dieseldom: the F-M design Consolidation Line cab unit. As late as 1974, five of CP's original fleet of 16 CFA16-4's and CPA16-4's, the last of their kind in existence anywhere, remained in service on the Kootenay Division. For a new generation, CP road numbers 4053, 4057, 4065, 4104 and 4105 possessed the same magic as numbers 29, 136 and 144 had held for their predecessors. And Nelson was the new nirvana.

There were those who questioned the wisdom of travelling to the wilds of British Columbia for no reason other than a hoped-for encounter with a handful of aging diesels. To walk through the engine room of CPA16-4 4065 as the sole survivor of the *City of Kingston* demonstrator set waited on a

Hauntingly similar to the steam scrap lines of years past. FA2's 4085 and 4050 languish at St. Luc on December 5, 1975, with the season's first snow piled on their noses and rooftops. The moribund MLW's have settled in for a winter's nap, a nap from which they will not awaken. **Greg McDonnell**

0200 call to take 979 west from Cranbrook, or to watch in wonder as C-line 4105, H16-44 sisters 8714, 8603 and M630 4511 struggled up McGillvary Loop, clawing their way to the Crow with an over-tonnage Extra East, was to understand why.

Following the fate of the dual-service Hudsons and heavy Pacifics that she was built to replace, CP's last 244-powered locomotive, boiler-equipped RS10 8570, finished her days in Montreal commuter service. Leased to STCUM, 8570 keeps company with ex-CP FP7's at Vaudreuil, Quebec, on St. Patrick's Day 1984.
Greg McDonnell

As if C-lines and H16-44's in road service weren't enough, the Kootenay Division was also home to a trio of CLC/F-M Train Masters, the last survivors of a CP H24-66 fleet that had once numbered 21 units. Toiling in relative obscurity, CP 8900, 8904 and 8905 spent most of their time switching the Cominco smelters in Trail, British Columbia. However, their Trail assignment also called for the big TM's to drag (or push) trains up the steep grade to Warfield—a line once home to CP's only geared steam locomotives, a trio of three-truck Lima Shays acquired between 1900 and 1903.

The Shays' tenure in Trail was brief, but six decades after the geared Limas vanished from Warfield Hill, the torturous 4.1-percent grade—complete with switchback—looked more like Shay territory than the bailiwick of six-motor, 2400-hp, 389,000-pound Train Masters. However, the battered TM's, filthy and corroded from years of labour in the shadow of the smelters, put on some of the most memorable performances in dieseldom as they tackled

the legendary hill in all their opposed-piston glory. Ephraim Shay himself would have been impressed.

If Nelson was nirvana, Montreal, home shop for one of the last bastions of Alco 244 power, was Mecca. Sweating its St. Luc-maintained Alco assets for all they were worth, CP worked its armada of aging FA's, FB's, RS2's, RS3's and RS10's until they dropped. All-244 lashups were common east of Thunder Bay, and boiler-equipped RS10's were often assigned to *The Canadian* (although rarely leading) as far west as Calgary.

By the mid-Seventies, CP was the last place in North America to find 244-powered FA's hauling trains. To the delight of diesel fans, the shop foremen at St. Luc, Toronto Yard and elsewhere were not averse to dispatching FA's in solid sets, from A-A's to incredible A-B-B-A's. To the chagrin of crews, yardmasters—indifferent to the age and infirmity of the tired cabs—didn't think twice about loading them up to A-rating, or beyond.

Train crews may have begged to differ, but finding an A-A of FA's chalked on the assignment board at Toronto Yard for Mactier Sub drag freight No. 955, or an all-maroon-and-grey A-B-B inked on the Smiths Falls train sheet for No. 911, was providential. Following or riding them over the road offered guaranteed adventure. There are few things in railroading more compelling than watching a matched set of FA's battling upgrade with A-rating hung on their drawbars, the loadmeter needle buried in the red zone, alarm bells clanging in the cab, 244's bellowing behind the electrical cabinet wall and progress measured in feet per minute, not miles per hour.

Remarkably, Angus shops continued to perform Class 1 overhauls on 244 power as late as 1975. Indeed, on March 10, 1975, I walked the overhaul bay at Angus, heartened to see RS3's 8441 and 8458 in the midst of complete rebuilds. The bliss was short-lived. Several hours later, I turned the corner of the diesel shop at St. Luc to be confronted with a long storage line that included more than a dozen FB1's, FB2's and FPB2's—all but three of CP's operable Alco-MLW B-units. The message from the motive power offices in

Behind the faded, battle-scarred hood of RS10 8570 beats the last operating Alco 244 engine on the CPR. Vaudreuil, Quebec, March 17, 1984. **Greg McDonnell**

Windsor Station was short and to the point. All remaining FA's and FB's were to be tied up. Worse yet, the entire CLC fleet was to be retired.

An upsurge in traffic prompted St. Luc to briefly reactivate most of the stored units, but the disturbing sight on that March night was a prelude to the inevitable and not-too-distant end. As spring turned to summer, the lines of dead FA's and FB's at St. Luc seemed to lengthen by the day. As the autumn leaves began to fall, only two FA's, 4084 and 4089, remained on the road. On October 22, 1975, FA2 4089 led SW1200RS 8151 out of Toronto on a Burlington Turn. It was the last time a CP FA would lead a train. Her stack neatly capped with a piece of white canvas, 4089 was shoved, dead and drained, onto the growing deadline at St. Luc on November 8. A day later, 4084 was added to the line, and it was over.

The long lines of dead FA's, FB's, RS3's and RS10's parked by the coal tower at St. Luc were hauntingly similar to the steam scrap lines of years past. CP investigated reactivating the aging cabs at least twice, but rejected the plan. As the season's first snow piled high on their noses and rooftops, the moribund MLW's settled in for a winter's nap from which they would never awaken.

The FA era had ended, but CP's 244-powered hoods would soldier on—albeit in ever-dwindling numbers—until 1984. Not surprisingly, the pristine RS2's, assigned to Newport, Vermont, since their delivery in 1949, were just about the last to go. Among CP's very first road diesels, Alco-built RS2's 8400–8404 spent virtually their entire lives working the territory for which they were purchased. The five pioneers of CP dieselization were finally retired in the summer of 1983 with performance records as unblemished as their polished action-red flanks, a testament to the meticulous care administered by the shop staff at the Newport roundhouse for most of their 34 years of service.

A far cry from the pampered Newport RS2's, RS10 8570, her paint bleached and faded, her carbody battered from brutal years of unforgiving road service, closed the book on CPR 244's in the summer of 1984. Following the fate of the dual-service Hudsons and heavy Pacifics that she was built to replace, boiler-equipped RS10 8570 finished her days in Montreal commuter service, operating under lease to STCUM, the government agency that had inherited CP's Lakeshore commuter trains. The throaty vocals of the Alco 244, a standard on Canadian Pacific since the arrival of its first FA's in 1949, were silenced as 8570 arrived at Windsor Station for the last time, with train No. 18 from Vaudreuil, on the morning of August 3, 1984.

Coincident with the fall of the 244, the syncopated rhythm of the McIntosh & Seymour 539 engine, the very heartbeat of railroading within yard limit signs from Saint John to Vancouver since the dawn of CPR dieselization, was fading fast. Rebuilt Geeps and SW1200's were replacing venerable S2's, S3's, S4's, S10's and S11's in yard service system wide. By the early Eighties, the aging Alco and MLW switchers had retreated to a handful of terminals and Toronto's John Street roundhouse had become refuge to a fleet of nearly three dozen 30- and 40-year-old S-series switchers.

Stepping past the massive wooden doors of the 32-stall roundhouse, built to maintain passenger power for trains out of nearby Union Station, was like stepping back in time.

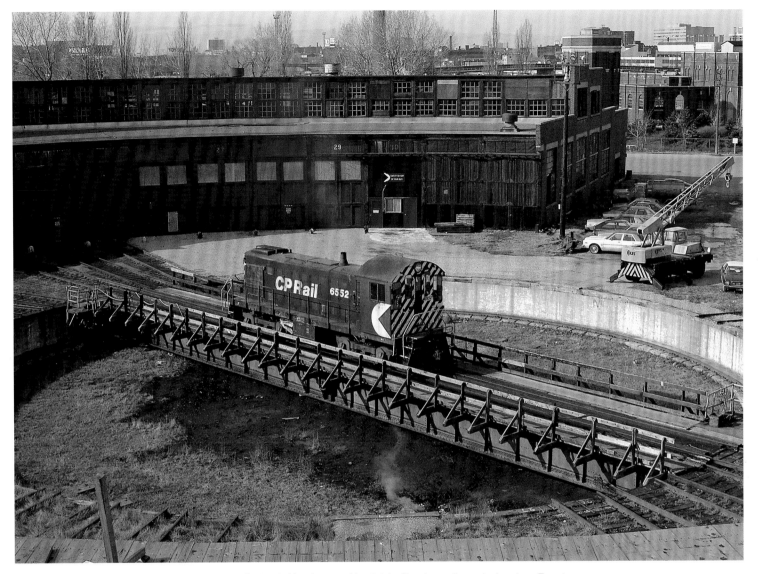

On February 1, 1983, S3 6552 rides the turntable at John Street roundhouse in downtown Toronto,
the last major bastion of 539 power on the CPR. **Greg McDonnell**

In the same dimly lit stalls where CP's only Northerns, K1a's 3100 and 3101, once slumbered while awaiting the call for First 22's overnight run to Montreal, where shopmen once readied Hudsons for *The Dominion* and the *Chicago Express*, and where Jubilees and Pacifics were once serviced for locals to Owen Sound, Hamilton and Windsor, begrimed, coveralled workmen ministered to the infirmities of ancient McIntosh & Seymour prime movers and dealt with the idiosyncracies of electrical systems that dated back to World War II.

In the decades since dieselization, little more than the locomotives had changed at John Street. As the number of CPR passenger trains posted on Union's arrival and departure

boards declined, John Street shifted its energies from servicing power for *The Canadian* and the overnight pool train to New York City, to maintaining S2's and S3's for the "Push" and "Express" jobs, and for Parkdale and Lambton and outlying points.

If anything, time moved backwards when the last Dayliners and F-units assigned to John Street were transferred to VIA and the downtown roundhouse became the near-exclusive domain of 539-powered switchers. In John Street of the 1980s, modernization meant retrofitting a 1944-built S2 with sealed-beam headlights, or exchanging an S2's blunt trucks for roller-bearing-equipped Type A's. Most of the locomotives at John Street were older than the men who worked on them. The dates cast on the iron Alco builders plates of most of John Street's S2's predated the construction of long-gone G5 Pacifics that once called John Street home. "New" power was an S11 with "7-59" stamped on its MLW builder's plate.

Dispatched beyond John Street's red brick walls and weathered wooden doors, the museum pieces assigned to the downtown roundhouse continued to fulfill promises made by Alco and MLW salesmen nearly a half-century earlier. Oblivious to age, untiring S2's dragged heavy yard cuts out of Parkdale and kicked cars at Lambton, while hoggers somehow managed to coax all 660 horsepower from aging S3's and make the most of control-stand plates reading "the maximum permissible operating speed of this unit is 60 miles per hour."

Time finally ran out for John Street and its rag-tag collection of S-series switchers. CP officially closed the roundhouse on August 26, 1986, and retired its last 539-powered locomotive, S3 6593, on October 29 the same year. While CN's adjacent Spadina roundhouse fell under the wrecking ball in May 1986, John Street survives. Part of the roundhouse has been set aside for a proposed railway museum, while the easternmost section has been renovated to house the Steam Whistle Brewery.

Despite the demise of its 244 and 539 power, CP remained one of the last great Alco-MLW strongholds, and 251

exhaust would hang heavy over Canadian Pacific rails for a dozen more years. Well into the 1990s, CP rostered more than 200 Alco-powered, Montreal-built locomotives, all but a handful of which were assigned to the St. Luc diesel shop.

As it had been for the end of steam, and for the final days of first-generation diesels, Montreal was again Mecca. Six-motor "Big Alcos" lugged hot intermodal trains out of Montreal Wharf and up Hochelaga Hill, while solid sets of rebuilt RS18's and C424's worked trains to Newport, Ottawa, Trois Rivieres and Quebec. Relegated to transfer duty, MLW mavericks, former RSD17 demonstrator 8921, Caterpillar-repowered M636 4711 and one-of-a-kind, 4,000-hp M640 4744 (converted to A.C. traction pioneer)

Still good for 660 horsepower and a mile a minute. Control stand, S3 6545, John Street roundhouse, February 1, 1983. **Greg McDonnell**

honoured the legacy of 2-10-0's and Train Masters as they dragged Hochelaga transfers across the Montreal Terminals. St. Luc was Alco heaven. At any given time, shop tracks, service bays and roundhouse stalls were crowded with MLW's of every size and description—RS23's, RS18's, C424's, C630's, M630's and M636's.

If anything could ever come close to the power, drama and excitement of steam's last stand, it was the heroic performance of CP MLW's in their eleventh hour. From RS23's

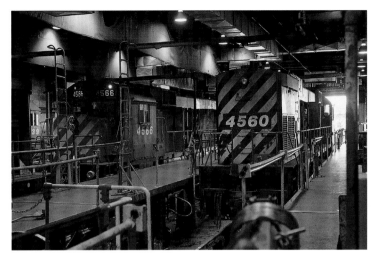

As it had been for the end of steam, and for the final days of first-generation diesels, Montreal was again Mecca. M630's 4560 and 4566 await attention in the diesel shop at St. Luc, Quebec, on July 10, 1991. **Greg McDonnell**

smoking it up with transfers in Saint John and locals out of McAdam, to RS18's slugging up Magowan Hill with hotshot 904; from C424's lugging INCO ore out of Levak and tearing across the Winchester Sub with an "Extra Toronto," to Big Alcos hurtling through the Eastern Townships with Saint John-bound containers and hammering up Campbellville Hill with 7,500 tons of Motown manifest, CP lines east of Thunder Bay were the stage for one of the most spectacular finales in dieseldom.

Most impressive of all were the Big Alcos: the original Montreal-built C630's delivered in maroon-and-grey, M630's built for unit-coal service in British Columbia, and M636's purchased for high-priority Montreal/Toronto–Calgary trains. Swiftly dethroned from their intended roles by SD40-2's, the six-motor MLW's had checkered careers, but their final years were their finest hour.

It was the ultimate sweating of assets. Instead of ending their days in low-grade drag service, the Big Alcos spent most of their final years working intermodals and hotshots out of Montreal, often in solid sets of three, four and even five units. Long overdue for overhauls that would never come, dressed in faded paint and showing the signs of age

and deferred maintenance, they soldiered on, working some of the hottest trains in the East, to Saint John, Binghamton, Toronto, Windsor, Detroit and even Chicago.

CP ran the wheels off the old girls. Deferred maintenance and a spending limit on repairs took its toll. Those locomotives that didn't self-destruct on the road were fueled, watered and patched together at St. Luc, only to be turned right back out again. Atoning for past sins and making up for lost time, they took all the company could throw at them and returned for more.

They were tough, rough, loud, dirty…and unforgettable. Watching a trio of battered Bigs literally explode from the east portal of the Detroit River Tunnel with a hot "boat train" of containers for Montreal Wharf was enough to take your breath away. Riding 400-plus miles in the cab of the third of five M630's and M636's as they made the most of their 75-mph gearing with Montreal–Detroit train 507 was exhilaration defined. However, it was sound that put the Big Alco experience over the top.

Nothing tugged harder at the heart or stirred the soul deeper than the staccato bark of aging Big Alcos on their last legs, marching upgrade in defiance of gravity and all laws of diesel maintenance, or storming triumphantly past at 70-plus, thumbing their noses at the odds-makers and doomsayers as they earned their keep rolling intermodal and manifest tonnage, long past their predicted demise.

The Big Alco era on Canadian Pacific came to an end on August 28, 1995, as M636 4743 arrived at St. Luc at dawn, the trailing unit on train 555-27. Four-motor RS18's and C424's, along with Caterpillar-repowered M636 4711, toughed it out for another three years until CP squeezed the last life from its Alco assets on July 8, 1998. Appropriately enough, the end came at St. Luc, as the Hochelaga transfer arrived with C424's 4216 and 4230 bracketing RS18 1837. Without ceremony or notice, the locomotives were shut down at 0130, and the storied allegiance between CP and MLW came to an end.

Just over two weeks earlier, I had said my own goodbyes as CP's last operating MLW's had made their final road trip

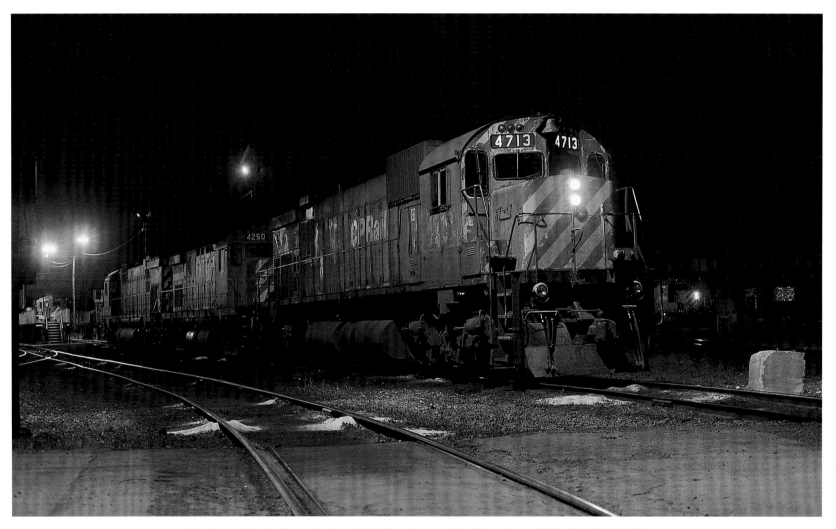

Tough, rough, loud, dirty...and unforgettable. Worse for wear, but still good to go, M636 4713, C424 4250 and M636 4704 stand on the shop track at St. Luc on October 1, 1993, ready to roll No. 509 to Detroit.
Greg McDonnell

on June 21. By special arrangement, St. Luc–Windsor train 923-20 was supplied with the last five operable CP Alcos: C424 4210, RS18's 1838, 1837 and C424's 4216 and 4230. Tradition and matters of the heart demanded that Andrew and I walk down to our crossing to give them a final PK and bid farewell as the old friends worked westward one last time.

Under a beautiful starry sky, we stood and listened as 923 lifted out of the siding at Killean after meeting No. 512 and dug in for the assault on Orrs Lake hill. The rolling thunder of 10,800 Alco 251 horses ripped the midnight stillness as we stood in quiet awe. Minutes later, the headlights swung into view and, in all their four-cycle magnificence, the five Alcos came storming up the hill, sounding, as DPM once said, like a thousand yesterdays.

Sweating the assets never sounded so good.

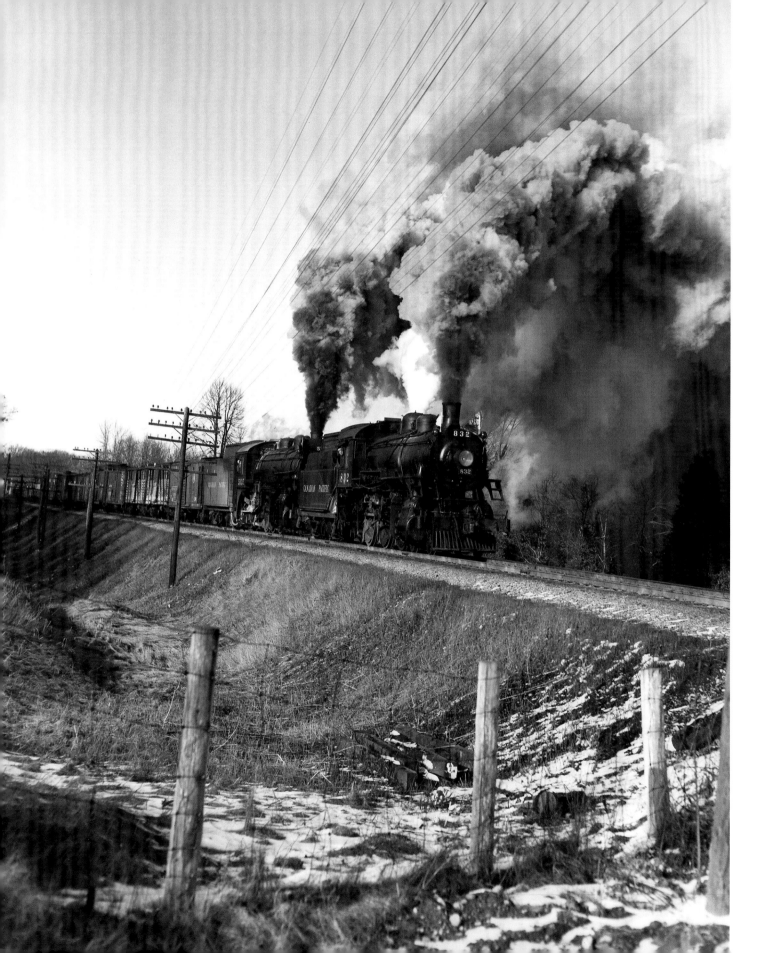

Putting on a spectacular display, D10e 832 and P1e Mikado 5135 trudge up Orrs Lake hill with westbound tonnage on March 9, 1957. Having assisted the train all the way from Lambton Yard in Toronto, the D10, assigned to the famed Cockney pool, will cut off at Orrs Lake and return home. **Jim Shaughnessy**

The days of the Cockney pool and double-headed steam are long gone, but Orrs Lake hill remains an impressive stage. Bearing the scars of decades of service, M630's 4570 and 4569 storm westward on May 12, 1993, with Montreal–Windsor train 923. **Greg McDonnell**

"Fireman's view of ancient engine crossing ancient drawbridge," writes photographer Hastings of this from-the-cab look as 136 rattles across the Canaan River at Washademoak, New Brunswick, with No. 160 on November 3, 1953.
Philip R. Hastings

Heavily rebuilt, but still the same old girl who first emerged from the Paterson, New Jersey, shop of the Rogers Locomotive and Machine Works in August 1883, A2m 4-4-0 136 basks in the attention of her engineer at Chipman, New Brunswick, on November 3, 1953. Her joints lubricated, the old girl will be ready to head back to Norton with mixed train No. 160.
Philip R. Hastings

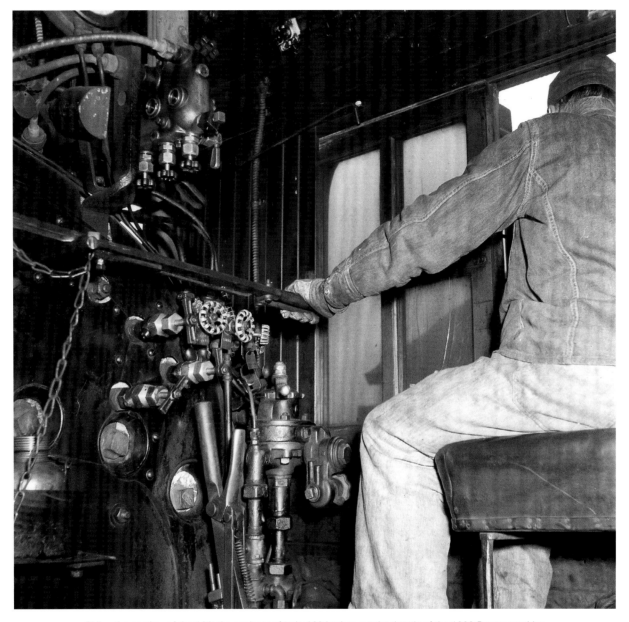

Riding the seatbox of the 136, the engineer of train 160 latches out the throttle of the 1883 Rogers machine
as the mixed returns from Chipman to Norton, New Brunswick, on November 3, 1953. **Philip R. Hastings**

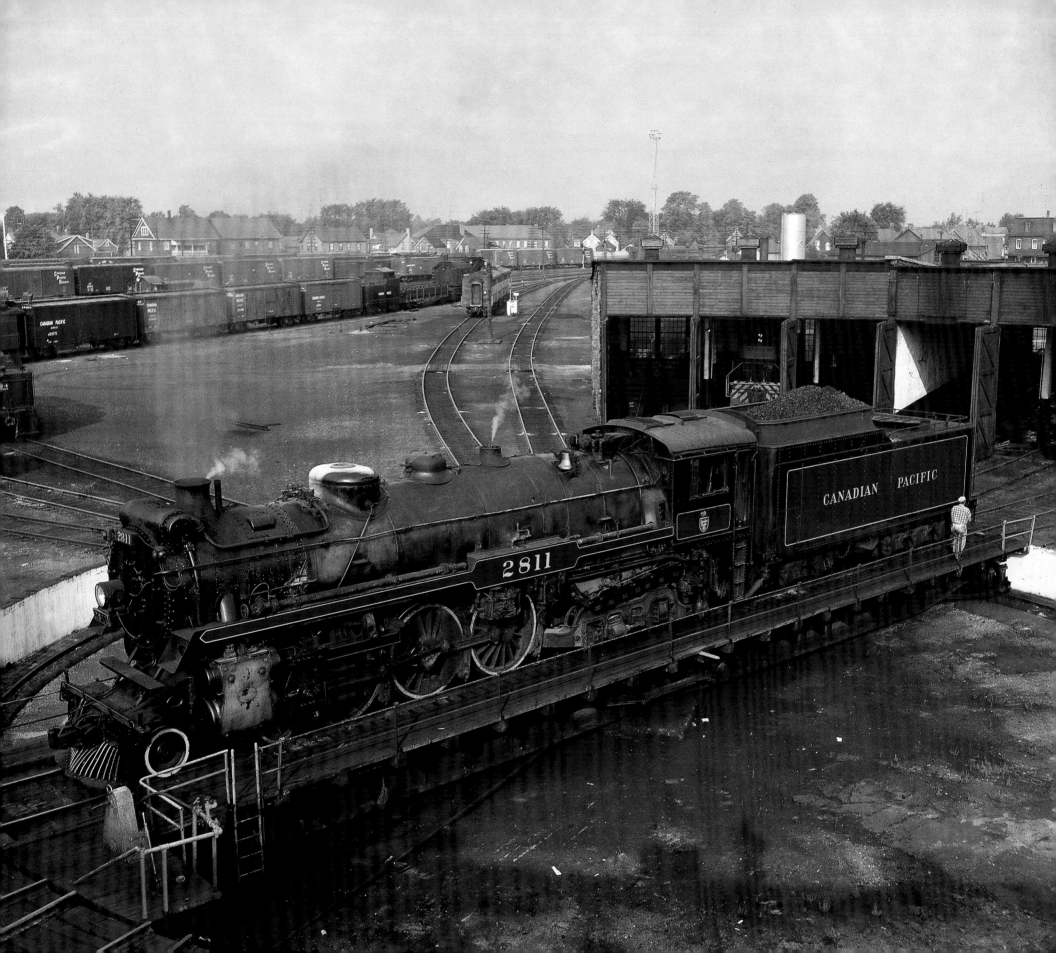

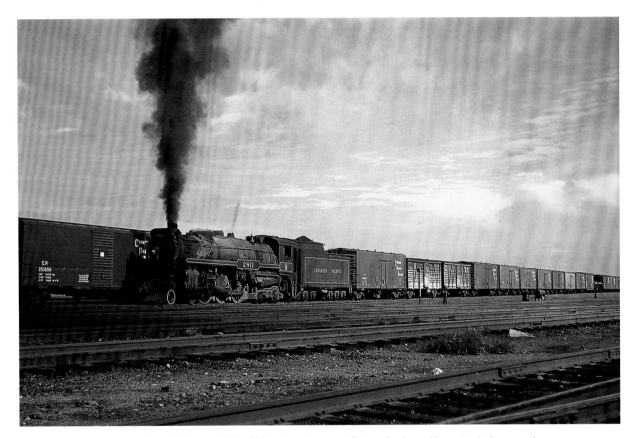

Smiths Falls-bound in August 1959, 2811 gets underway at St. Luc, Quebec, with empty stock cars and reefers tied to her tank. **Paul Meyer**

(Left) From his perch on the roundhouse roof at Smiths Falls, Ontario, photographer Wood captures not only a classic view of H1b 2811 Hudson riding the turntable, but the essence of steam's last stand. Steam is in indeed in its eleventh hour, and the interlopers are everywhere. An A-B set of FA's stands on the ready track, RS18 8766 is in the roundhouse, and an S3—visible just behind the wooden boxcars of the MF Auxiliary outfit—is switching the yard. **Don Wood**

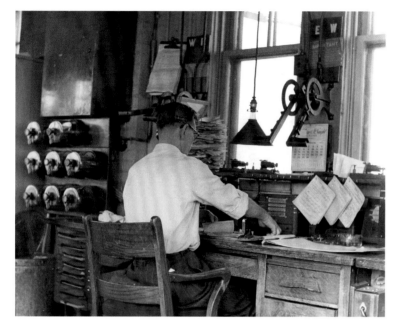

Copy three Ballantyne. Working the tower at the CN/CP diamond at Ballantyne, just west of the CP yard at St. Luc, Quebec, the operator instinctively repeats one of the time-honoured rituals of train-order railroading, inserting the carbons between another set of clearance forms, in November 1955. **Jim Shaughnessy**

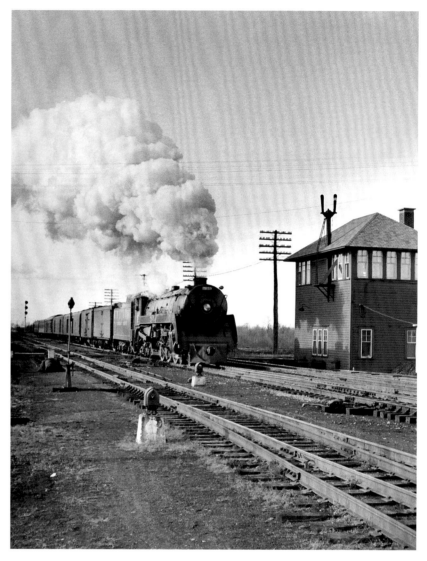

Trailing a pair of express reefers, two baggage cars, an RPO and two coaches, H1d Royal Hudson 2859 hammers the CNR diamond and rattles the windows of the tower at Ballantyne, Quebec, as she hurries Sudbury–Montreal train No. 10 on the home stretch into Windsor Station in November 1955. **Jim Shaughnessy**

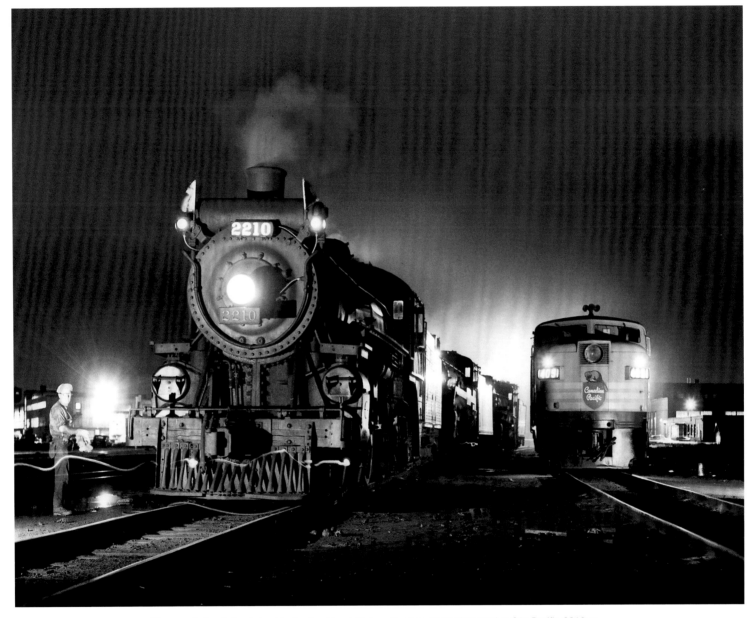

Steam and diesel stand shoulder to shoulder at St. Luc, Quebec, as hostlers tend to G1s Pacific 2210, a G3 Pacific and a Mikado, while FA2 4091 idles on the next track on August 25, 1956. Outshopped from Angus in November 1907, the 2210 will be retired in the summer of 1958, while 4091 will labour on for another two decades. **Jim Shaughnessy**

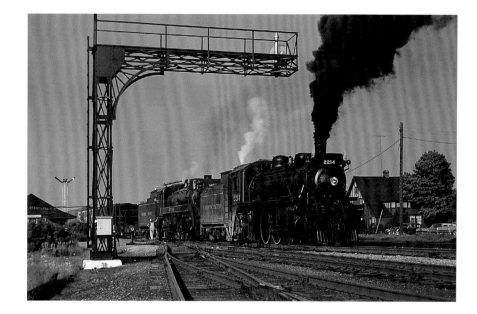

The head-end brakeman on helper G1 2214 chats with the crew of the road engine, semi-streamlined Mike 5406, as the fireman tops up the tank of the P2 at Guelph Jct., Ontario, in June 1959. Moments later, the crews crowd the gangways of both engines as the westbound extra stomps out of GU. The G1 and its Cockney Pool crew will assist the train as far as Orrs Lake. **Paul Meyer**

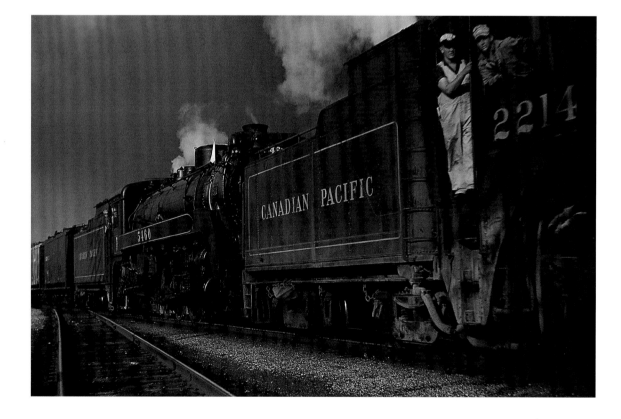

(Right) The fireman on assist engine 832 gives his D10 a drink at Guelph Jct., Ontario, as G1r 2203, flying green flags, and a Mike head west with the first section of a London-bound time freight at dusk on a cold March 1957 day. **Jim Shaughnessy**

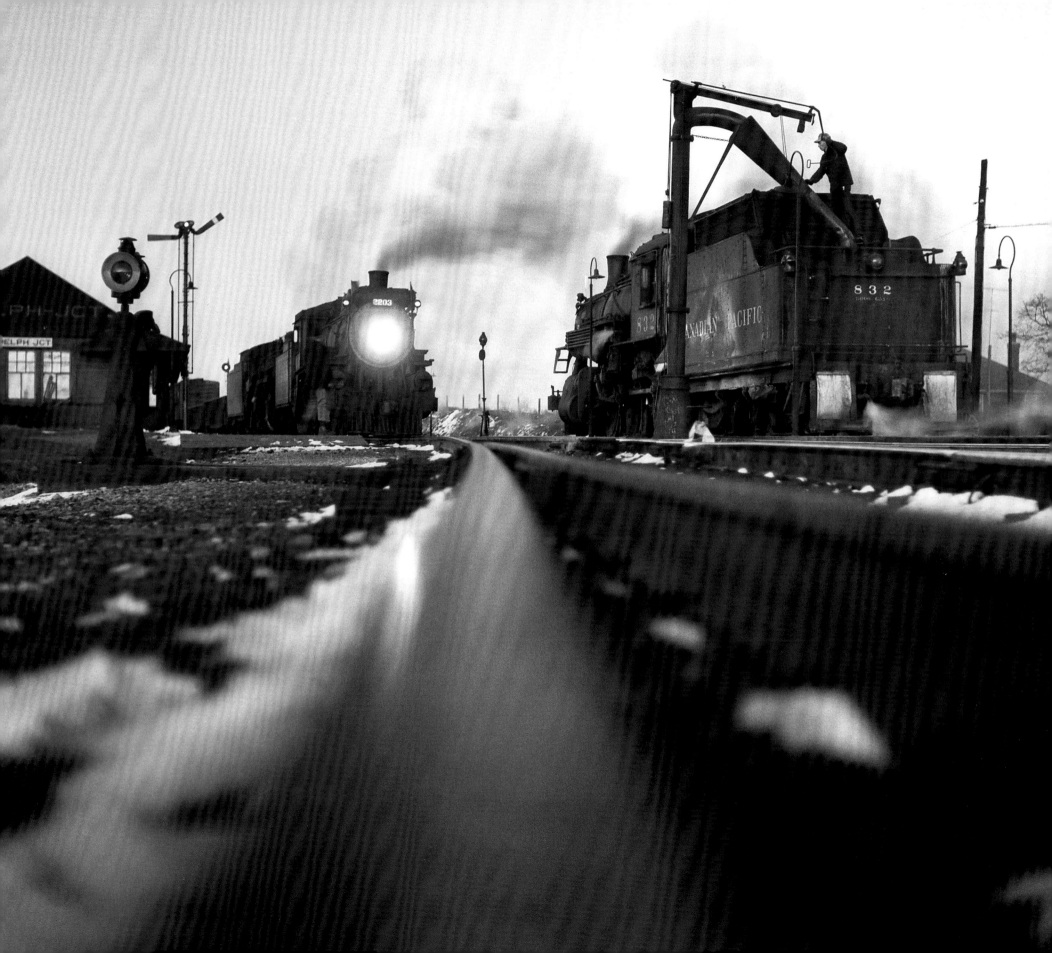

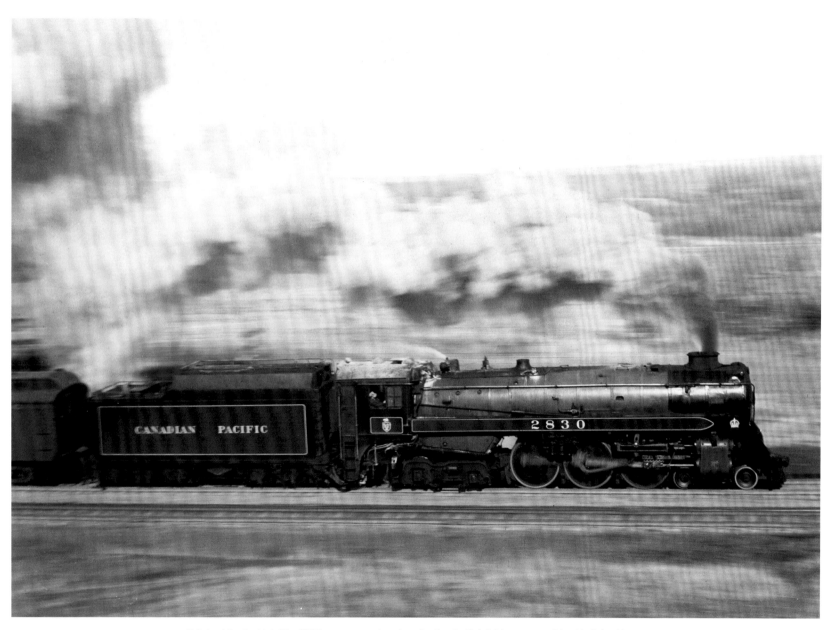

Hell-bent for the Hat, H1c 2830 screams eastward on the Brooks Subdivision, approaching Medicine Hat, Alberta, with eastbound transcontinental local No. 2, the last vestige of the old *Imperial Limited*, in March 1954. **John Barras Walker, David Shaw collection**

Prairie pans. Extra flags stretched taut, bell in the upswing, exhaust laid straight back, oil-burning G3g 2380 races an Extra East between Moose Jaw and Swift Current, Saskatchewan, in 1955. **Robert O. Hale, David Shaw collection**

(Below) Working the same territory, coal-burning P1e Mikado 5128 slices the winter landscape with outside-braced wooden boxcars in tow in 1955. **Robert O. Hale, David Shaw collection**

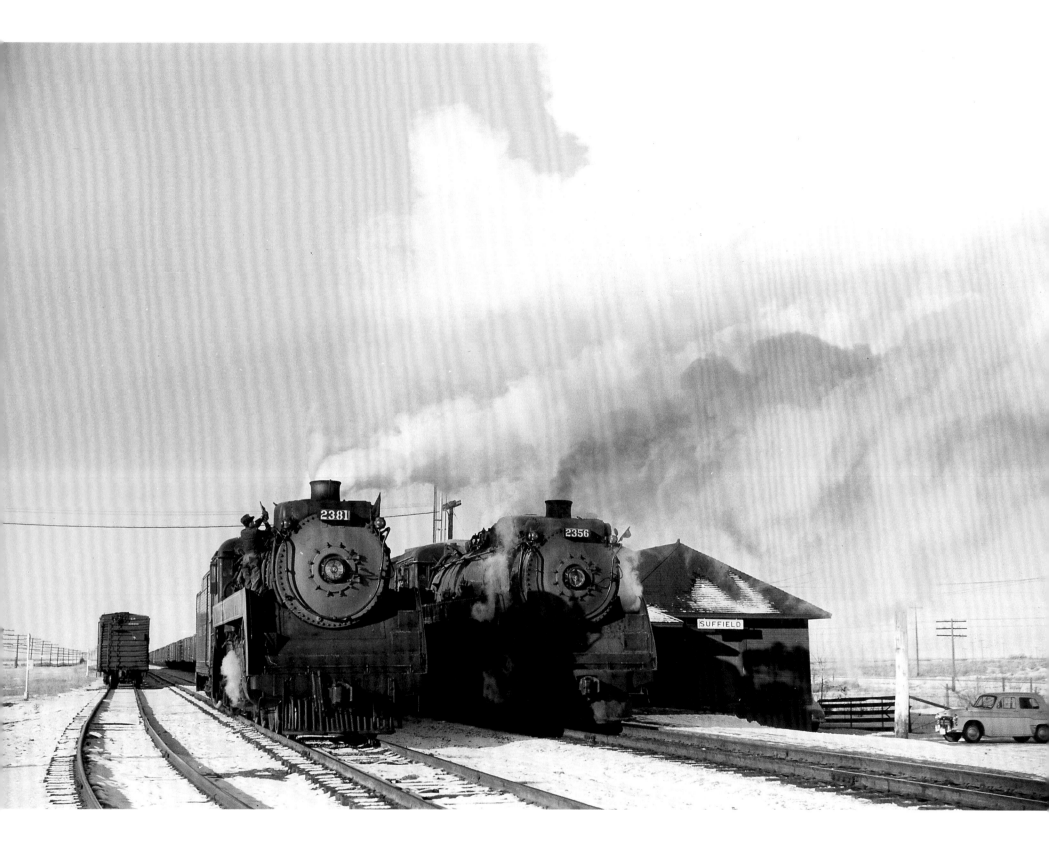

Hosing down the gangway, the hostler at Medicine Hat, Alberta, readies T1b 2-10-4 5921 for the road in August 1953. **John Barras Walker, David Shaw collection**

Less than a decade old, but looking well past her years, T1c 2-10-4 5935 clumps off the turntable at Medicine Hat, Alberta, on August 18, 1956. The last steam locomotive purchased by the CPR, 5935 was delivered in March 1949—the last of six T1c's built by MLW for service in the Rockies. Banished from the mountains by diesels, the six nearly new Selkirks finished their careers working Calgary–Swift Current until their retirement in 1959. While all of the standard T1a or semi–streamlined T1b 2-10-4's were scrapped, two T1c's have been preserved, 5931 at Calgary (where it masqueraded as 5934) and 5935 at the Canadian Railway Museum in Delson, Quebec. **John Barras Walker, David Shaw collection**

(Left) Wearin' the green. Smoke and steam hang heavy in the cold prairie air as G3g Pacific 2381, assigned to helper duty at Suffield, Alberta, gets decked out with green flags on December 23, 1958. Already carrying green, sister G3e 2356 holds the main with an eastbound time freight operating in sections, as indicated by the green flags. The signals displayed by the CLC-built Pacifics are mandated by rule 20 of the Uniform Code of Operating Rules: "All sections except the last will display two green flags and two green lights by day and by night," and by UCOR rule 22: "When two or more engines are coupled, over all or a portion of a subdivision, each engine will display signals as prescribed by rules 20 and 21." The addition of helper engine 2381 to the eastbound train is necessitated not by the rules but by the ruling grade. The change in elevation east of Suffield is steep enough to formally designate the east end of the Brooks Sub as a helper grade. Indeed, between Calgary and Suffield, the eastbound tonnage rating for a single G3 was listed as 3,500 tons; east of Suffield, the same G3 was good for just 1,800 tons. Once 2381 is coupled onto the head end of the train, the Kingston-built pair will put on a spectacular display as they take on Bowell hill on a brisk morning two days before Christmas. **John Barras Walker, David Shaw collection**

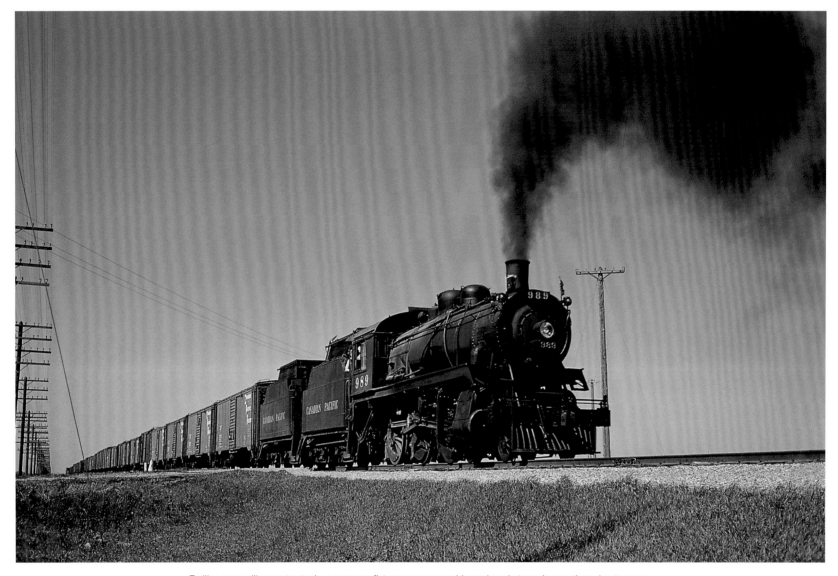

Trailing an auxiliary water tank, a common fixture on many prairie-assigned steam locomotives due to poor water supplies, D10h 989 makes her way east of Portage la Prairie, Manitoba, with the wayfreight from Brandon on May 9, 1959. **Ruth E. Hillis**

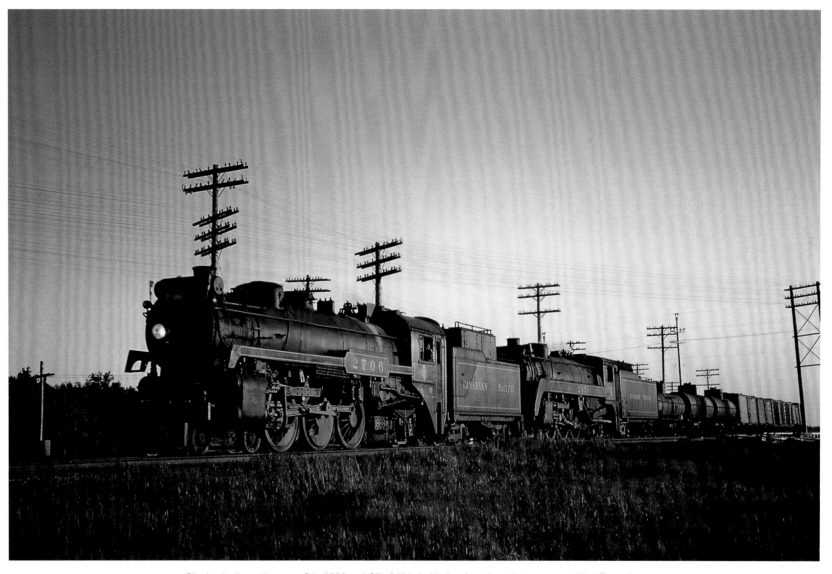

Glowing in the setting sun, G4a 2706 and G3h 2451 double-head eastbound tonnage past West Tower in Portage la Prairie, Manitoba, on June 7, 1959. Built at Angus in February 1920, 2706 was one of 22 steam locomotives assigned to general freight service in the Manitoba District Pool out of Winnipeg as of May 15, 1959. A passenger engine according to the same assignment sheet, 2451, outshopped from CLC Kingston in February 1945, has apparently been bumped from her duties on Nos. 43 and 44 to chain gang freight service. **Ruth E. Hillis**

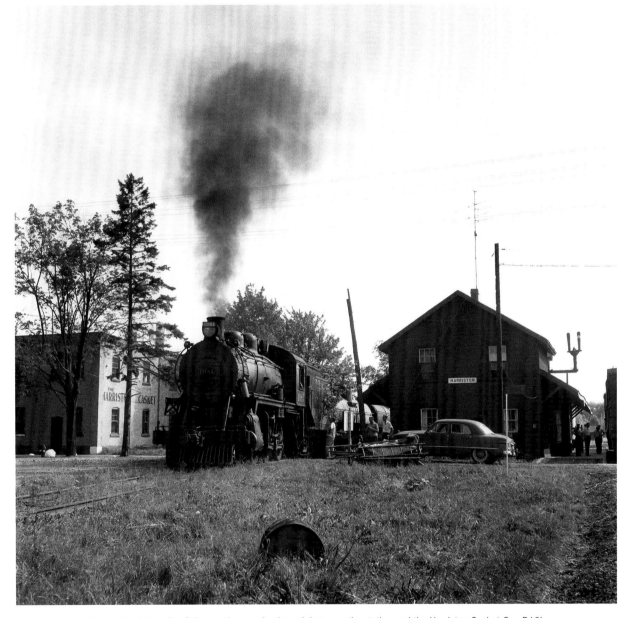

Probing the light rails of the weed-grown back track between the station and the Harriston Casket Co., D10k 1081 switches at Harriston, Ontario, while working the Teeswater mixed, No. 753, on August 2, 1957.
Jim Shaughnessy

Working on hand signals and instinct, the crew of No. 753 switches at Harriston, Ontario, on August 2, 1957.
Jim Shaughnessy

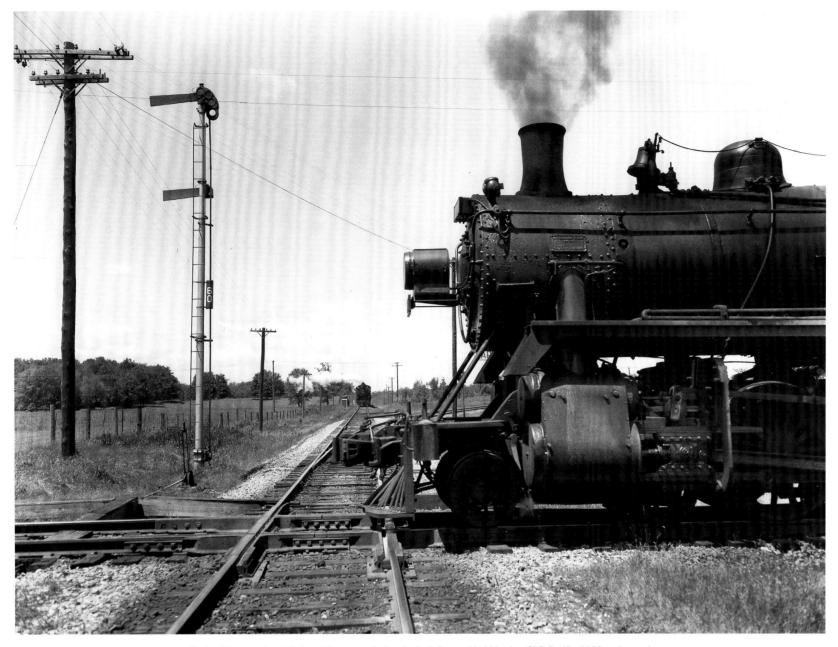

Horizontal semaphore blades at the manually interlocked diamond hold back a CNR Pacific 5563 and a work train as D10h 1004 crosses the Owen Sound Subdivision at Harriston, Ontario, with mixed train No. 753 on July 24, 1957. **Don Wood**

(Right) Summer memories. Three boys and a small girl take in the action on the platform at Sharbot Lake, Ontario, on the 1958 Labour Day weekend. The order board is set and the baggage cart piled high with bags of mail as D10e 840, working the Renfrew mixed, pauses at the standpipe. The sweat line on the Ten-Wheeler's tank marks the water level as the fireman swings the plug into position to replenish the 5,000-gallon tender. **Don Wood**

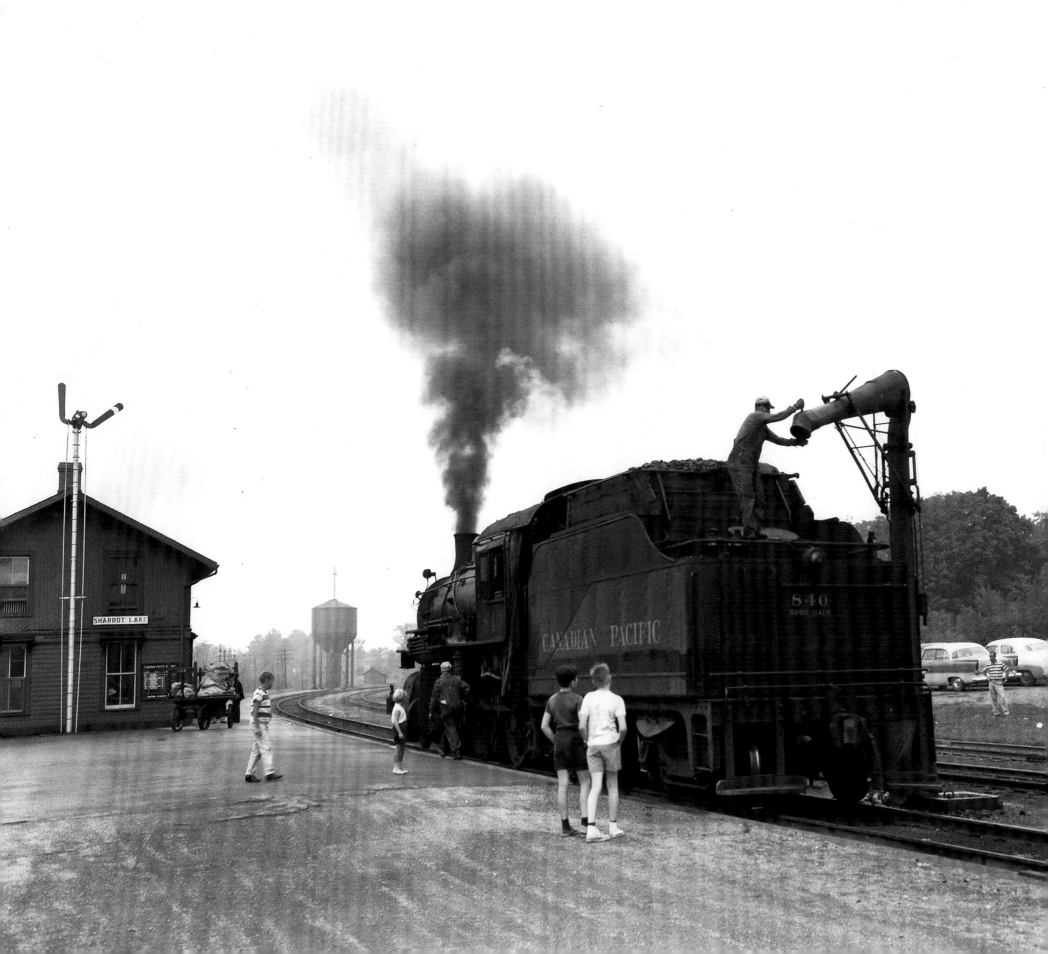

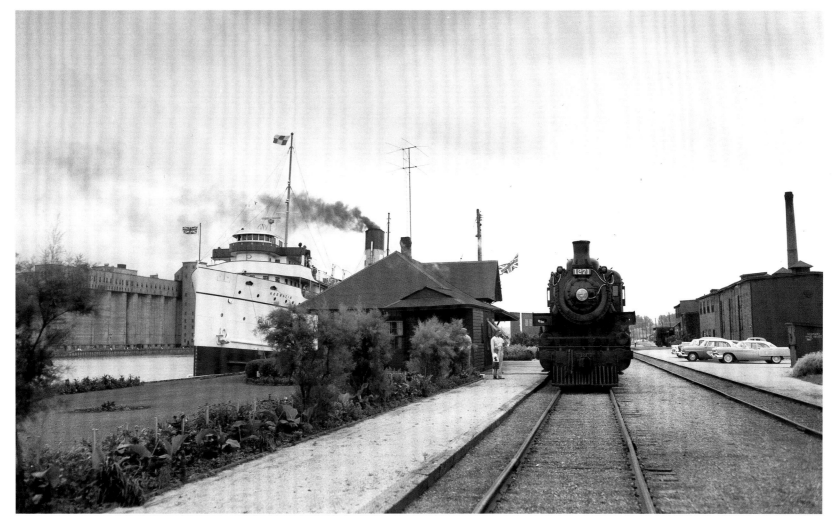

Boat Train. Making a time-honoured across-the-platform connection at the Georgian Bay port of Port McNicoll, Ontario, the Boat Train from Toronto, led by G5c 1271, meets CP Great Lakes steamship *Keewatin* from Port Arthur/Fort William in July 1957.

CP's Georgian Bay-Lakehead, Great Lakes steamship service was established in May 1884 when Scottish-built ships *Algoma*, *Athabaska* and *Alberta* began scheduled sailings between Owen Sound and Port Arthur/Fort William. *Algoma* was lost in Superior's legendary gales of November, hitting the rocks at Isle Royale in raging snowstorm on November 7, 1885, the same day that the last spike was driven at Craigellachie. Fire destroyed the CPR elevators at Owen Sound in December 1911, prompting CP to relocate the service to Port McNicoll in the spring of 1912.

Built by Fairfield Shipbuilding & Engineering in Govan, Scotland, in 1908, *Keewatin* and sister ship *Assiniboia* worked CP's Great Lakes Steamship service between Port McNicoll and Port Arthur/Fort William until its discontinuance in November 1965. *Assiniboia* was later destroyed by fire, while *Keewatin* has been preserved as a museum exhibit in Douglas, Michigan. **Don Wood**

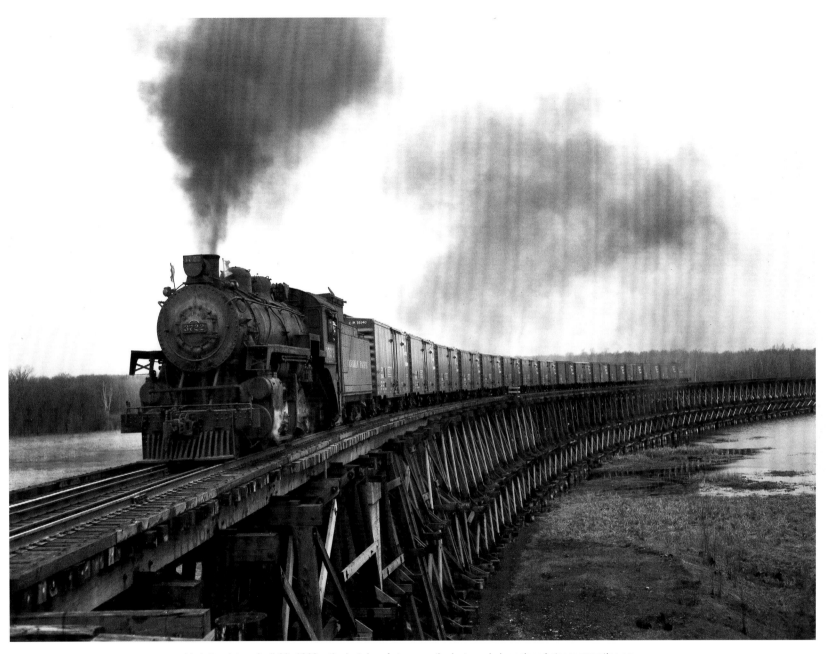

Mark the date—April 30, 1960—the last day of steam on the last regularly assigned steam operation on the CPR in Ontario. Adhering to the permanent 5-mph slow order on the famed Hog Bay trestle, high-head-lighted N2b Consolidation 3722 walks across the 2,141-foot timber trestle at Port McNicoll on her final assignment. Tomorrow belongs to the diesel. **Don Wood**

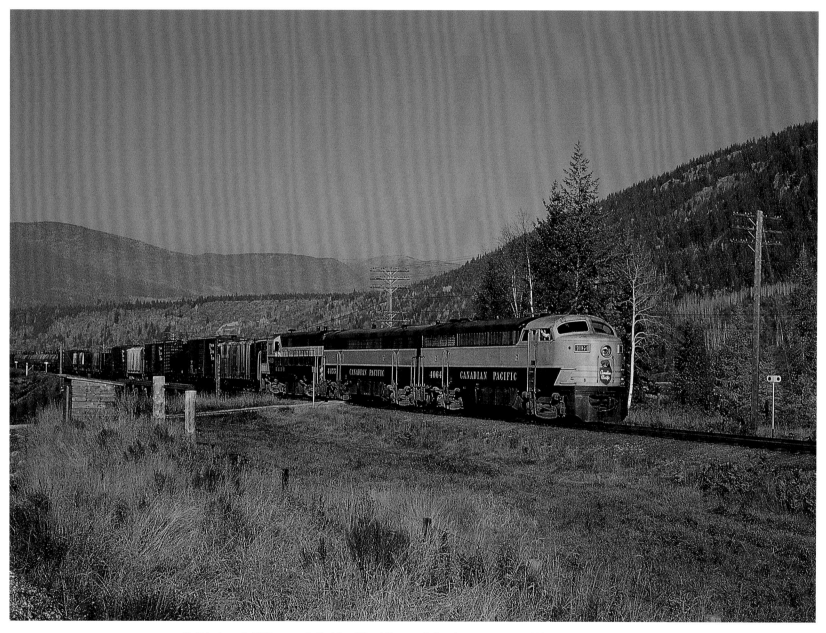

Built in August 1951 as one half of the *City of Kingston* C-line demonstrator set, CPA16-4 4064 heads No. 87 west of Nelson, British Columbia, bound for Tadanac with CFB16-4 4455 and H16-44 8603 on October 20, 1964. Numbered 7005 and 7006, the CPA16-4 demonstrators were purchased by CP in December 1951, becoming Canadian Pacific 4064 and 4065. Damaged by fire in July 1969, 4064 languished out of service at Ogden Shops until being retired in 1972 and scrapped. **James A. Brown**

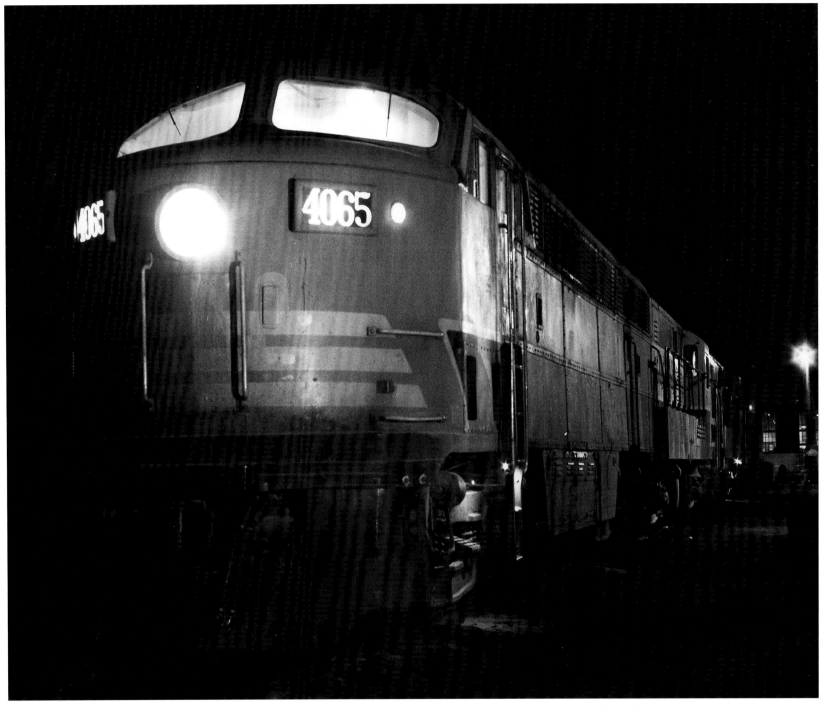

The Holy Grail. The sole survivor of the *City of Kingston* demonstrator set, CPA16-4 4065 idles at Cranbrook,
British Columbia, with H16-44's 8710 and 8721, awaiting a 0200 call to work westbound time freight 979.
Retired on June 20, 1975, 4065 was saved as part of CP's historic diesel collection and now resides at
the National Museum of Science and Technology in Ottawa. The only other C-line in existence, sister
CPA16-4 4104, was purchased privately and has been restored at Ogden Shops in Calgary. **Greg McDonnell**

Modified to short-hood-forward configuration, and repainted accordingly, 8919 eases down the Don Branch at Leaside, Ontario, with a Toronto transfer on December 6, 1964. Just over a decade old, 8919 was out of service by 1967 and among the first CP Train Masters to leave the roster. Retired on May 27, 1968, she and sisters 8906, 8911, 8913, 8914 and 8915 were sold to Streigel Supply in Baltimore, Maryland, and scrapped for parts. **James A. Brown**

(Below) Workers at the Canadian Locomotive Company plant in Kingston, Ontario, clamber about H24-66 8919, making predelivery adjustments to the just-out-shopped Train Master on October 27, 1956. With shop serial 2940 stamped on her diamond-shaped CLC plate, 8919 will be delivered to CP along with sisters 8918 and 8920 on October 31. Painted and configured for long-hood-forward operation on their delivery, CP's Train Masters were modified for short-hood-forward operation in the early 1960s to improve visibility. **Robert Sandusky**

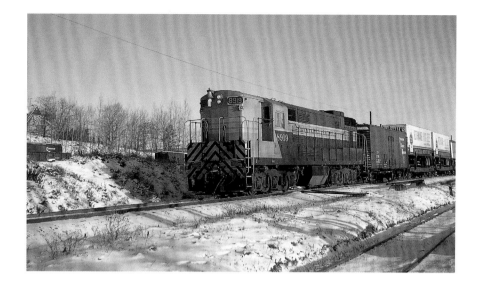

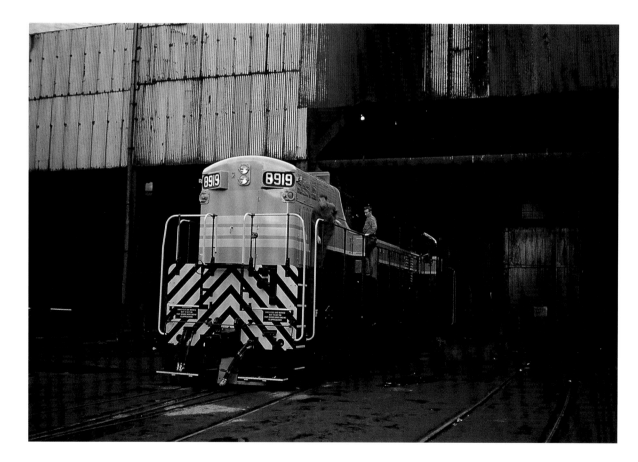

(Right) With brake shoe smoke enveloping her short train, H24-66 8904 passes ancient work equipment as she works at Trail, British Columbia, on June 16, 1973. The trio of Trail-assigned Train Masters regularly tackled storied Warfield Hill, once the domain of CP's little-remarked trio of three-truck Lima Shays. Filthy and corroded from years of labour in the shadow of the smelters, the big TM's nevertheless put on some of the most memorable performances in dieseldom as they stormed the legendary hill in all their opposed-piston glory. Ephraim Shay himself would have been impressed. **James A. Brown**

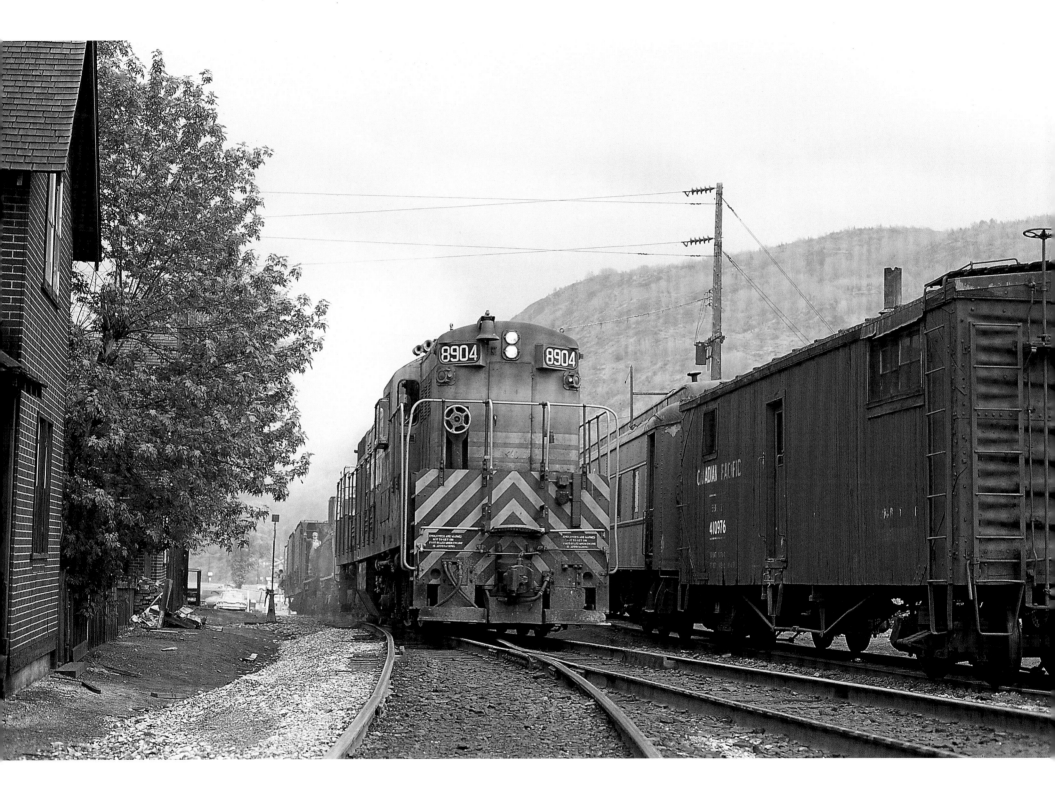

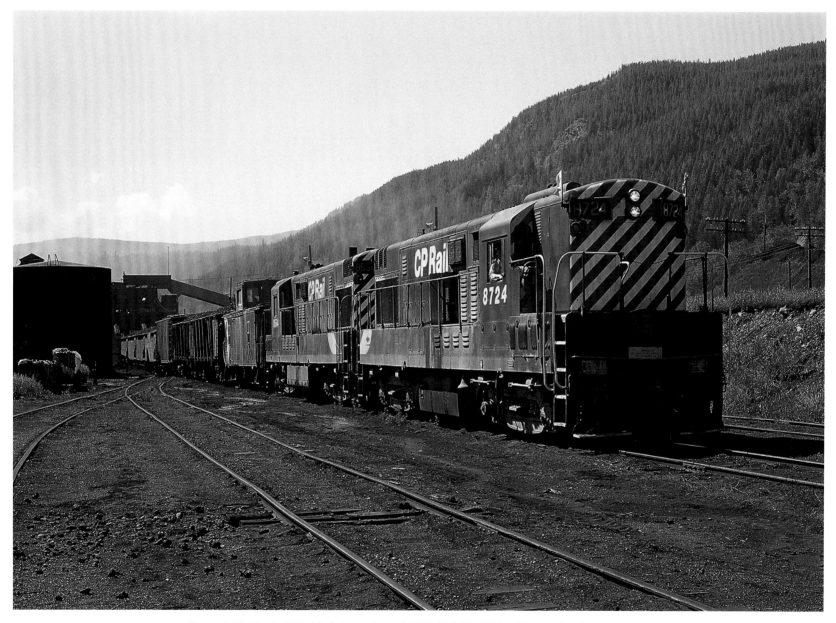

Dirty work. Working the Michel Switcher on June 21, 1974, H16-44's 8724 and 8554 switch the ramshackle colliery at Michel, British Columbia. Bath tub hoppers and unit trains; Michel coal is loaded in battered 348-series high-side gons and beat-up triple hoppers. The Michel mine, the hoppers and the 8724 are gone, but 8554 was spared the torch by CP's historic diesel collection and awaits restoration in Calgary.
Greg McDonnell

Nirvana. The small diesel shop at Nelson, British Columbia, was home to most of CP's Fairbanks-Morse design CLC diesels for more than two decades. Surrounded by spare wheel sets and traction motors, H16-44 8602 and CPA16-4 4104 await attention on June 24, 1974. **Greg McDonnell**

Ready to lead No. 90 east to Cranbrook, H16-44 8724 gets a quick bath on the shop track at Nelson, British Columbia, on June 25, 1974. **Greg McDonnell**

Diesel Dispatch board, Nelson, British Columbia, June 25, 1974. **Greg McDonnell**

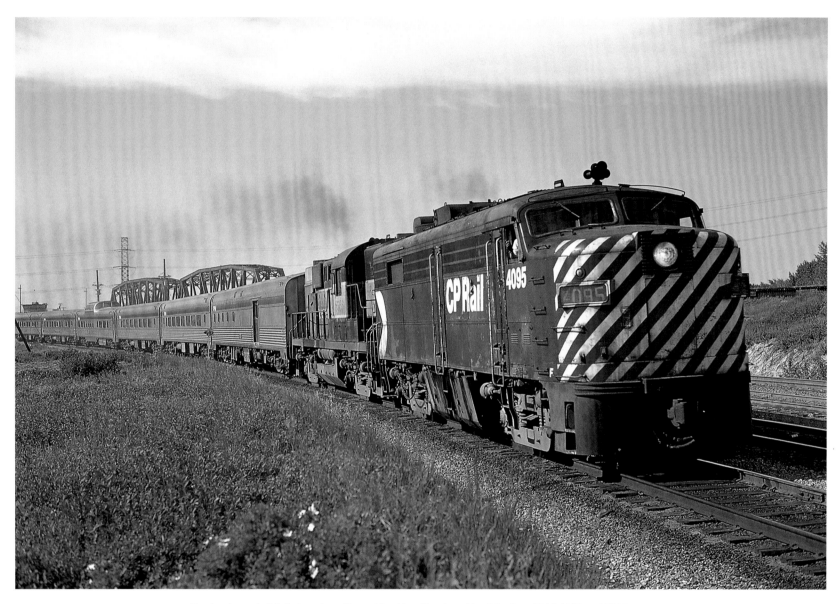

Nearing the end of their days, but still capable of handling the pride of the fleet, FPA2 4095 and RS10 8566 exit Calgary, Alberta, with train No. 2, the eastbound *Canadian*, on June 19, 1974. While FPA's regularly worked Nos. 11 and 12, the Sudbury–Toronto section of *The Canadian*, they rarely worked through to western Canada. **Greg McDonnell**

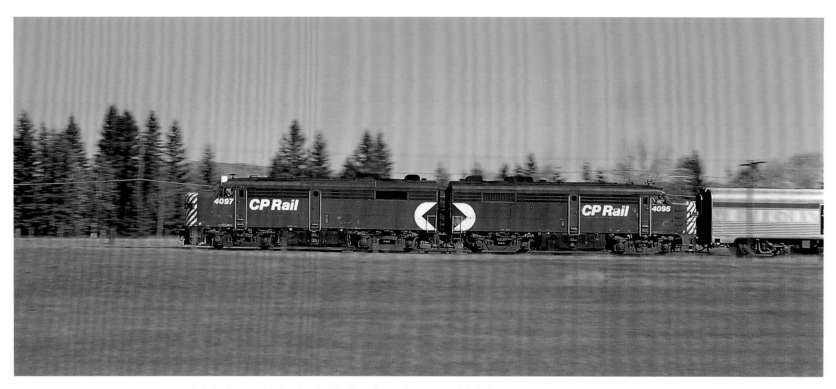

Ask the fireman, it's hot. Inspired by the unforgettable pairing of J. Parker Lamb's remarkable pan of GM&O FA1 718 and David P. Morgan's inimitable prose, Stan Smaill captures FPA2's 4097 and 4095 accelerating northward on the Ste. Agathe Sub near Morrison, Quebec, with a Montreal–Mount Laurier excursion on October 1, 1973. **Stan J. Smaill**

There are few things in railroading more compelling than watching a matched set of FA's battling upgrade with A-rating hung on their drawbars, the loadmeter needle buried in the red zone, alarm bells clanging in the cab, 244's bellowing behind the electrical cabinet wall and progress measured in feet per minute, not miles per hour.
Engine room, FPA2 4095, April 2, 1975. **Greg McDonnell**

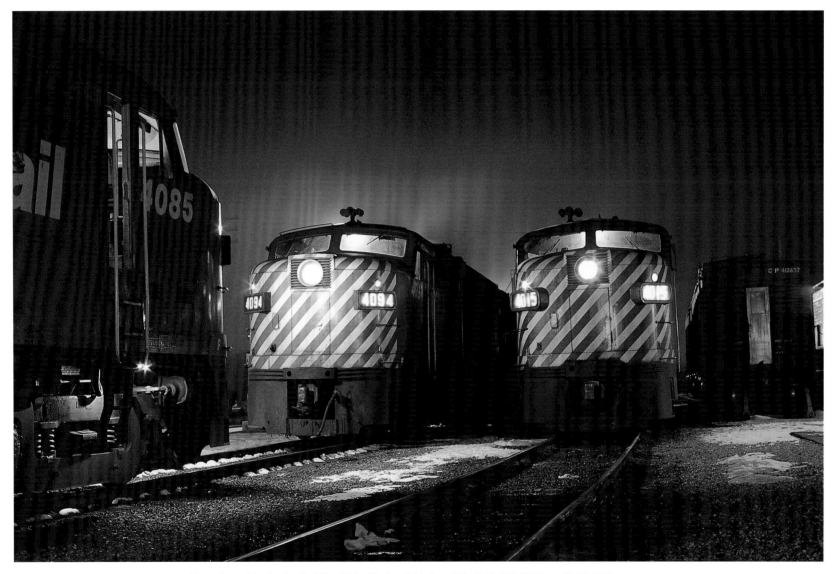

The pulse-quickening beat of Alco 244's fills the night air as FA1 4015, FA2 4085 and FPA2 4094
face off on the shop tracks at the Quebec Street roundhouse in London, Ontario, on March 15, 1975.
Greg McDonnell

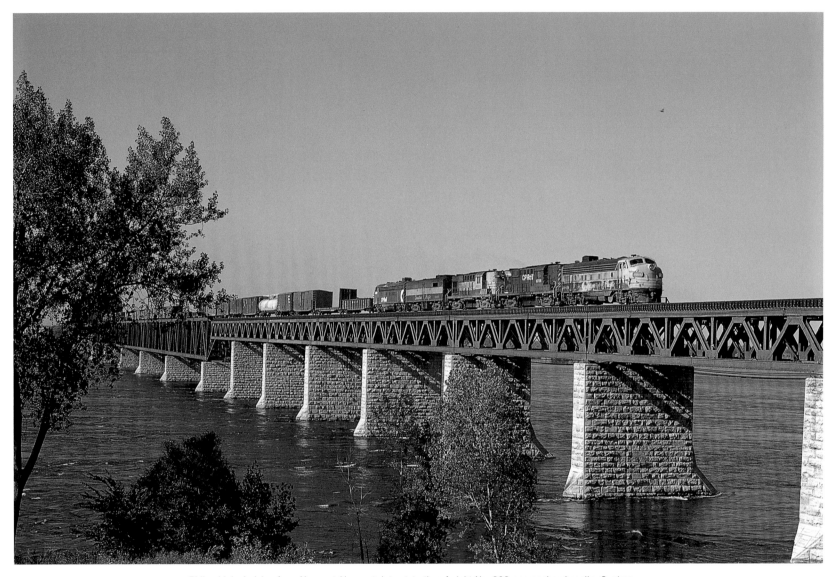

Riding high. Arriving from Newport, Vermont, interstate time freight No. 903 approaches Lasalle, Quebec, on the massive St. Lawrence River bridge with venerable dual-service FP7 4066 leading RS18's 8735, 8768, FB2 4469 and another FP7 in typical early Seventies dog's breakfast lash-up in June 1973.
Stan J. Smaill

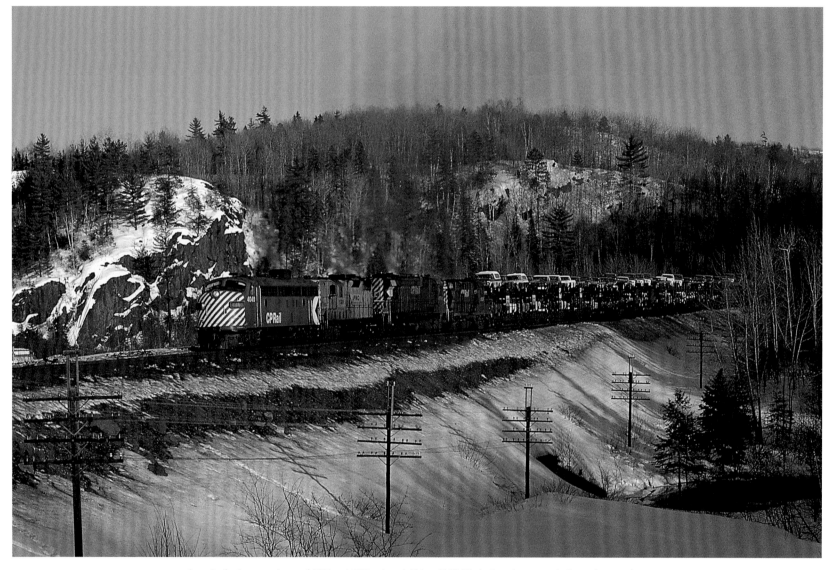

In a deafening symphony of 567 and 251 exhaust, Extra 4040 West struggles upgrade through rugged Canadian Shield terrain at Levack, Ontario, with FP7 4040, leased PNC GP9 130 (still in the colours of former owner QNS&L), M640 4744 and RS18 8739 on February 21, 1975. On the head end of the train are open bilevel autoracks loaded with Oakville-built Ford trucks destined for western Canada. **Greg McDonnell**

Highlighting the meticulous care afforded the Vermont-assigned RS2's, class-engine 8400, working the local from Newport, glistens in the autumn sun as road-weary RS3 8459—dressed in faded Tuscan and grey—switches at Richford, Vermont, on October 9, 1974. **Greg McDonnell**

Sweating the assets. Bumped from road service, but still capable of producing tractive effort and ton-miles, more than half of CP's 36 RS3's were granted a brief reprieve from the torch. Chop-nosed but otherwise unaltered, they replaced even older S2's and S3's in yard and hump duty in Montreal and Winnipeg. Doing their best to emulate the 2-10-0's, 0-8-0's and Train Masters that once trod the same rails, RS3's 8449 and 8439 put on an impressive display as they switch at Hochelaga in east-end Montreal on June 14, 1982. Purists can complain all they like about the dirt and chopped noses, but the throaty roar of 244's in 8th notch and the dramatic performance of never-say-die Alcos is enough for the faithful. **Greg McDonnell**

End of the line. Raindrops drip from the steam-style number board of RS3 8452, languishing on the scrap line at St. Luc, Quebec, on October 8, 1983.
Greg McDonnell

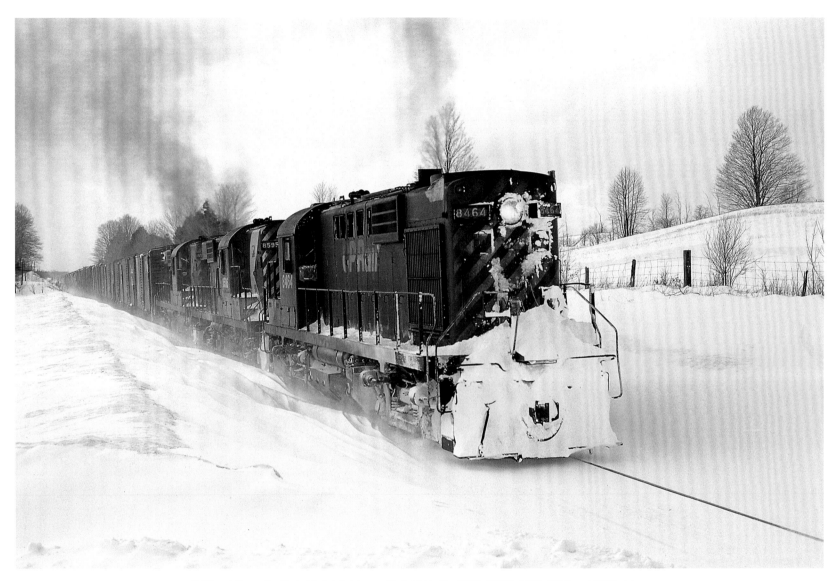

Battling drifts on the Goderich Subdivision on St. Patrick's Day 1976, RS10's 8464, 8595 and 8586 slog through the snow near Auburn, Ontario, with a heavy train of Saint John-bound grain and Goderich-mined salt. **Greg McDonnell**

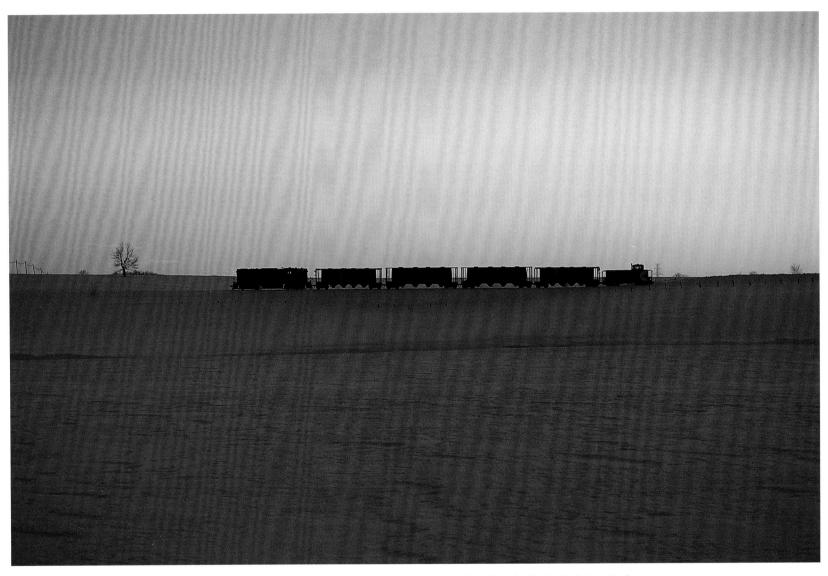

Slipping across the frozen landscape at sunset, RS10 8579 trundles along the St. Mary's Sub north of
Embro, Ontario, returning from St. Marys to Woodstock with four loads of cement and a steel van at 1826,
March 8, 1978. **Greg McDonnell**

Idling beneath the full moon, S2 7021 slumbers at Parkdale Yard in Toronto, Ontario, on December 1, 1982. **Greg McDonnell**

In the print. Still dressed in Tuscan and grey paint and original pre-script lettering, sequentially numbered S3's 6538 and 6539 switch at Lambton Yard in Toronto's west end on January 12, 1981. Both locomotives were retired in 1983, having never received CP Rail lettering or action-red paint. While 6538 went to scrap in 1986, 6539 was sold to Kimberly-Clark for use at Terrace Bay, Ontario. Upon its retirement there, the locomotive was restored and placed on display in the Northern Ontario division point town of Schreiber.
Greg McDonnell

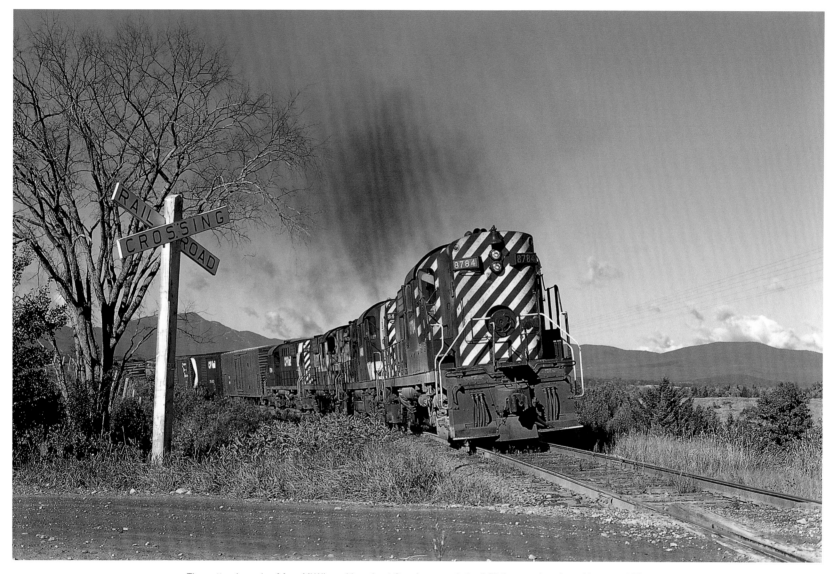

The guttural vocals of four MLW's making about 8 mph on sanded rail fill the morning air on Magowan Hill on the Newport Sub as RS18 8784, RS10 8480 and two more RS18's approach Magowan, Vermont, with train No. 904 in August 1973. One of the hottest trains on the CPR for generations, 904 originated in Windsor, Ontario, and handled New England manifest freight bound for Boston & Maine Connecticut River Line connections. **Stan J. Smaill**

Angus rebuild plate, CP 1814, formerly 8767, Woodstock, Ontario, September 17, 1984. **Greg McDonnell**

Following in the footsteps of the fabled Vermont lines RS2's, rebuilt RS18's 1801 and 1826 bring a wayfreight into the weed-grown yard at St. Johnsbury, Vermont, on August 23, 1994. **Steve Glischinski**

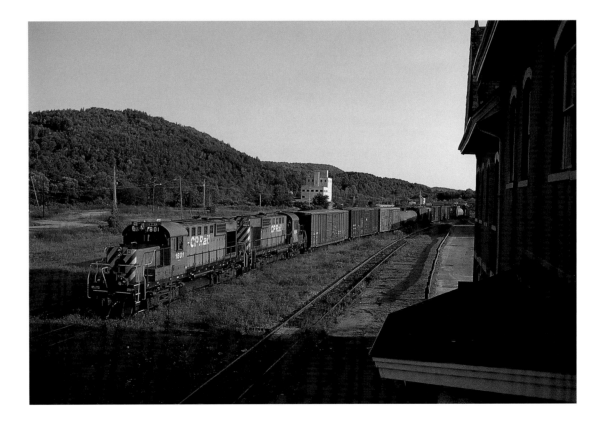

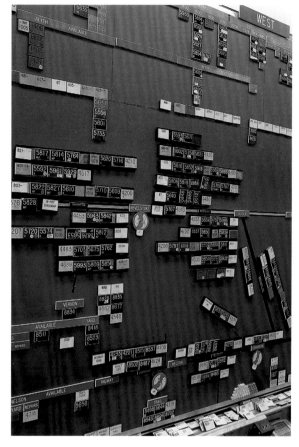

West board, Room 115, Windsor Station, Montreal, Quebec, 1200 MDT, December 17, 1982. **Greg McDonnell**

Fielding phone calls and studying a wall-to-wall system map blanketed with a brilliant mosaic of magnetic tags etched with numbers and codes, Bruce Chapman sits at his desk in Room 115 in Windsor Station, Montreal, and does what he does best: sweats the assets. At 1835 local time—1635 Mountain Daylight Time—on May 30, 1994, Chapman is working the "West board" in the Power Bureau; planning, assigning and tracking the movements of every locomotive, caboose, train and yard assignment on the CPR between Swift Current, Saskatchewan, and end of steel on the Esquimalt & Nanaimo. At the adjacent East and Central desks, his co-workers handle the rest of the system.

In an office resembling the great war rooms of World War II, each magnetic tag—colour coded and marked to indicate home shop assignment, equipment and mechanical features—represents a train, locomotive or van. Like generals and strategists, Chapman and his compatriots plot and wage battles, but theirs are of a different kind, as they do their best to keep the trains and tonnage of the CPR on the move.

Nelson is short of power; 808 has two engines down on the Shuswap; the power for outbound 902 is stuck behind a work block on an inbound Extra West.... The Power Bureau boys take it all in stride.

The Power Bureau and its functions have since moved west to the NMC in Calgary, and Chapman retired on November 1, 2001, with 39 years of company service. The torch has been passed and the battles wage on.
A. Ross Harrison

More than just magnets on a map. The dramas plotted on the big board in Room 115 at Windsor Station, play out on the road. At 1825 Eastern Daylight Time, May 30, 1994—at the same moment as Ross Harrison sets up his Pentax 67 to record images of Chapman at work, there is trouble on the East board with the magnets marked 923, 5737 and 5400. No. 923's lead unit has died.

Spooked perhaps by memories of a crossing accident that put her in the swamp there on her first trip, SD40-2 5737 shut down coming through Puslinch, Ontario. Struggling out of the sag at Mileage 50.6 on the Galt Sub, No. 923 approaches Killean at an excruciating 6 mph. On her knees, trailing SD40 5400 is working all out to shoulder the tonnage assigned to two locomotives. The ill-fated train will pull into the siding at Killean and attempt to resuscitate 5737 while Montreal–Chicago intermodal 503 rolls past. Just another day on the railroad. **Greg McDonnell**

At the west end of his Saturday morning track patrol, roadmaster Dan Doyle's motorcar sits in the clear as Extra 4203 West, the London Pickup, pulls into Galt, Ontario, at 1030, February 1, 1986. Nearly 21 years after Jim Brown encountered her in factory-fresh Tuscan and grey at Agincourt, 4203 continues to rack up the miles in mainline service, just as the MLW man promised. **Greg McDonnell**

Less than two months old, C424 4203—delivered from MLW on March 31, 1965—leads an RS3 and GP7 on a westbound freight departing Toronto Yard in Agincourt, Ontario, on June 12, 1965. **James A. Brown**

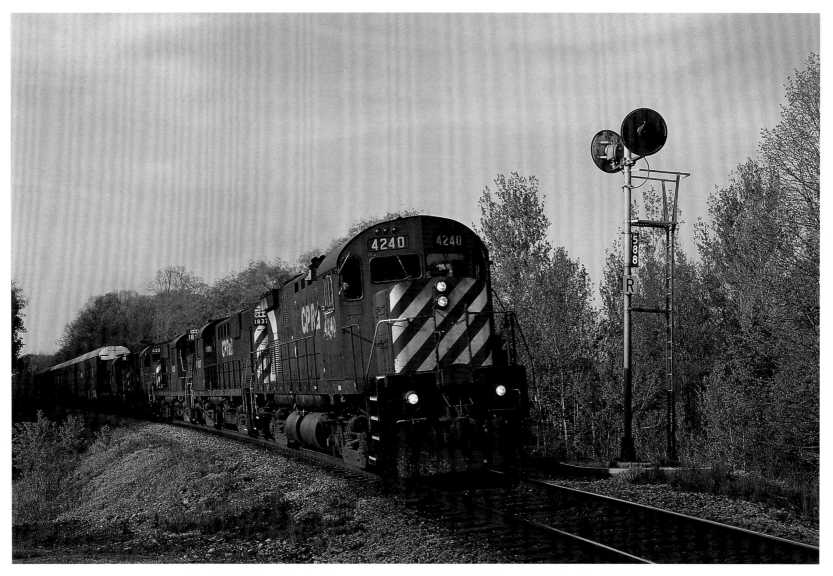

Foreshadowing the end, just weeks away, MLW's 4240, 1837, 1839, 4204 and 1822 storm Orrs Lake hill west of Galt, Ontario, with train 923-04 at 1805, May 4, 1998. On June 21, 1998, Orrs Lake hill echoed the exhaust of labouring Alco 251's for the last time as 923-20 worked west in the charge of C424 4210, RS18's 1838, 1837 and C424's 4216 and 4230—the last five operable CP MLW's on their last mainline trip. **Greg McDonnell**

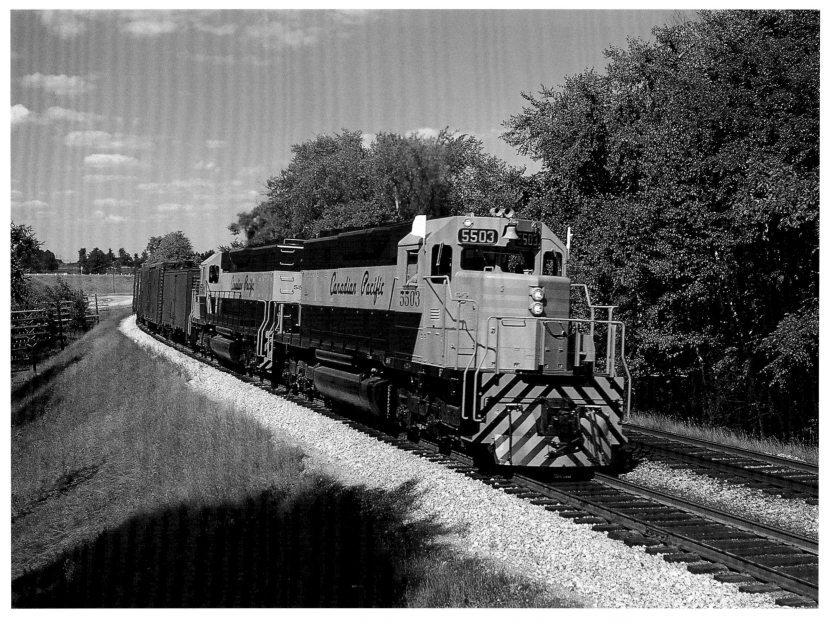

Few assets have presented CP with a better return on their investment than the railway's fleets of SD40's and SD40-2's. Just five days old, SD40's 5503 and 5502 gleam in the afternoon sun as they work a west-bound manifest up Campbellville hill, approaching Campbellville, Ontario, on July 30, 1966.
James A. Brown

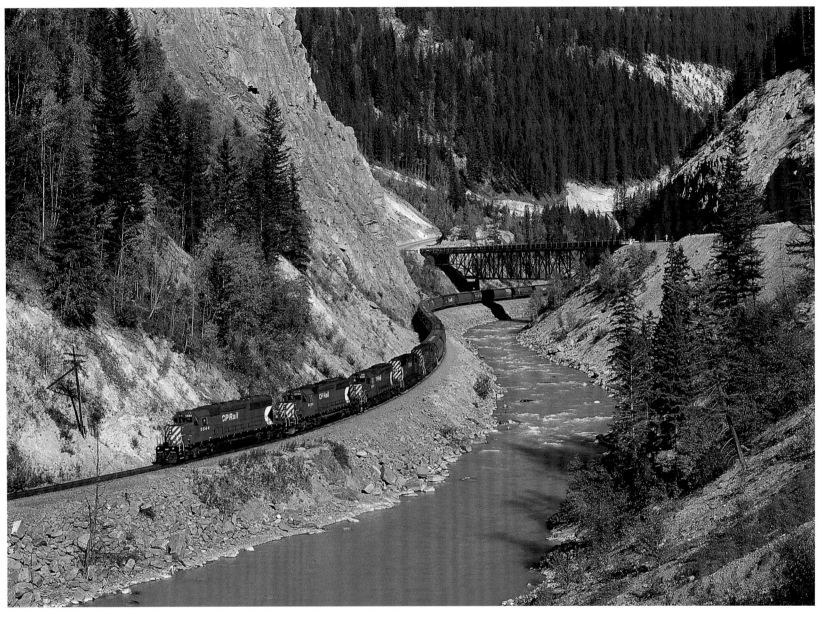

Carved by the Kicking Horse, ancient canyon walls that once echoed the exhaust of triple-headed Ten-Wheelers and double-slotted Decapods reverberate the turbocharged howl of EMD 16-645's as four SD40-2's and an SD40—5844, 6044, 5583, 5563 and 5756—grind through Glenogle, British Columbia, with westbound grain train 351-48 on September 19, 1987. **Robert J. Gallagher**

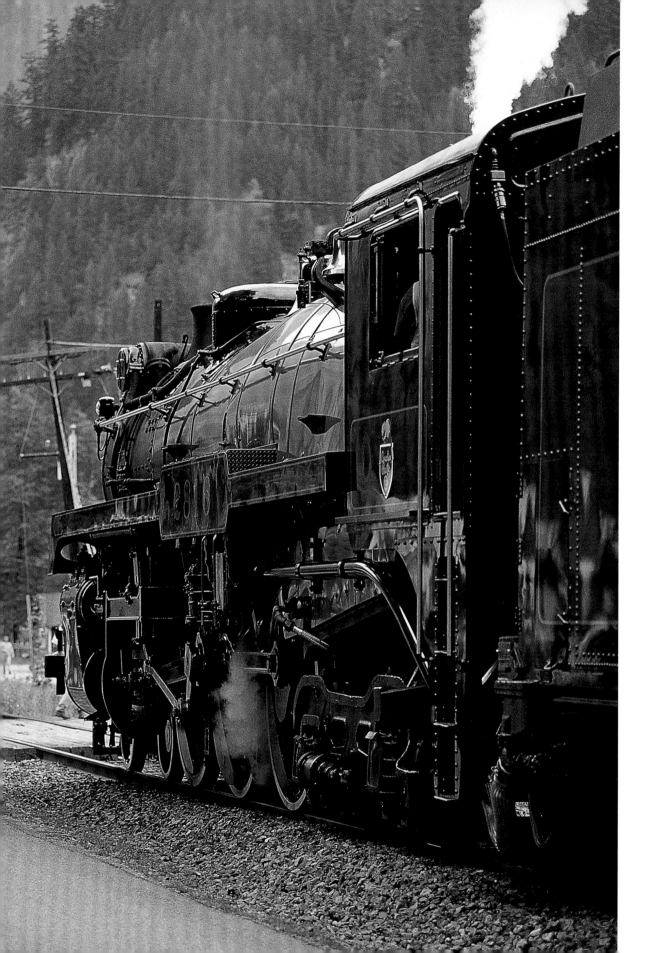

Lake Louise, Alberta, September 22, 2001. **Greg McDonnell**

Steam lives! Looking as fine as on the December 1930 day she rolled off the erecting floor of the Montreal Locomotive Works, 2816 glistens at Yale, British Columbia, on her debut run east on September 19, 2001. **Greg McDonnell**

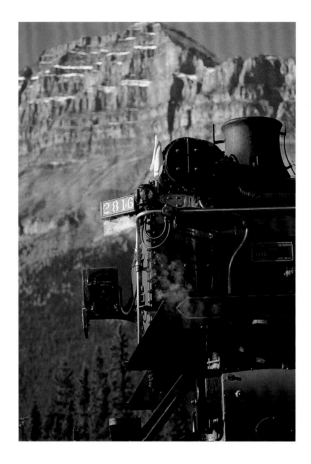

Twenty-Eight Sixteen

The warm September sun plays on the polished rods, gunmetal-grey boiler jacket and maroon-and-gold trim of Canadian Pacific 2816 as the freshly shopped Hudson pants impatiently on the head end of an eight-car passenger train stopped at the CPR station in Banff. The sounds of steam are all-absorbing—the soft pant of exhaust, the thumping air pumps, the hiss of escaping steam and the ever-present whine of the turbo-generator. I'm lost in the moment, as the magic of steam transcends the confines of time and place and sets the imagination free. It could be *The Dominion* at Broadview, Saskatchewan, in 1932, or the *Chicago Express* at Windsor Station in wartime, or the *Overseas* at Galt sometime in the Fifties, or a Rigaud-bound commuter train at Montreal West in 1960. But it's Banff, Alberta, and the year is 2001.

The prospect of finding steam on the CPR in the 21st century—and mainline steam at that—was beyond the realm of even my wildest dreams as I caught my last glimpses of revenue CP steam from the platform at Galt and through the slats of the board fences at Lambton Yard in Toronto in 1959 and 1960. Canadian Pacific closed the book on steam in 1960, and although a number of engines remained on the property as late as 1966, CP did

Mountain majesties. Amid the grandeur of the Rocky Mountains, CP 2816 pauses at Massive, Alberta, on September 23, 2001. **Greg McDonnell**

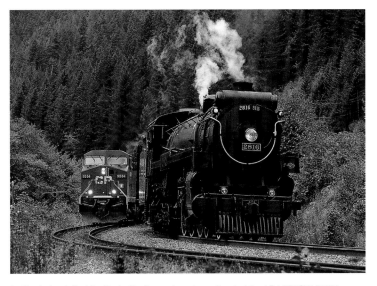

In the hole at Saddle Rock. Eastbound coal empties led by AC4400CW 9584 overtake 2816 East at Saddle Rock, British Columbia, on September 19, 2001.
Greg McDonnell

not follow CN's lead and recondition an engine (or three) for excursion service. The edict issued from Windsor Station was final. There would be no looking back. "Steam is dead."

Or so they said.

Forty-odd years later, on September 23, 2001, H1b Hudson 2816 stands by the station in Banff on a sunny Sunday morning. The 70-year-old 4-6-4 is fresh from a $2-million overhaul and barely winded as she works the home-stretch of a five-day, 627-mile break-in run from Port Moody, British Columbia, to Calgary. More than four decades after the last fires were dropped, there is fire in a firebox and steam coursing through the dry pipe, superheaters and cylinders of a Canadian Pacific-owned locomotive. Steam lives!

As they did at Agassiz, Yale and North Bend, Lytton, Spences Bridge, Savona and Kamloops, Craigellachie, Revelstoke, Glacier, Golden and Field, Divide, Lake Louise, and Morant's Curve, the curious and the faithful come out at Banff to see 2816. They come to hear the whistle, to absorb the aromas of hot oil and grease, and to bask in the glory of steam. They come to see steam for the first time or to renew old acquaintance and reminisce.

Children shout excitedly, exclaiming in wonder of 75-inch drivers that tower overhead, and plead with the engineer to blow the whistle just one more time. Old men talk quietly of firing 5800-series 2-10-2's and semi-streamlined Selkirks, compare the standard H1b to the Royal Hudsons on which they cut their teeth working out of Kamloops and Revelstoke, and regale all who will listen with tales of wild rides on 2816's regal kin.

"Highball Banff, 2816!" The radio in business car *Assiniboine* crackles quietly and 2816's whistle hoots in response. With a gentle tug, we're underway at 1115, gliding along a platform packed with smiling faces and listening to the high-stepping Hudson's razor sharp exhaust echo off distant peaks.

According to the June 24, 1945, timetable tucked in my grip, we're about an hour and five minutes off the advertised schedule of old No. 2—the all-stops Vancouver–Montreal transcontinental local—as 2816 puts Banff behind the brass railings of *Assiniboine*. As far as engineer Bill Stetler is concerned, we might just as well be No. 2, Calgary-bound with a vengeance, doing everything possible by man and machine to make up the 65-minute deficit on the timecard.

Standing on the rear platform of *Assiniboine*, looking up the all-Tuscan consist to the Hudson on the head end, listening to the stack talk and urgent whistle, feeling the solid ride of a 12-wheeled battleship of a business car, it's hard to believe we're not No. 2. Never mind that the Laggan Sub was the domain of eight- and ten-coupled power in the steam season and never really Hudson territory, 4-6-4 2816 is more than equal to the occasion.

Thundering east of Ozada, I've exhausted my supply of superlatives as the 2816 sprints towards Calgary. Scribbling in a spiral notebook, the best I can come up with is…*riding rear platform of Assiniboine—flying!* With the wind in my face, the mountains at my back, and a 70-year-old Hudson supplying the substance and soundtrack for the experience of a lifetime, I'm on top of the world—and forever indebted to R.J. Ritchie, President and CEO, Canadian Pacific Railway. For it was R.J. Ritchie who brought this all to be.

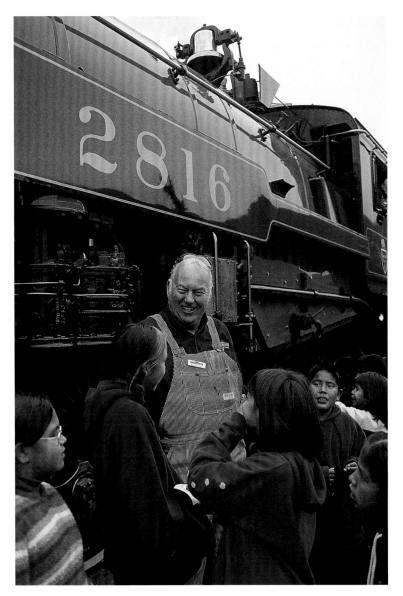

Power for the people. The generation gap vanishes and any doubts over steam's worth as both educator and inspiration are washed away in the rain at Lytton, British Columbia, as schoolchildren gather around engineer Doyle McCormack and 2816 on September 20, 2001. Money can't buy the lessons learned, rapport earned and memories made in just 20 minutes in the rain. Greg McDonnell

(Right) *The lessons learned beside the 75-inch drivers of 70-year-old Hudson can't be taught in a classroom.* Mark Seland takes the time to explain the mysteries of steam during a station stop at Savona, British Columbia, September 21, 2001. Greg McDonnell

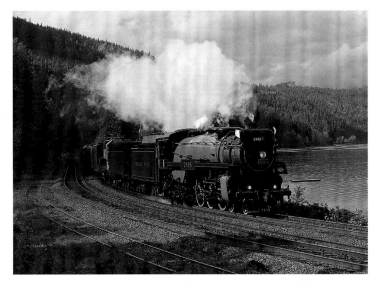

Her polished rods and gunmetal-grey boiler glistening in the sun, 2816 skirts the Salmon Arm of Shuswap Lake at Annis, British Columbia, on September 21, 2001.
Greg McDonnell

Let the record show that it was R.J. Ritchie who repatriated 2816 from Steamtown in Scranton, Pennsylvania, in 1998. And it was R.J. Ritchie who authorized the transcontinental deadhead move of the rusting hulk from Scranton to the BC Rail steam shop in North Vancouver. It was R.J. Ritchie who gave Al Broadfoot and his BCR steam shop the go-ahead to rebuild 2816 from the rails up. And when the old Hudson proved to be in even worse shape than the experts feared, it was Ritchie who kept the faith, defied the skeptics and ordered Broadfoot to drive on.

The 17th of 20 2800-series H1a and H1b class Hudsons designed by Henry Blaine Bowen—Canadian Pacific's Chief of Motive Power and Rolling Stock from 1928 to 1949—2816 rolled off the erecting floor of the Montreal Locomotive Works in December 1930. Delivered with a price tag of $116,555, she was assigned to passenger service out of Winnipeg, working east to Fort William (now Thunder Bay) and west to Calgary.

Through the mid-1930s, standard Hudsons 2800-2819 were the pride of the fleet, but they were soon outclassed—and outnumbered—by 45 semi-streamlined H1's built

between 1937 and 1940. Stylish and smooth-lined Bowen-design Hudsons 2820-2864 were accorded further notoriety after 2850 handled the transcontinental Royal Train of Their Majesties King George VI and Queen Elizabeth in 1939. The Hudson's command performance was rewarded when the British government granted the CPR permission to affix embossed crowns to the skirts of all 45 semi-streamlined 4-6-4's and to dub them "Royal Hudsons."

Dethroned from the Winnipeg passenger pool by her royal kin, 2816 put the prairies behind her and worked most of her career in freight and passenger pools in Ontario and Quebec. Among the last CP steam locomotives in active service, she finished her days in commuter duty, assigned to the Glen roundhouse in Montreal. As steam made its last stand, she managed to keep one step ahead of the diesel until May 26, 1960, when she rolled the last of her estimated 2,046,000 revenue miles, working a commuter train from Windsor Station to Rigaud, Quebec.

While most of her stablemates were dragged off to the scrap docks at Angus, 2816 bought a stay of execution, drawing stationary-steam duties at the Glen roundhouse in the winter of 1960–61. There was little prestige in providing steam heat to the roundhouse, but the H1 got to occasionally stretch her legs (and take trackside observers by surprise) sprinting to St. Luc and back whenever a boiler wash or other maintenance was due. A far cry from the glory days wheeling the *Imperial*, *The Dominion* and the *Great West* across the prairie, the humble assignment did earn 2816 the distinction of being one of the last CPR steam locomotives with a fire on her grates. And for a while, it kept the scrappers at bay.

Although preservationists saved four Royal Hudsons from the torch, 2816 was the sole survivor of CP's 20 standard H1a and H1b Hudsons when Nelson Blount's Steamtown Foundation plucked her from the scrap lines at Angus in December 1963. Along with a half-dozen other CP locomotives rescued by Blount (including D10h 1098, G5c 1246, G5d's 1278 and 1293, G3c 2317 and F1a 2929), 2816 travelled south of the border for display at Steamtown in Bellows Falls, Vermont.

A man in his element. Engineer Doyle McCormack—master of all things steam—has the throttle hooked up and the Hudson sprinting at a sustained 50 mph east of Donald, British Columbia, on September 22, 2001. **Greg McDonnell**

Engineer Bill Stetler and the *Empress*, Port Moody, British Columbia, September 19, 2001. **Greg McDonnell**

The man behind the dream. Rob Ritchie, Calgary, Alberta, September 21, 2001. **Greg McDonnell**

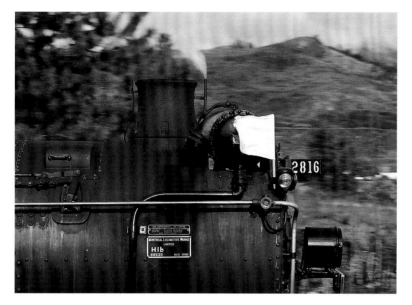

West of Chase, British Columbia, September 21, 2001. **Greg McDonnell**

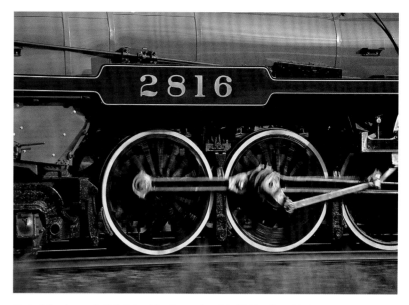

East of Kamloops, British Columbia, September 21, 2001. **Greg McDonnell**

Following Steamtown's move to Scranton, Pennsylvania, and subsequent designation as a National Historic Site, 2816 was deemed surplus to the collection. Showing the ravages of 30 years of outdoor storage, the last CPR H1b in existence faced an uncertain fate. However, fortune smiled on the old girl once more as word of her circumstance reached Calgary at the same time Rob Ritchie was giving serious consideration to establishing a CPR steam program. The H1b fit the bill, and on September 12, 1998, a special entourage, led by maroon-and-grey CP FP7 1400, GP38-2 3069 (wearing CP's new beaver emblem) and STL&H GP9u 8216, arrived at Scranton to escort the 2816 home.

Working on steam has been hot, hard, dirty business since Richard Trevithick put the first steam locomotive to work, hauling 10 tons of iron and 70 passengers on the Pen-y-darran tramway in Wales in 1804. Rebuilding a steam locomotive for mainline service in the 21st century is all that and more. In the BCR steam shop in North Vancouver, British Columbia, Al Broadfoot and his shop crew put in three years of hot, dirty, difficult work as they tore the Hudson apart piece by piece and put it back together again—reconditioning,

rebuilding or replacing every bolt, bearing, bushing, appliance and component as they went. As part of the overhaul, 2816 was also converted from a coal- to oil-burning locomotive.

What couldn't be done on site was farmed out; the driving wheels went to the Tennessee Valley Railroad Museum in Chattanooga, Tennessee, and the boiler went to Doyle McCormack (master of all things steam and veteran of more than three decades of restoring and running post-dieselization mainline steam) in Portland, Oregon. Local fabrication shops and foundries created hundreds of other components that could not be rebuilt, from crown brasses and superheater components to an all new cab. New springs were fabricated by a local supplier, employing some of the same equipment used to produce springs for the CPR in the steam era.

When 2816 was again the sum of its parts, Canadian Pacific had invested over $2 million in the rebuild. Broadfoot, McCormack, Don Noel, Martin Jergens, Derek Shaw, Dave Richards and a host of others had invested not only invaluable time and talent, but heart and soul.

In August 2001, 2816 emerged under steam for the first time in 40 years. Many of those who had worked to make

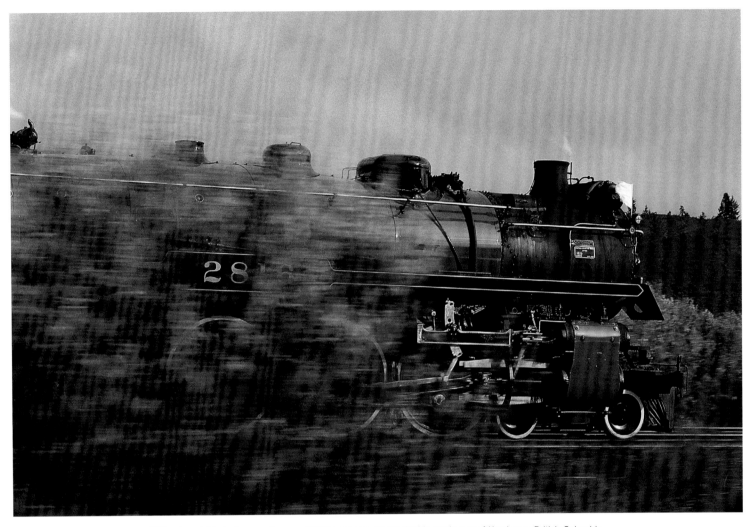

Hitting her stride in the morning sun, 2816 opens up on the double track east of Kamloops, British Columbia, on September 21, 2001. **Greg McDonnell**

the moment possible were on hand; almost all would be part of the crew for the debut run to Calgary just weeks later. Broadfoot would work as fireman for much of the trip, while Doyle McCormack (a Union Pacific engineer by trade) alternated with Bill Stetler as engineer. Noel, Jergens, Shaw and Richards would do yeoman work as oilers, wipers, engine watchmen and safety crews.

If the sparkle in an old man's eye, the excited laughter and happiness of children of all ages, and childhood memories

that last a lifetime were currency, Canadian Pacific would have recouped its investment in 2816 long before the reborn Hudson reached Calgary on her maiden run.

Indeed, CP's intention is to employ 2816, christened "the Empress" upon her rebirth, as an ambassador of community relations, for charitable and educational causes and to celebrate the railway's rich heritage and proud history. She assumed the role right out of Port Moody, as the five-day break-in run to Calgary included numerous stops en route,

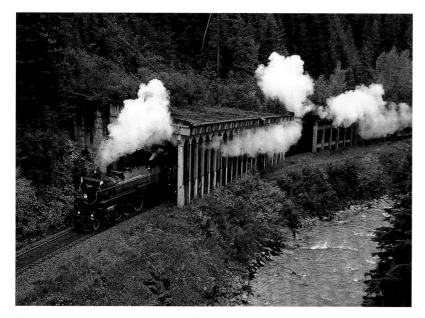

Steam hangs in the damp morning air as 2816 emerges from the snow sheds at Illecillewaet, British Columbia, at 0930, September 22, 2001. **Greg McDonnell**

for school groups to see the engine and, in some cases, to ride the train to the next town.

Any doubts over 2816's worth as both educator and inspiration were washed away in the cold rain at Lytton, British Columbia. At 0915 on the second day out, 2816 East braked to a stop at Lytton, where schoolchildren shrugged off the weather to give the train an enthusiastic greeting. Ignoring the bone-chilling drizzle, they gathered around McCormack, Broadfoot and the 2816. The *Empress* simmered quietly in the background, hooting her whistle once or twice, and the distance between generations disappeared. Young hands felt the radiant heat from the firebox and the cold steel of polished rods. Young hearts were introduced to the romance of steam and the knowledge and wisdom of veteran railroaders.

Money can't buy the rapport established in that 20 minutes in the rain; the lessons learned beside the 75-inch drivers of a 70-year-old Hudson can't be taught in a classroom, and a steam whistle never sounded so poignant as it did in salute to the friendly cheers and parting waves of the children as

2816 stomped out of Lytton. The warmth cutting the cold air at Lytton was from more than the firebox and the moisture on more than a few cheeks from more than the rain. Suddenly, $2 million seemed like a bargain.

Four days, 17 stops and 580 miles later, 2816 is closing in on her Calgary destination. Her diesel companion on the trip—maroon-and-grey GP38-2 3084—has been left behind for the home stretch and the *Empress* is doing what she does best. Making like it's 1930 again, barreling eastward with a maroon passenger train at all the speed Bill Stetler and the CPR will allow, looking at least like Second 8, feeling like the *Trans-Canada Limited*, "the fastest train across the continent" and the CPR's finest.

In the mahogany-panelled lounge of *Assiniboine*, there's time to sit and listen to the syncopated exhaust and soulful whistle. Time to wonder if it's all real. Time to absorb, or at least start to absorb, the full substance of the experience. From standing on the rear platform of *Assiniboine* and listening to the engine get underway at Port Moody, to pacing alongside as she races eastward out of Agassiz, and huddling in the rain near Cisco, listening to air horns and steam whistles echo up and down the canyon as 2816 East and CP 5491 West exchange greetings as they pass on opposite sides of the Fraser River. From hovering feet above the treetops in a helicopter as 2816 threads through the snowsheds along the Illecillewaet, to riding the cab and standing in the gangway as Doyle McCormack hooks up the throttle and lets the old girl cut loose—running at a sustained 50 mph on the fast track east of Donald. The sound of steam assaulting Kicking Horse Pass, the sharp, cannonading exhaust reverberating off rock walls and the heart-piercing call of the whistle echoes in my memory still.

H.B. Bowen knew what he was about when he inked the plans for the H1 and when he commissioned MLW to fashion, fabricate, rivet and weld together the machine illustrated on the blueprints delivered to 1505 Dickson Street in Montreal in 1929 and again in 1930. I like to think that he's somewhere smiling as the 2816 races eastward, and that he's looking proudly over Rob Ritchie's shoulder as the president and

CEO climbs into the cab at Keith for the final 9.6 miles of the run and the triumphant march into Calgary.

Victory is at hand as 2816 struts into Calgary at 1520 on Sunday, September 23, 2001. The town and the railway have changed immeasurably since she last saw Calgary under steam. In a symbolic gesture, past and present come face to face as the 70-year-old Hudson eases to a stop in front of one of CP's newest locomotives: 6,000-hp SD90MAC-H II 9302.

The faceoff is more than a photo op; it's a tribute to Rob Ritchie's vision. Since taking the CEO chair in 1995, Ritchie has brought a new sensibility to CP. He's initiated renewed emphasis on the company's role as a nation-building institution and inspired pride in the railway's heritage. He's presided over the revival of the company's

original name and reinstallation of the beaver atop a new logo that recalls the rich history of the Canadian Pacific Railway. On Ritchie's watch, CP has bolstered its long tradition of giving back to the community, a tradition dating as far back as an 1881 donation to Winnipeg General Hospital, and as contemporary as the Holiday Train.

More than a historic artifact, 2816 is a working, breathing, 360,000-pound, 75-inch-drivered, Walschaerts-valve-motion-equipped, oil-burning, steam-generating (at 275-pounds-per-inch), whistling, clanking, barking, rocking, rolling embodiment of the rich heritage and community spirit of the railway whose name is spelled out on her tender: Canadian Pacific.

They call her *Empress*, and she's every bit royalty.

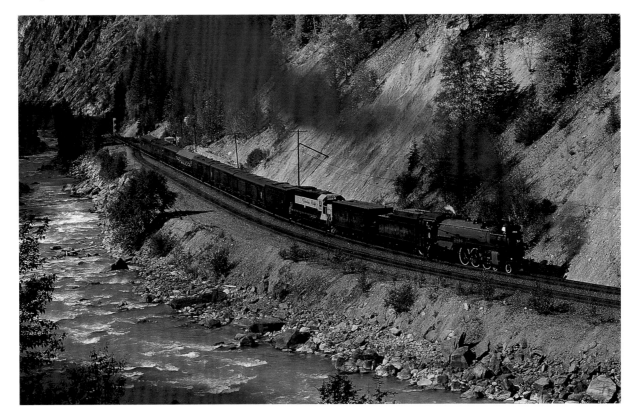

The sound of steam assaulting Kicking Horse Pass, the sharp, cannonading exhaust reverberating off rock walls and the heart-piercing call of the whistle echoes in my memory still. Assisted by running mate 3084, 2816 works through Glenogle, British Columbia, at 1354, September 22, 2001. **Greg McDonnell**

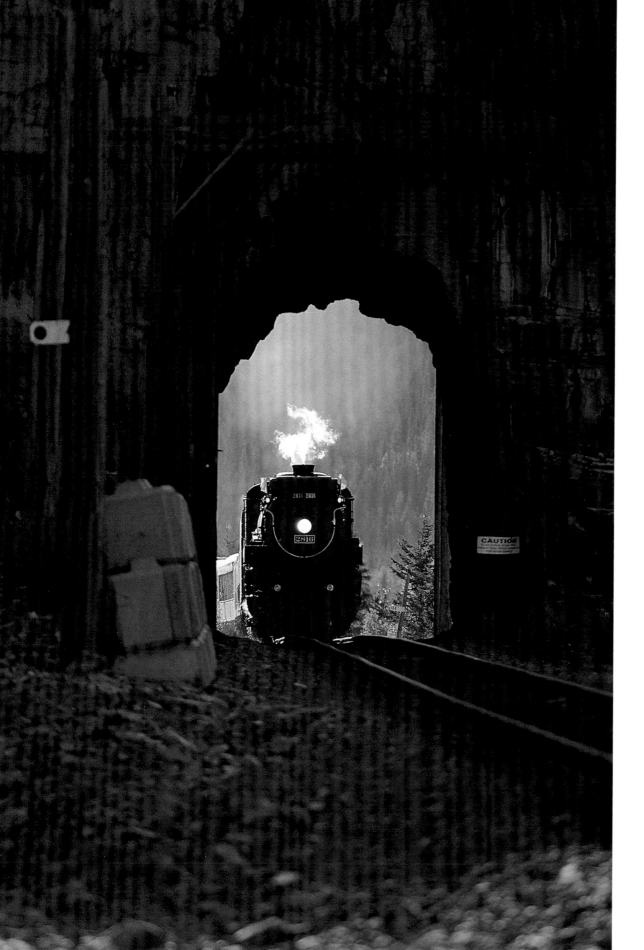

Storming the storied Field Hill, 2816 ducks into a tunnel at Mileage 134 on the Mountain Sub just east of Field, British Columbia, on September 22, 2001. **Greg McDonnell**

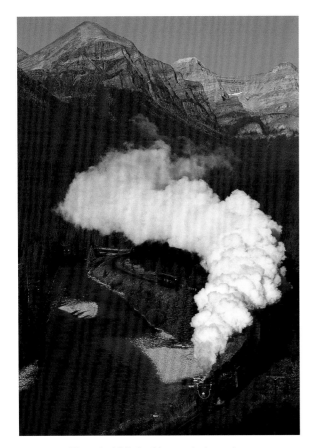

Morning at Morant's. Nicholas Morant, the legendary company photographer who made the curve at Mileage 113 on the Laggan Sub one of the most famous scenes on the CPR, would be pleased as 2816 traces the Bow River under a majestic plume of steam, threading the curve that bears his name at 0920, September 22, 2001. **Greg McDonnell**

Shades of Second 8! After meeting the westbound *Rocky Mountaineer*, 2816 East departs Massive, Alberta, for Banff on September 22, 2001. Assigned to Calgary, the Empress continues to fulfill her new role as educator, ambassador and historic artifact. She has toured extensively to help promote Breakfast for Learning, a national non-profit organization dedicated to supporting child nutrition programs throughout Canada. **Greg McDonnell**

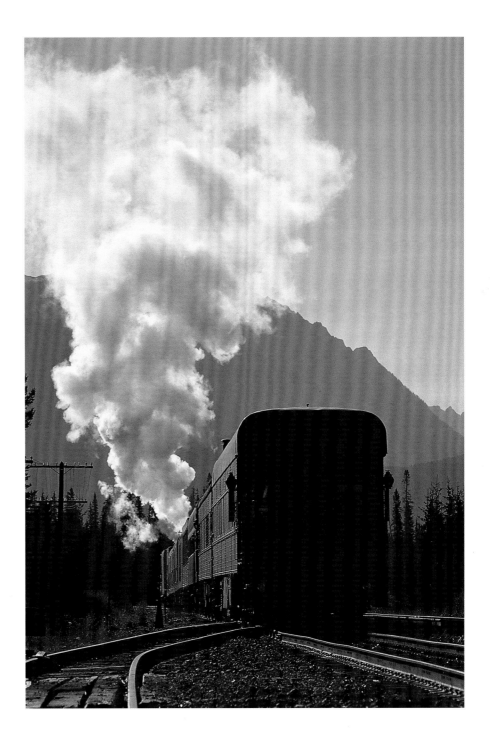

Fashioned from a CPR-standard 7-by-7 cedar crossbuck post, a simple silver-painted cross jutting from the frozen prairie at Chancellor, Alberta, marks the trackside grave of Mytro Borys, a CPR labourer killed during the construction of the Bassano–Irricana Branch in 1913. January 22, 2001, **Greg McDonnell**

Lest We Forget

A simple silver cross juts from the frozen prairie on the edge of the tiny Alberta hamlet of Chancellor. Fashioned from a CPR-standard 7-by-7 cedar crossbuck post, the silver-painted cross marks a trackside grave at Mileage 28.8 of the Irricana Subdivision.

For 90 years, CPR sectionmen have tended to the grave of Mytro Borys, a CPR labourer crushed under the weight of rails that fell from a flatcar during the construction of the Bassano-Irricana Branch in 1913. Using track material and tools of the trade—ties, wooden planks and silver paint stocked for trackside signs, mileposts, signals and crossbucks—they've maintained the memorial without ceremony or notice.

When construction threatened the site, Borys was officially exhumed and reburied. In the early 1980s, when the Irricana Sub was rebuilt as part of the Prairie Branch Line Rehabilitation Program, the grave site was included —unofficially, no doubt—in the work. Medicine Hat Division B&B Master Jim McLennan and his crew cleaned up the site, rebuilt the memorial and researched its history. A new cross was built, but the original, weathered and split from decades in the prairie sun, still leans against the fence.

A memorial to honour the 33,127 Canadian Pacific employees who served in two World Wars, 1,774 of whom sacrificed their lives, Coeur-de-Lion MacCarthy's *Winged Victory* presides over the concourse of Windsor Station in Montreal, Quebec, on September 23, 1993, as it has since 1922. **Philip Mason**

The exact details of the incident at Chancellor and memories of Mytro Borys may be as faded as the weatherbeaten cross, but the integrity and class of the railroaders who have maintained the simple monument for generations is not. Indeed, from stone cairns and wooden crosses erected along the right-of-way by construction crews, track gangs and train crews, to company-commissioned statues and monuments, the rich sense of history and honour exemplified by the Chancellor monument has been a CPR tradition for generations.

Twenty-two-hundred miles east of Chancellor, *Winged Victory*, a dramatic Coeur-de-Lion MacCarthy sculpture featuring a winged angel and a fallen soldier presides over the concourse of Windsor Station in Montreal. Commissioned in 1922 as a memorial to CPR employees who served in the First World War, the heroic piece has since been rededicated to honour the 33,127 Canadian Pacific employees who served in two World Wars, 1,774 of whom sacrificed their lives. Similar statues were installed by CP in Winnipeg and Vancouver.

Winged Victory dominated the Windsor concourse on my first visit to the station in December 1967, and visions of the great winged angel towering overhead still prevail. Dressed in heavy overcoats, fedoras and fur caps, commuters hurried across the glass-roofed concourse with briefcases gripped in gloved hands, folded copies of the *Montreal Star*, the *Gazette* and *le Devoir* tucked under their arms and eyes fixed ahead. They paid little heed to the angel and the soldier; concentrating instead on the maroon coaches that stood shrouded in steam under the train shed, waiting to take them home. Their indifference only heightened my appreciation for the true purpose of the work.

Less imposing than Windsor's *Winged Victory* are the 22 bronze tablets also commissioned by CP in 1922 to honour its World War I veterans. The plaques, the work of Archibald Pearce, were installed in CP stations, shops and offices from Saint John, New Brunswick, to Victoria, British Columbia, as well as in Canadian Pacific offices in New York, New York, Liverpool and London, England, and Hong Kong.

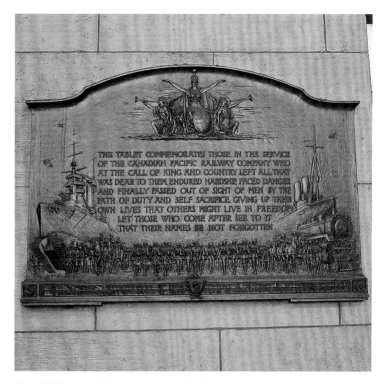

One of 22 bronze tablets commissioned by CP in 1922 to honour its World War I veterans, and installed in CP stations, shops and offices from Saint John, New Brunswick, to Victoria, British Columbia, and from New York, New York, to Hong Kong, the plaque in Toronto's Union Station calls upon passersby to remember. *Let those who come after see to it that their names not be forgotten.*
Greg McDonnell

The bronze tablet first caught my eye with its gripping image of Canadian soldiers, flanked by high-headlighted CP Pacific 2301 and an Empress-class steamship on one side and by a World War I tank and battleship on the other. The text of the memorial captured the heart.

> *This tablet commemorates those in the service of the Canadian Pacific Railway Company who at the call of King and Country left all that was dear to them, endured hardship, faced danger and finally passed out of sight of men by the path of duty and self sacrifice, giving up their own lives that others might live in freedom. Let those who come after see to it that their names not be forgotten.*

In raised letters of bronze, the plaque carries the names of the great battles, names spelled out in bronze, but written in blood: Ypres, Festubert, The Somme, Vimy, Hill 70, Passchendaele, Amiens, Cambria, Drocourt Queant, Mons.

To this day, I find it impossible to pass one of those bronze tablets without pausing to read the prose and to consider the sacrifice. Telegraphers, trainmen and track workers, porters, shopmen and engineers—by the thousand, they laid down their tools, hung up their caps and overalls, and joined tens of thousands more to answer "the call of King and Country." Many never returned, many more came home with physical and mental wounds that would never heal.

Let those who come after see to it that their names not be forgotten. The CPR goes far beyond the reach of statues and plaques of bronze to honour the memory of the veterans of war. In 1999, an edict from no less than the office of CPR president and CEO Rob Ritchie initiated a Remembrance Day tradition that endures still: *At 11 a.m. local time on Nov. 11, 1999, all CPR trains across its network will come to a full stop in a safe zone and observe the tradition of two minutes of silence. At the end of the two minutes, they'll blast one long whistle as a final tribute to this century's freedom fighters.*

"Two minutes of reflection is time well used to honour those who served, and in particular the many thousands who sacrificed their lives, including 1,774 Canadian Pacific employees," said Ritchie. In what has become an annual address, Ritchie's 2002 remarks went straight to the heart. "We hope the sound of our train whistles will be a poignant reminder of the sacrifices of those who have served in armed conflicts and a call to unity in the face of new threats to the rights and liberties of people around the world,"

On November 11, 1999, I stood in our kitchen with the radio tuned to the live CBC broadcast from the Remembrance Day ceremonies on Parliament Hill in Ottawa. At 1100, the haunting call of a lone bugler sounded, followed by the gut-wrenching strains of bagpipes. Then silence. As the sound of the pipes faded, I opened the front door to listen for the CPR's observance of Ritchie's Remembrance Day order.

Dashing through the snow. Outlined in lights and sporting the traditional Christmas tree on its cab roof, AC4400CW 9587 climbs the hill at Campbellville, Ontario, with the Holiday Train on December 8, 2000. **Greg McDonnell**

The piper stopped, silence reigned for two minutes and then a lone K3LA horn—STL&H 8206 on the Electric Lines job at Galt—blasted "one long whistle as a final tribute to this century's freedom fighters." The intensity of emotion generated by that simple gesture caught me by surprise and I stood quietly on the porch, with a chill running up my spine.

Lest we forget.

Freedom, community, unity. The values that are the foundation of the solemn Remembrance Day observance are not forgotten. Indeed, they're brought to life in the bright lights of the Holiday Train, a CPR Christmas tradition since 1999.

The Holiday Train, with its locomotive, freight cars, stage car and CP business cars outlined from pilot to markers with decorations and thousands of tiny Christmas lights is a spectacle to behold. But it's the spirit of the train, on a CP-sponsored transcontinental journey, with whistle-stop performances, concerts and displays, to raise funds (and awareness) and collect food for food banks across North America, that is truly moving.

Twinkling in the dusk, the Holiday Train ducks beneath an overpass on the former TH&B in Hamilton, Ontario, as the train positions for an evening concert on December 8, 2000.
Greg McDonnell

and money. In the glow of the Holiday Train lights, they gather around the stage—a converted boxcar that resembles something that might be found in an old Lionel Christmas train set—to sing and to celebrate and attend concerts performed by a host of musicians.

In four short years, the celebrity roll-call of Holiday Train musicians has included Tom Jackson, Beverley Mahood, Amanda Stott, Duane Steele, Tracey Brown, Randall Prescott, Patricia Conroy, Clint and Bob Moffatt and Kelly Prescott. Even more impressive is the more than 166 tons of food and approximately $1.3 million in cash donations collected by the holiday train and distributed to more than 300 food banks across North America.

Since 2001, the train, which operates with the assistance of corporate sponsors including the Hudson's Bay Company, Consolidated Fastfrate, General Electric, IMC Global, Alstom and Canadian Tire, has become an international event. In addition to the Montreal–Vancouver train, a second section of the Holiday Train operates over CP lines in the United States, covering D&H and SOO territory from New York to North Dakota.

It wasn't the sound of reindeer on the roof, or the jingle of sleigh bells, but when the radio crackled "Highball Galt 8638" on a cold December 2002 night, the excitement of Christmas tingled in my veins—and I dashed to the front porch in anticipation. The night was crisp, cold and still. But for the distant rumble of a train on the Galt bridge, the only sound was that of snowflakes hitting late-fallen oak leaves on top of the snow.

The Holiday Train had come this way before—including the previous year, when it made a brief, unscheduled but deliberate stop on the Galt bridge—but the thrill was undiminished. With a CP AC4400CW, a string of freight cars, double-stacked containers and a pair of business cars decked out with decorations and over a kilometre of Christmas lights, the train is an awe-inspiring sight. It's the ultimate train beneath the Christmas tree.

So I stood in the cold on the porch, listening to the FDL wind out for a run at the hill, the K3LA calling for the

Like a travelling minstrel show, the Holiday Train makes its annual cross-country trek each December. In the spirit of Christmas, in Montreal and Mactier, White River and Marathon, Nipigon, Brandon, Broadview and Banff, Ashcroft, Lytton and Agassiz, young and old come bearing gifts of food

crossing, and waited for the lights to emerge from the trees. I knew what to expect, but the first sight of the train took my breath away just the same.

"More rapid than eagles his coursers they came…" Out of the night, CP 8638 came charging up the hill, festooned with lights and proudly carrying the traditional Christmas tree on its cab roof. "And he whistled, and shouted, and called them by name; Now, Dasher! now, Dancer! now, Prancer and Vixen! On, Comet! on Cupid! on, Donner and Blitzen!" I looked across the ravine as the big GE drew even with the porch—its 16-cylinder FDL barking loudly, air horn blaring in adherence of Rule 14L—and I watched in wonder as a string of brilliantly outlined cars followed in its wake.

"Now dash away! dash away! dash away all!" In what seemed like a flash, the Holiday Train was gone. The Christmas wreath and red markers hung with care on the rear of business car *Lacombe* blinked out of sight as the train rounded the curve into Barries Cut and disappeared.

"But I heard him exclaim, ere he drove out of sight, happy Christmas to all and to all a good night." Snow fell all around me as I stood quietly on the porch. A surge of emotion shot through my entire being as the chugging FDL faded into the night. Canadian Pacific's rich sense of history, heritage and honour has never shone brighter than it does in the lights of the Holiday Train. And the spirit of Christmas, the true spirit of Christmas, sparkles in the eyes and dwells in the hearts of the people who make it happen.

From town to town and coast to coast; from the corporate towers in Calgary to the crew rooms and section houses across the system; from the musicians who take the stage each night to the volunteers at the gate and the people, who come bearing gifts of foodstuffs and funds for the needy and stay to hear music, sing carols and celebrate, the Holiday Train is a company and a community effort. And it's Canada and Canadian Pacific at its finest. Falling snow gently rustles the late-fallen leaves and a faint horn calls for the crossing at Orrs Lake as the Holiday Train hurries to its next stop.

Peace on earth, good will towards men…lest we forget.

Tradition and technology. Punctuating the Holiday Train at Guelph Jct., Ontario, on December 8, 2000, business car *Assiniboine* is adorned with both a snow-covered wreath and an electronic SBU. **Greg McDonnell**

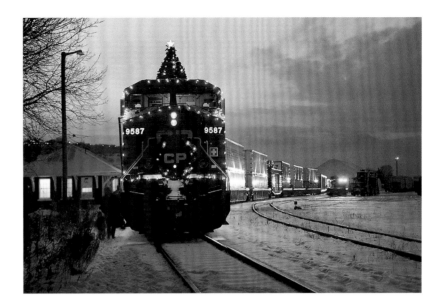

The ultimate train beneath the Christmas tree, the Holiday Train hosts children of all ages at Aberdeen Yard in Hamilton, Ontario, December 8, 2000.
Greg McDonnell

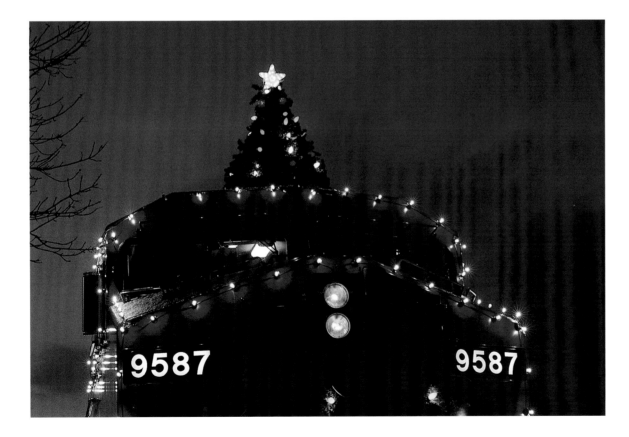

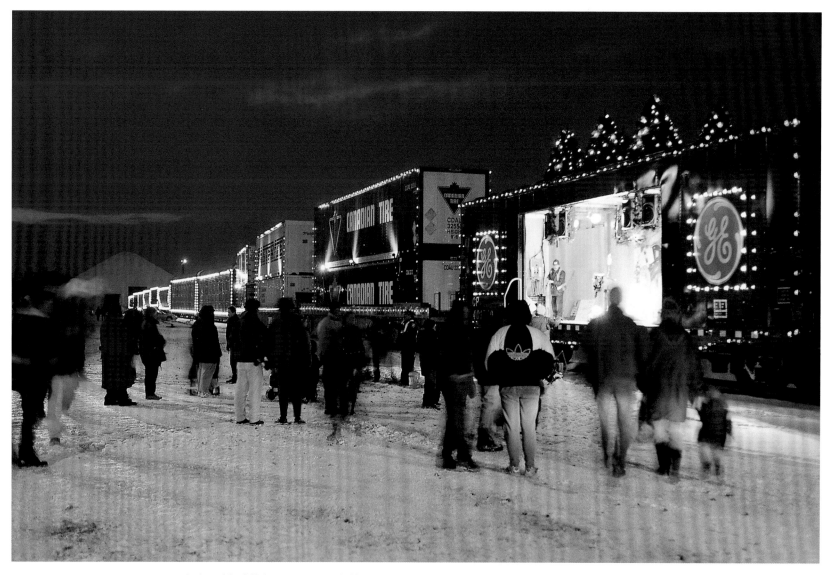

In the spirit of Christmas, young and old come to see the Holiday Train bearing gifts of food and money for the Food Bank. In the glow of the Holiday Train lights at Hamilton, children of all ages gather around the stage—a converted boxcar that resembles something that might be found in an old Lionel Christmas train set—to watch crews set up for the show, to celebrate and attend concerts performed by a host of musicians.
Greg McDonnell

Standing on the prairie where the CPR intersects the family farm west of Wood Mountain, Saskatchewan, Lee Hysuick (centre), his son Denis (right), and CP rail gang supervisor Norm Graham watch as crews dismantle the Wood Mountain Subdivision on October 20, 1999. As a young man, Lee watched track gangs and teams of horses bring the railway to Wood Mountain in 1929. Seventy years later, at age 90, he looks on as another generation of track gangs and horses of iron take it away. **A. Ross Harrison**

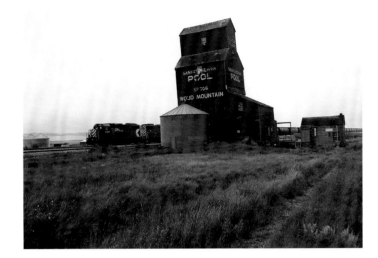

Not Fade Away

Iee Hysuick was a young man when the CPR came to Wood Mountain, Saskatchewan, in 1929. He watched construction crews grade the line with teams of horses and saw track gangs spike down 80-pound steel as they worked westward through territory where Sitting Bull and some 5,000 Sioux had once taken refuge in the wake of Little Big Horn. "The crews used to camp here," his wife, Helen, recalls of the railway builders. "They'd water their horses from our well and we'd give them cheese, milk, butter and vegetables from the garden."

Probing westward from the junction with the Fife Lake Sub at Ogle, the 64.8-mile branch reached end of steel at Mankato in the summer of 1929. By August, steam whistles echoed across the rolling prairie west of Wood Mountain and coal cinders dusted the wheatfields of the family farm as Ten-Wheelers worked past the farmhouse with mixed trains, wayfreights and grain peddlers.

For 70 years, Hysuick watched CPR trains roll through the 1,500-acre farm that had been in the family since before Saskatchewan became a province. Tilling soil first turned by his wife Helen's parents, Nick and Elizabeth

One of the last revenue trains to rumble through Wood Mountain, Saskatchewan, the westbound
Assiniboia Tramp—in the charge of GP38-2's 3130, 3070 and 3091—passes the closed
Saskatchewan Pool elevator at 0945, August 3, 1998. **Andrew G. McDonnell**

Coroluick, in 1904, he watched the D10's and light Pacifics, assigned to the twice-weekly mixed as late as the spring of 1959, give way to maroon-and-grey Geeps. He saw the combine vanish from the rear of the mixed and the wayfreight evolve from a motley collection of wood and steel boxcars to strings of multicoloured Trudeau hoppers.

For most of those 70 years, the uncounted thousands of bushels of wheat, oats and barley harvested from the undulating fields were trucked to the Saskatchewan Pool and Pioneer elevators in Wood Mountain and loaded in CPR boxcars and government hoppers. However, by the 1990s, the wayfreight was spotting fewer and fewer cars at Wood Mountain, and the elevators finally closed on July 31, 1996.

In the summer of 1998, 70 years after the construction crews struck west from Ogle, the Assiniboia Tramp rambled out the Wood Mountain Subdivision to Mankota and back for the last time. The line was officially abandoned on January 6, 1999. Throughout 1999, the Wood Mountain lay fallow and rust formed on the 100-pound rails slicing across the Hysuick farm as Lee and his son Denis brought in the harvest.

Efforts to revive the 64.8-mile branch as a short line failed, and in October 1999, CPR track gangs and a quarter-mile-long work train returned to the Wood Mountain for the last harvest. They came not for grain, but for salvageable rail.

On October 20, 1999, Lee and his son Denis stood at the farm crossing with rail gang supervisor Norm Graham and watched CPR crews tear up the 100-pound steel and load it in 1,440-foot lengths aboard a long black rail train headed by a trio of GP38-2's. In a serendipitous moment, the man charged with dismantling the Wood Mountain and the man who observed its construction stood face to face on the prairie. The senior Hysuick talked of horse teams and men spiking down 80-pound rail. Graham spoke of stripping and loading 3 to 3 1/4 miles of track per day with, in the words of photographer Harrison, devastating efficiency.

In a man's lifetime, the railway had come full circle. At age 19, Lee Hysuick watched track gangs and teams of horses bring the railway to Wood Mountain. At age 90, he watched track gangs and horses of iron take it away. "We seen it come, and we seen it go," his wife Helen reflects. "Sure felt sad to see it go."

Lee Hysuick passed away in July 2002, but his legacy lives on as Denis and his wife, Carmen, carry on the tradition and continue to farm the land that has been in the family for nearly a century. The days of D10's, Geeps and 40-foot grain boxes are but a memory, and Hysuick's grain leaves the farm in hired 18-wheelers destined for distant elevators. However, most—if not all—of it ultimately rolls to market, to the Lakehead, or to ocean ports in the bellies of covered hoppers coupled in 100-plus-car CPR unit-grain trains.

The prairie is slowly reclaiming the Wood Mountain Sub and a thousand more miles of abandoned branchlines. However, just as the Hysuick's roots run deep in the tract outside Wood Mountain, the CPR is inextricably rooted in the prairie.

In the thousands of families whose relatives came west on the hard boards of CPR colonist cars to homestead on the prairie, in the names painted on station boards, grain elevators and town halls—Fleming, Secretan, Estevan and Lanigan; in the street names, Shaughnessy Street and CPR Avenue in Tompkins, Saskatchewan, Van Horne in Morris, Manitoba, and Strathcona in Winnipeg; in poignant reminiscences of D10's plodding along wobbly branchlines with wooden grain boxes and varnished combines; in the faded lettering of an old 40-foot boxcar abandoned in a farm field, and in the beaver-and-shield crests emblazoned on the brand-new AC4400CW's thundering towards the Lakehead or Pacific tidewater with 18,000-ton grain trains. The imprint of the Canadian Pacific Railway on the face, the history, the economy and the very psyche of the prairie will not fade away.

In better times, the Pioneer and Saskatchewan Pool elevators at Wood Mountain, Saskatchewan, tower in the distance as GP9's 8657 and 8689 work westward with the Assiniboia Tramp on July 25, 1977. **Andrew J. Sutherland**

Burdened with prairie grain, Trudeau hoppers glint in the setting sun as CP 8540 West departs Carmichael, Saskatchewan, at 1936, August 30, 2002. **Greg McDonnell**

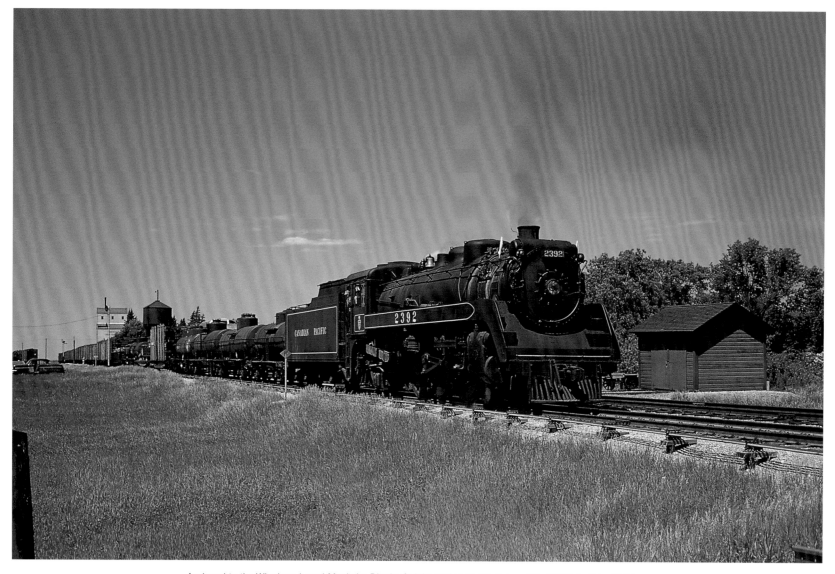

Assigned to the Winnipeg-based Manitoba District freight pool in her final days, G3g 2392, built by CLC in June 1942, approaches the CN diamond at Carberry, Manitoba, with an eastbound drag freight on June 14, 1959. **Robert Clarke**

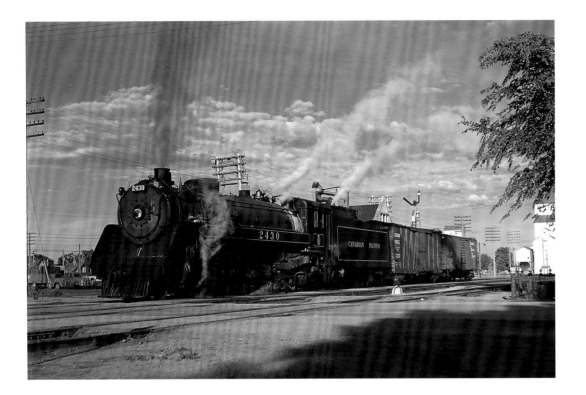

Her handsome semi-streamlined face streaked with rust, her boiler jacket stained with soot and alkali, G3h 2430 carries soiled white extra flags and trails a pair of grain boxes as she switches at Portage la Prairie, Manitoba, en route to Brandon with an Extra West in June 1959. **Paul Meyer**

Trailing wooden grain boxes, G3h 2451 races across the prairie near Portage la Prairie, Manitoba, in June 1959. **Paul Meyer**

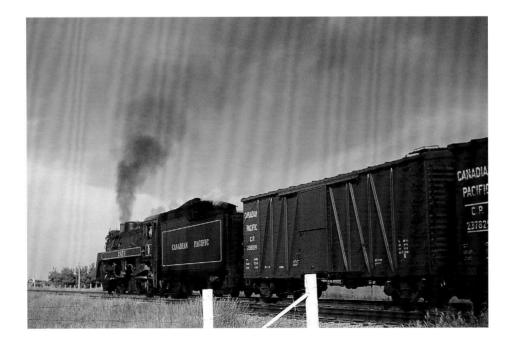

His trusty Graflex in hand, Bob Clarke looks on as P1n 5253 slugs tonnage uphill out of Minnedosa, Manitoba, on February 28, 1959. One of 65 P1-class Mikados built in 1949 from N2 Consolidations, 5253 was out of service at Weston Shops by spring, awaiting repairs that would never come. **Ruth E. Hillis**

Assigned to Minnedosa, Manitoba, R3d 2-10-0 5781, built at Angus in June 1918, lumbers up the lead on June 13, 1959. The lanky Decapod's Minnedosa duties include working the yard, as well as pushing east and westbound trains out of the Manitoba division point nestled deep in the valley of the Little Saskatchewan River. **Ruth E. Hillis**

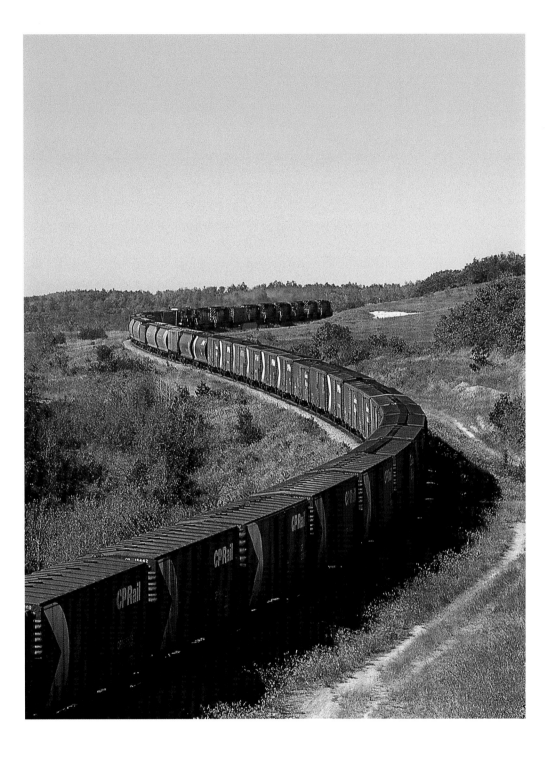

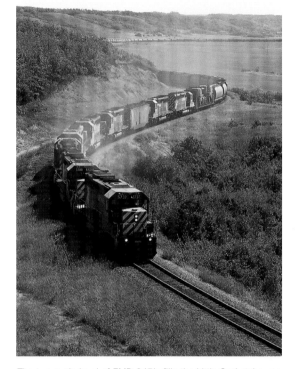

The two-cycle howl of EMD 645's fills the Little Saskatchewan River valley as Extra 5737 West thunders up the 2 percent grade out of Minnedosa, Manitoba, with eight SD40-2's, a deadheading robot car, a load of farm machinery and 142 grain empties ahead of the van. **Greg McDonnell**

Assigned to wayfreight service in the Manitoba District pool in the summer of 1959, D10j 974—outfitted with an auxiliary tender and painted with the traditional Western Lines graphite smokebox—eases off the turntable at the prairie branchline division point of Souris, Manitoba, on July 18, 1959. Outshopped from MLW in September 1912, No. 974 was retired in April 1960. **Robert Clarke**

Its windows boarded over and division point status long gone, the two-storey brick depot at Souris, Manitoba, shudders as SOO SD60 6056 and CP SD40-2 5834 rumble west with a train of grain empties at 2010, May 29, 1997. **Greg McDonnell**

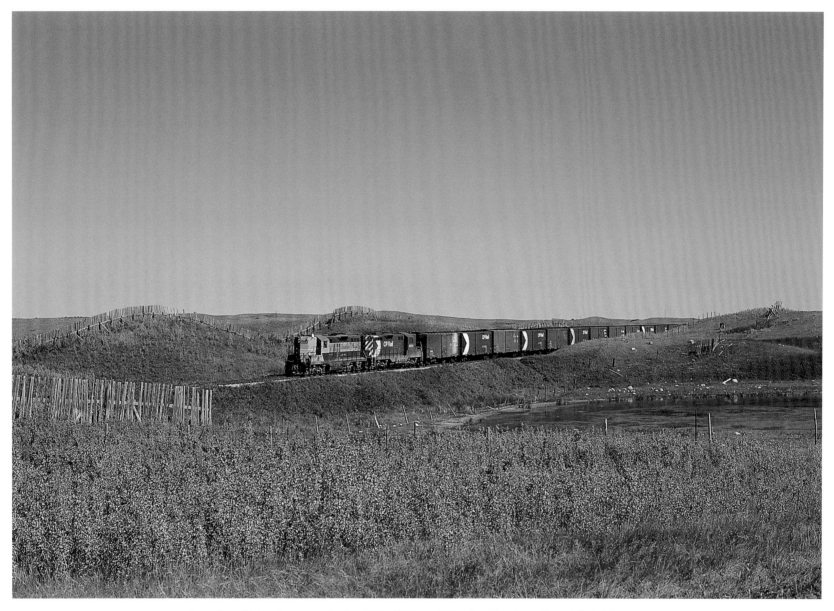

Boxcar lines. Working boxcar-only territory, GP9's 8654 and 8533 roll westward near Abound, Saskatchewan, peddling grain boxes to the elevators on the Shamrock Sub on July 24, 1977. Grain loadings on the 103.4-mile Shamrock Sub were restricted to boxcars only for the duration of the line's existence. The trackage between the junction with the Expanse Sub at Archive and McMahon was out of service by 1990–91 and the rails were lifted by 1992. Elevators at McMahon kept the westernmost section of the line—from the Vanguard Sub junction at Hak to McMahon—in service until its official abandonment on March 31, 1996. Much of that trackage remains intact and used to store cars. **Andrew J. Sutherland**

Nearly a decade after the Shamrock Sub rails were lifted, the station at Old Wives, Saskatchewan, relocated a few yards from its original site, stands abandoned on September 30, 2001. **Greg McDonnell**

"Shamrock Agt 2 Long." The station and agent at Shamrock have been gone for years, but the ring-code remains pencilled on the wall of the derelict station at Kelstern, Saskatchewan, 8.5 miles west of Shamrock, on September 30, 2001. **Greg McDonnell**

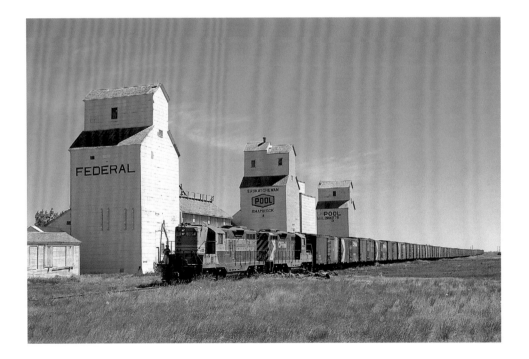

Car orders placed by the Saskatchewan Pool manager at Shamrock, Saskatchewan, are about to be filled as Tuscan-and-grey GP9 8654 and CP Rail-painted 8533 pull into town with a train of empty grain boxes at 1150, July 24, 1977. Although all three elevators are owned by Sask Pool, the Federal and Lake of the Woods Milling heritage of those flanking the "Shamrock A" is clear. **Andrew J. Sutherland**

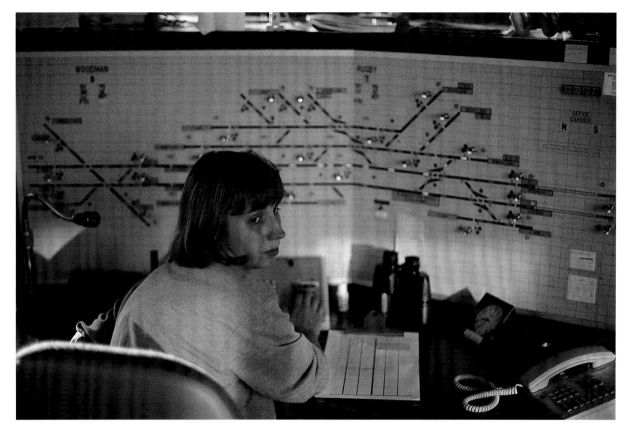

Gateway to the West. Surrounded by telephones, radios and blinking indications on the CTC machine, Shelly Buchinski works second hours at Rugby Tower on July 21, 1997, funnelling trains through the busy interlocking at the west end of Winnipeg Yard, quite literally CP's gateway to the West. **Mark Perry**

Flying green and treading historic ground, CP SD40-2 6026 and SOO sister 6614 accelerate First 950, the first section of the Winnipeg–Minneapolis runthrough, past the elevators at St. Boniface, Manitoba, at 0750, August 18, 1984. Now part of the Emerson Sub, the line from Winnipeg/St. Boniface to the international border at Emerson is one the oldest on sections of the CPR, built by contractor Joseph Whitehead in 1877–78 as the Pembina Branch. **Greg McDonnell**

A vanishing example of a one-time CPR standard, a flame-cut whistle post guards a grade crossing on the Irricana Sub at Bassano, Alberta, as the sun disappears on the prairie horizon on February 3, 1997. **Greg McDonnell**

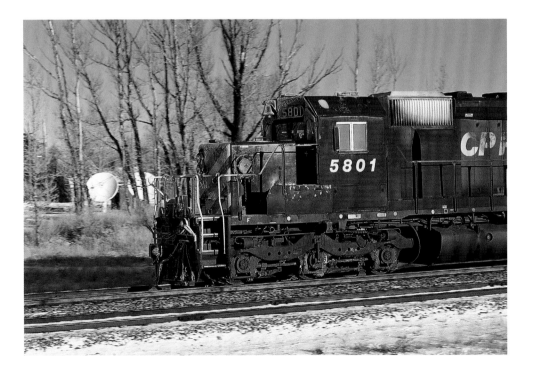

Coated with frost on a bitterly cold winter morning, SD40-2 5801 hurtles through Mortlach, Saskatchewan, with train 471-04 on December 6, 1998.
Greg McDonnell

(Left) The winter sun hangs low in the noonday sky as SD's 5804, 5509, 5944 and 5714 lead westbound potash train 671-026 through Crowfoot, Alberta, at 1230, February 3, 1997. **Greg McDonnell**

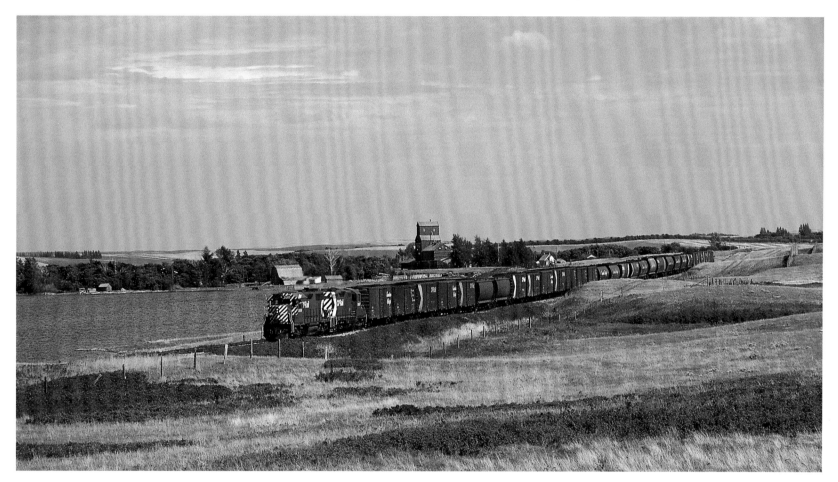

A single Sask Pool elevator at Dahlinda, Saskatchewan, juts above the horizon as GP38AC 3009 and GP9
8697 work northward on the Amulet Sub on June 9, 1977. **Andrew J. Sutherland**

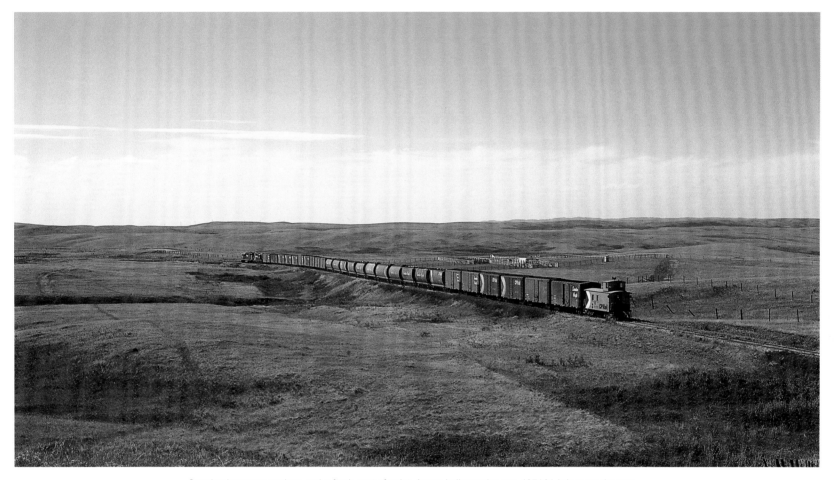

Sporting kerosene markers and a fresh coat of paint, Angus-built wooden van 437161 brings up the rear of Extra 3009 North on the Amulet Sub near Wheatstone, Saskatchewan, on June 9, 1977. The train is bound for Cardross with two cuts of grain boxes bracketing a string of covered hoppers.
Andrew J. Sutherland

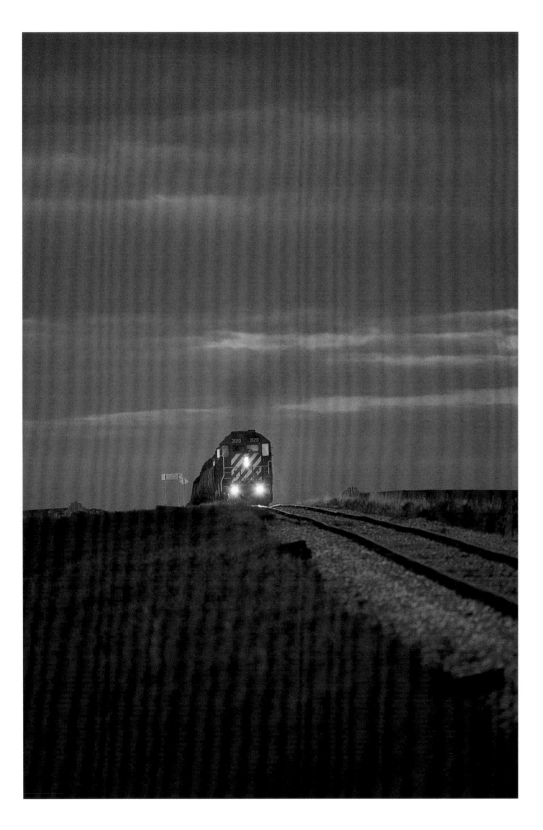

Wobbly rails glisten in the headlights' glare and the last rays of sun catch the red face of GP38-2 3120 as train KILE-31 labours past the mileboard at Boissevain, Manitoba, at sunset, May 31, 2001. **Mark Perry**

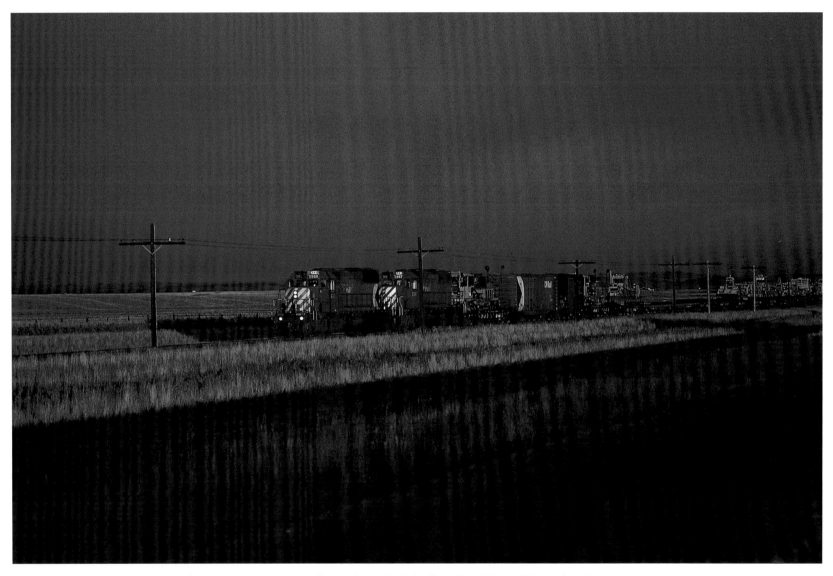

Slicing between golden wheatfields and a jet-black sky, SD40-2's 5988 and 5987 race into the setting sun near Irvine, Alberta, with an Extra West at 1807, October 18, 1995. **Greg McDonnell**

A 70-year-old relic of the glory days of prairie homesteading and branchline construction, OCS boxcar 401371, built by Canadian Car & Foundry in September 1929 as CP 244805, awaits its fate, stored in the siding at Kirkaldy, Alberta, on September 12, 1999. Immediately identifiable by its low profile and unique arched roof, the car is one of 7,500 CP-designed "miniboxes" built for the CPR by Canadian Car & Foundry, National Steel Car and the Eastern Car Company between June 1929 and March 1930. Precious few of the cars survive, none of them in revenue service.
Greg McDonnell

Rattling along one of the last active boxcar branches on the prairies, empty grain boxes rock and roll over a dirt grade crossing west of Player, Saskatchewan, on October 18, 1995. The cars are billed to the Pioneer and Sask Pool elevators at Simmie, end of steel on the lightly trafficked Dunelm Sub. The line was officially abandoned on March 31, 1996, and the elevators at Simmie have been demolished. **Greg McDonnell**

Not fade away. The rails of the Shamrock Sub are gone and the elevators in town demolished, but vestiges of the railway remain. Stripped of their trucks, grain boxes 141371 and 17535 sit forlornly in a farm field along the abandoned Shamrock Sub just outside McMahon, Saskatchewan, on June 28, 1999. **Mark Perry**

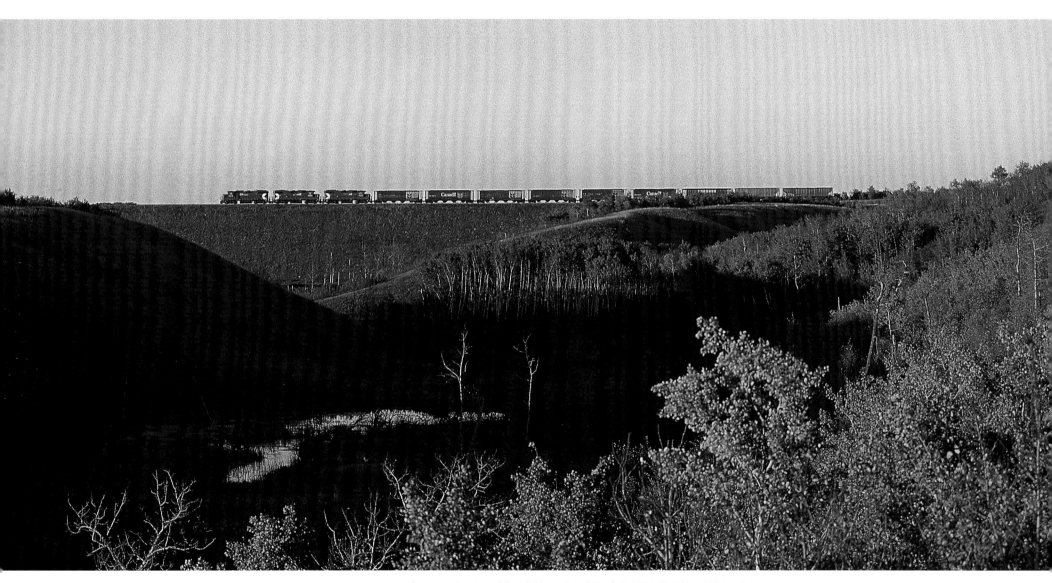

A dozen or so miles out of the one-time branchline division point of Neudorf, GP38-2's 3095, 3080 and 3047 cross a high fill west of Lemberg, Saskatchewan, with the westbound Regina Tramp at 1837, September 15, 1999. **Greg McDonnell**

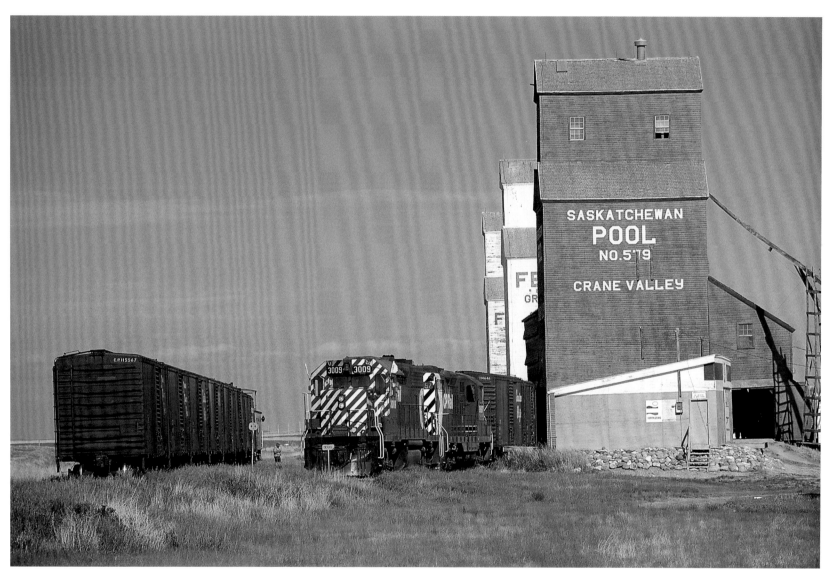

Spotting cars at the Sask Pool elevators—two of which still wear Federal lettering. GP38AC 3009 and GP9 8697 work at Crane Valley, Saskatchewan, on June 9, 1977. **Andrew J. Sutherland**

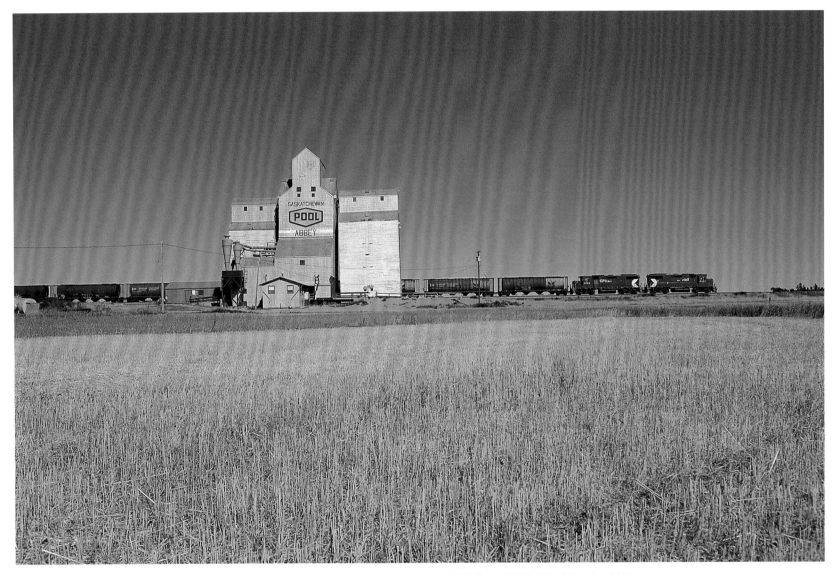

Working slowly back to Swift Current, GP38-2's 3107 and 3063 drift past the Sask Pool elevator at Abbey, Saskatchewan, with the Leader wayfreight on September 14, 1999. **Greg McDonnell**

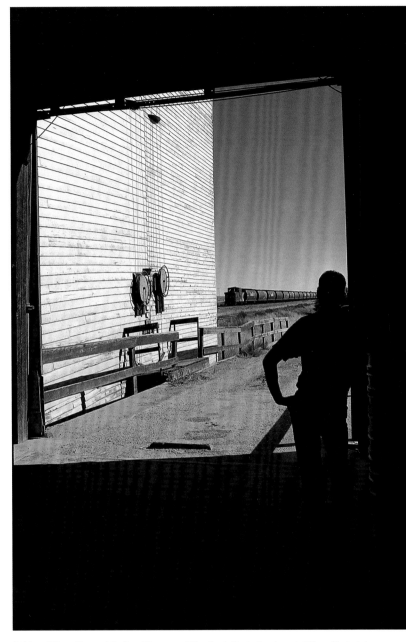

Exiting Abbey. Framed in the driveway of the Sask Pool elevator at Abbey, Saskatchewan, the elevator manager watches as the Leader wayfreight, punctuated by van 434630, leaves town at 1449, September 14, 1999. **Greg McDonnell**

Elements of bygone eras, the Leader wayfreight, one of the last trains on the prairie with a working van, passes an abandoned homestead west of Cabri, Saskatchewan, on August 25, 2000. **Mark Perry**

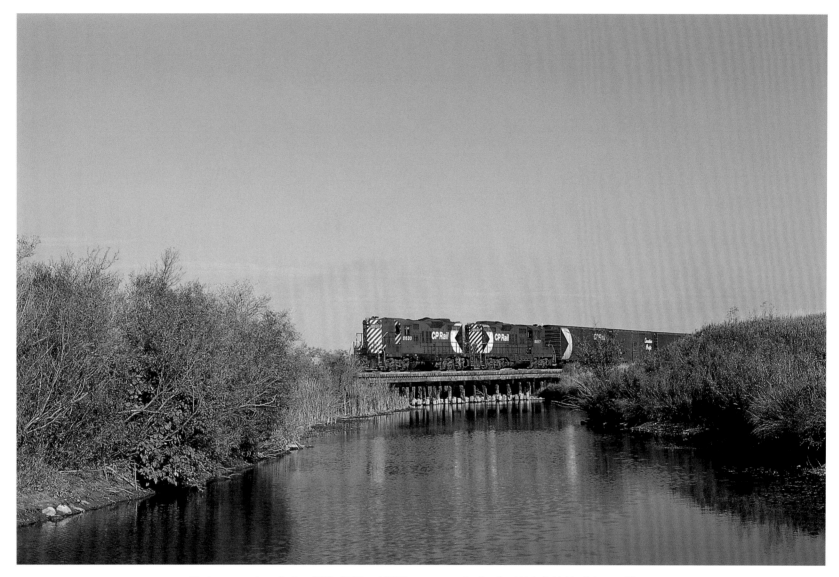

Timbers groan in protest as GP9's 8630 and 8817 cross a wooden trestle at Holmfield, Manitoba, working westward on the Napinka Sub at 1655, September 24, 1976. **Andrew J. Sutherland**

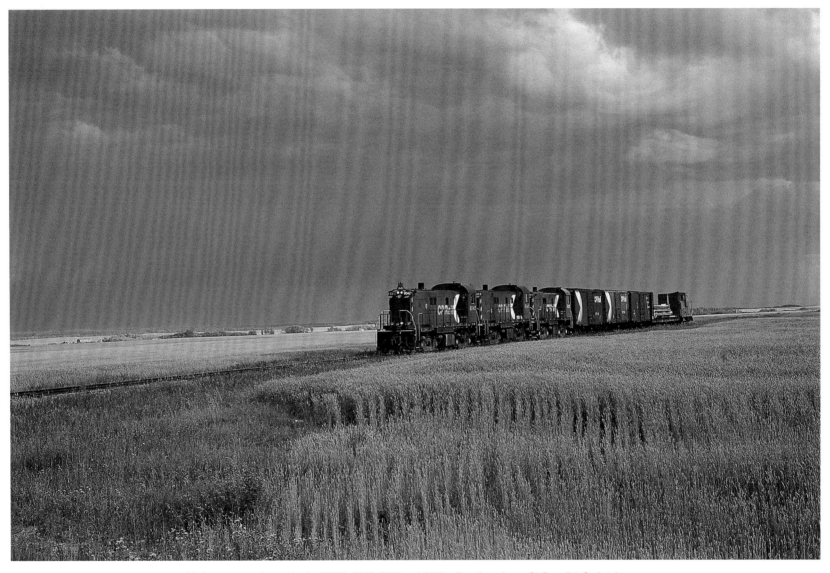

Under a spectacular prairie sky, RS23's 8042, 8041 and 8021 roll northward near St. Benedict, Saskatchewan, with a particularly short edition of train No. 85 on August 30, 1985. **Robert J. Gallagher**

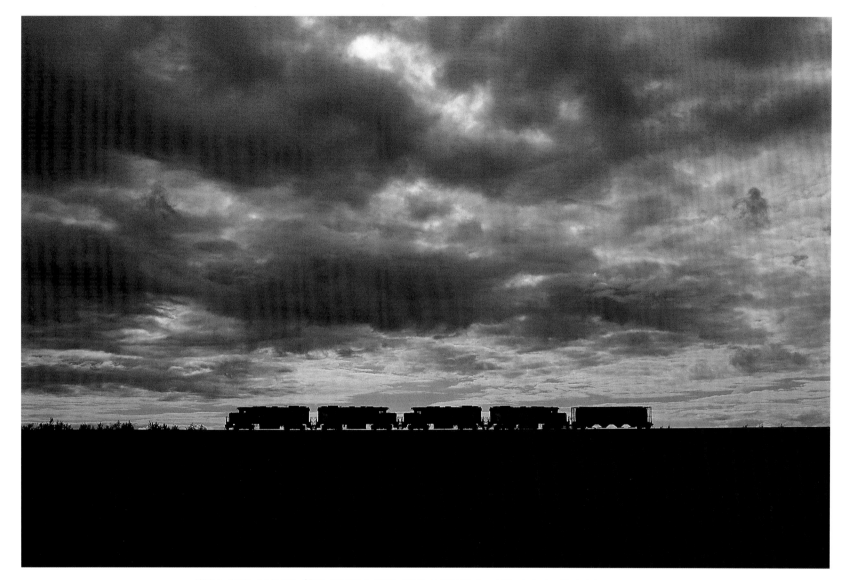

With a single car in tow, GP38-2's 3114, 3105, 3078 and 3047 depart Lloydminster, Saskatchewan, returning to Wilkie with local LLO-25 on June 26, 1999. **Mark Perry**

Its last harvest a distant memory, an ancient Cockshutt combine rusts in the wheatfields east of Lancer, Saskatchewan, as the caboose of the Leader wayfreight rolls past on September 15, 1999. **Greg McDonnell**

Forty-one minutes past midnight, there is still a trace of light in the prairie sky as the headlights of GP38-2 3036 illuminate the Sask Pool elevator as local N27 calls at Choiceland, Saskatchewan, on June 29, 2002. End of steel on the White Fox Sub, Choiceland sees trains no more than a few times each crop year.
Mark Perry

The last load-out. Standing atop a dirty brown Trudeau hopper, Steve Caswell loads 65 tons of No.1 Red Wheat into the cavernous belly of CPWX 603824 as the sun goes down at Vauxhall, Alberta, on January 25, 2001. The No. 1 Red spilling into the 4,550-cubic-foot hopper from the No. 3 elevator will not fill the car but will be sufficient to qualify the load as a "cleanout" car. And that is just what it is, for when Caswell slams the hopper lids shut, the No. 3 elevator will be empty and Vauxhall will have loaded its last car.

Idling nearby, four GP38's powering local LOM-24, the last train to call on Vauxhall, wait patiently for Caswell to complete the job as the sun sets on the railroading and grain business in another prairie town.

Just after 1800, Caswell finishes the load, climbs down and locks the doors of the Agricore Vauxhall No. 3 elevator. Lanterns swing hand signals and radios chatter in the dark as GP38's 3086, 3016, 3103 and 3109 creep up the elevator track to couple to a string of 16 covered hoppers. For the last time, the familiar chant of normally aspirated 645's fills the night air, flanges and steel wheels squeal in protest, and at 1835, the CPR pulls out of Vauxhall for ever. **Greg McDonnell**

Switching at Bassano, Alberta, GP38AC 3011
eases past the Alberta Pool elevators with the
Brooks Sub local on February 3, 1997.
Greg McDonnell

Created with steam locomotive boiler tubes and a distinctive casting crafted in CPR shops, a "boiler tube" whistle post stands sentinel on the Empress Sub east of Grant, Saskatchewan, as the Leader wayfreight rumbles past on September 14, 1999.
Greg McDonnell

Forever etched on the face, the history, the economy and the very psyche of the prairie—and of Canada—the mark of the Canadian Pacific Railway will not fade away. CPR Avenue and Shaughnessy Street, Tompkins, Saskatchewan, June 2, 2001.
Ted Benson

Living legends. Stepping through the grass, CP 1400 leads the *Royal Canadian Pacific* past the mileboard at Legend, Alberta, ambling along the little-used Stirling Sub with a rare-mileage charter on June 3, 2002.
Ted Benson

"The rainbow's end has been found amid the wind and the wheat of Nemiskam, Alberta." Photographer Benson's summation says it all as the *Royal Canadian Pacific*, working a Rare Miles Rail Cruise led by FP7 1400, F9B 1900 and GP38-2 3130, passes the Nemiscam Cemetery, a mile from the east end of the Stirling Sub on June 3, 2001. **Ted Benson**

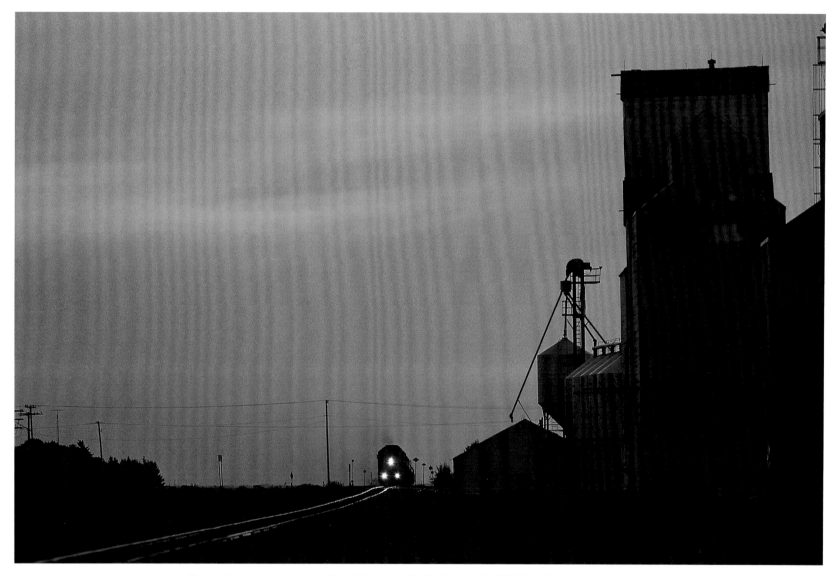

The prairie sky glows crimson in the setting sun as the Lloyd wayfreight, LLO-23, rolls through Cutknife, Saskatchewan, on August 24, 2000. **Mark Perry**

Rising above the prairie, the Rockies loom in the distance as AC4400CW 9541 leads grain train 353-24 out of Vulcan, Alberta, at sunset on January 24, 2001. **Greg McDonnell**

O.S. Orrs Lake

anadian Pacific Railway. Stencilled in neat sans serif print on the riveted flanks of the boxcars that rolled past my grandmother's house on Union Boulevard in Kitchener, those three words were the first I learned to read. The CPR has been a part of my life ever since.

As such, this book has been a lifetime in the making. It is not a historic treatise or an academic work, but a tribute to the railway that has been a part of the Canadian experience and the Canadian consciousness for almost as long as there has been a Canada. A tribute to the railway that permitted me, even before I was old enough to attend school, to be on intimate terms with the zebra-striped steeple-cabs of its electrified subsidiary and with mainline revenue steam making its last glorious stand. A tribute to the railway that provided me with my first permanent, full-time employment and continues to employ, or has employed, some of my best friends.

My CPR career began on a hot June night in 1973 as I swung aboard the head end of train No. 54 as the eastbound time freight rolled through Galt. As Stan Smaill so astutely observed in his foreword for this book, time is money on the CPR, and No. 54's crew did not have the time to stop just to taxi a new operator to Guelph Junction.

"Tell him if he wants a ride," engineer Brennan barked over the radio, "he'll have to get on on the fly. If we stop, we won't have time to make the Junction for 903." So I grabbed

There is a rich history of railroading on this hill and a deep personal connection. Dropping downgrade into Galt, H1b Hudson 2817 exits Barries Cut, drifting past the Orrs Lake mileboard with an eastbound time freight on March 9, 1957.
Jim Shaughnessy

my big red taxi on the fly, heaving my grip to the head-end brakeman in the cab of FA2 4087 and sprinting alongside until I gained enough speed to safely grab the handrails of the third unit of the A-B-B of MLW's and climb aboard. As Brennan notched out the 244's to accelerate No. 54 eastward, I walked up through the hot, noisy engine rooms of FB1 4405, FB2 4466 and FA2 4087 and took up the middle seat as

Brennan worked those old Alcos for all they were worth. With 79 cars and 4,972 tons, the best we could make was 45 mph, but we made GU ahead of 903 and in time for me to work my first third-trick shift.

Just 13 months after I dropped off No. 54 to work that first assignment at GU, I resigned my position as the swing operator at Eastend in Chatham and traded railroading for firefighting. However, the London Division was short of operators and at the request of Chief Dispatcher W. C. Baynes, I stayed on the payroll and continued to work as a spare operator. The relief work lasted less than a year, but I was never officially furloughed and never resigned. Just as well, for I was never good at goodbye.

My time in the employ of the company may have been short, but the CPR gets in the blood, no matter how brief the exposure. There is a brotherhood among those who have laboured in the service of the World's Greatest Travel System, and I'm proud to have counted myself in their number, however briefly. It is a fitting tribute that nearly half of those whose work is presented in this volume are, or have been, CPR employees. Employees or not, all of those whose photographs appear here share the passion, and it is an honour to have the privilege to include and celebrate in this volume, the art of some of the finest railroad photographers in North America.

It is fitting, too, that this book has been written and assembled within yards of the CPR, where the rails of the Galt Subdivision climb Orrs Lake hill. There is a rich history of railroading on this hill and a deep personal connection. From boyhood days when we'd stop the family car at the crossing to watch double-headed steam work up the hill, to teenage years when I'd camp on the edge of Barries Cut with just a sleeping bag, camera and a stack of 1950s vintage *Trains* magazines, to read Morgan and revel in the sight and sound of FA's, RS3's, RS10's and RS18's working past. For the past 15 years, we've had a home and raised a family on this hill, and the CPR has been a good neighbour, not to mention a continuing source of excitement and inspiration.

Much of what appears on these pages has been composed to the beat of FDL's and 645's as trains work past the window.

Thundering up Orrs Lake hill, M630's 4561 and 4573 work through Barries Cut with train 923-26 at 1828, May 26, 1989. **Greg McDonnell**

Indeed, even as I type this (at 2347 on a pleasant spring Sunday) the sound of SD40-2's taking a run at the hill is audible in the distance. As I have a thousand or more times during the course of preparing this volume, the work will be interrupted by a trip to the kitchen window to observe the passage of another train. Times and trains have changed here on the hill, but the drama and excitement of railroading has not. And will not.

The challenges facing the CPR today are no less daunting than those that confronted Van Horne and Stephen more than a century ago. As it has been for 122 years and counting, the CPR remains an integral element of the Canadian experience and an unfaltering Canadian institution. The howl of turbocharged 645's shatters the Sunday-night quiet of the household, the ground shakes and the windows rattle as 9000 EMD horses wrestle with gravity and tonnage on the climb away from the Grand River at Galt to the summit at Orrs Lake. The call of a K3LA splits the night air, carried on the wind like the defiant cry of the Clan Grant.

Stand fast!

Greg McDonnell, Employee No. 291025
Mileage 59 Galt Sub, June 1, 2003

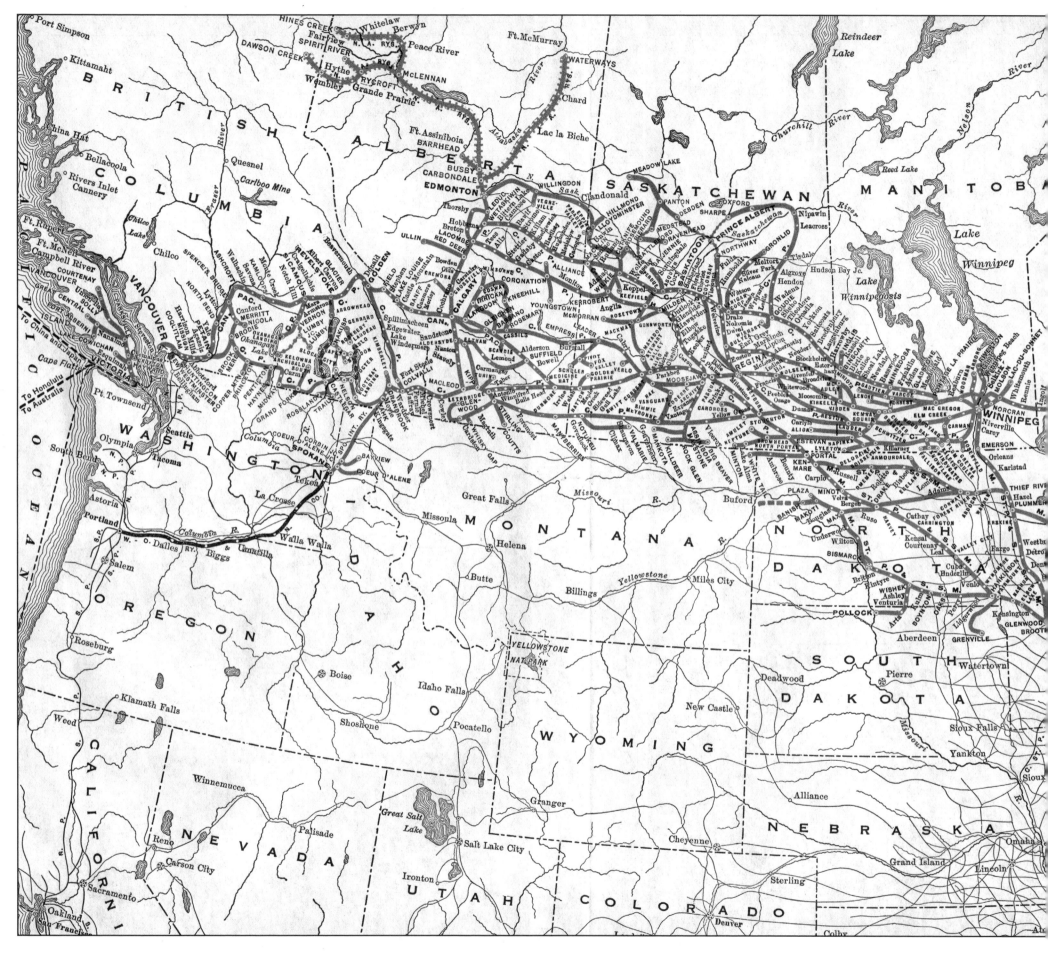